the best Invitation, Card, and Announcement design

new FACE

design with bite

roots aving success

get smart

Beguile us in the way you know;

...ease one leaf at the break of day;

...noon release another leaf;

...om our trees, one from far away;

...with gentle mist;

...and with amethyst.

...ow, slow!

Excerpt from the poem October by Robert Frost

First published in the United States of America by:
Rockport Publishers, Inc.
33 Commercial Street
Gloucester, Massachusetts 01930-5089
Telephone: (508) 282-9590

Distributed to the book trade and art trade in the United States by:
North Light Books, an imprint of
F & W Publications
1507 Dana Avenue
Cincinnati, Ohio 45207
Telephone: (800) 289-0963

Other Distribution by:
Rockport Publishers, Inc.
Gloucester, Massachusetts 01930-5089

ISBN 1-56496-363-2

10 9 8 7 6 5 4 3 2 1
Designer: Cathleen Earl
Cover Images: Front cover clockwise from top left: p. 80, 153, 114, 55, 65
 Back cover from top: p. 37, 105, 39, 25, 55

Printed in Hong Kong

the best
Invitation,
Card, and
Announcement
design

new FACE

design with bite

rOots
craVing
success
get smart

Kevin Mellen
BFA Visual Communication
Northern Illinois University

Beguile us in the way you know;

...lease one leaf at the break of day;

...tt noon release another leaf;

...m our trees, one from far away;

...with gentle mist;

...e land with amethyst.

Slow, slow!

Excerpt from the poem October by Robert Frost

ROCKPORT
PUBLISHERS

Rockport Publishers
Gloucester, Massachusetts
Distributed by North Light Books,
Cincinnati, Ohio

Contents

Introduction

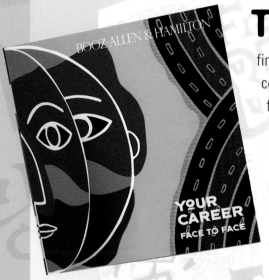

There are a plethora of greeting cards on the market; walk into any drug store, grocery store, or department store and you will find more cards than you could possibly read in one sitting. They come in every shape and size, with every type of image on the front. Greeting cards have become commonplace, with mass-produced sentiments attempting to fulfill the needs of any potential buyer. But these are not the only cards being sent. Many occasions call for something more special than these; once in a lifetime events—wedding, births, bar mitzvahs— these cards need to be personal and special. It is these special and original cards that can be found in this beautiful volume.

The graphic designer creating a greeting card is limited by the needs of the client, as with every project, but these cards allow for a certain level of frivolity not found in other design projects—brochures, direct mail, corporate identity systems. There is rarely a need for serious text, and more often than not, it is a chance to allow the designer's creativity show through. Every one of these cards is sent to bring good tidings to the recipient, whether it be holiday greetings, the announcement of a birth or wedding, or even just a reminder of the good services a business can supply.

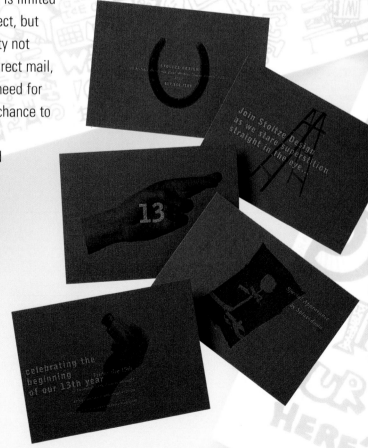

Each and every card presented in this volume is full of innovation, originality, and personality. Whether created to invite someone to a party, announce a birth, or send holiday greetings, each of these cards sends the personality of the designer in the mail right along side.

The amazing potential of today's software programs has had an obvious effect upon the cards being designed. No longer is it necessary to rely on expensive printers and large print runs; sophisticated in-house printers and image-manipulating software can produce an equivalent product. The printing options are endless: the number of colors, the size, the shape, the folds, the paper stock—yet each and every one of these details plays an important role in the final product. Look at how a vellum cover adds a sense of elegance by muting the images behind it; note how a die-cut invites the recipient to open the card; see how accordion-folds allow for word plays otherwise un-obvious. The possibilities are endless.

The cards presented in this book should supply continuous inspiration to any card- or would-be card-maker: Sayles Graphic Design created a double use for a glassine envelope: when assembled, it creates a free-standing building; Franz and Company, Inc. forced recipient participation through a clever, unsolved crossword puzzle for a moving announcement; instead of sending a flat card, Marsh, Inc. used miniature marshmallows in a canister for a humorous holiday greeting; by including a small, handmade book in the card, K.E. Roehr Design and Illustration gives the recipient a beautiful keepsake and reminder. The list could go on endlessly; the designers have allowed their creativity and whimsy free reign, but still, most importantly, sent their clear and strong message.

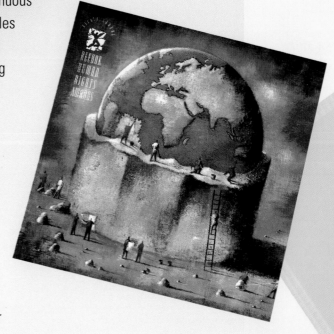

Whether you are searching for simple elegance in a wedding invitation, or a promotional mailing strong enough to catch the eye of the most jaded mail recipient, you will find it in this book. This collection is original and varied, it shows the power and creativity of today's graphic designer.

Invitat

Come be our gue
for a special sneak pr
of Connecticut's
first medical center
just for children.

Connecticut Chil
Medical Center Auxiliary

Sponsors
ASEA Brown Boveri, Inc.
Entex Information Service
Healthsource
Hewlett Packard
M.D. Health Plan
SHER'S Automotive Center, Inc.

Connec
Childr
MEDICAL CE

ions Invitations

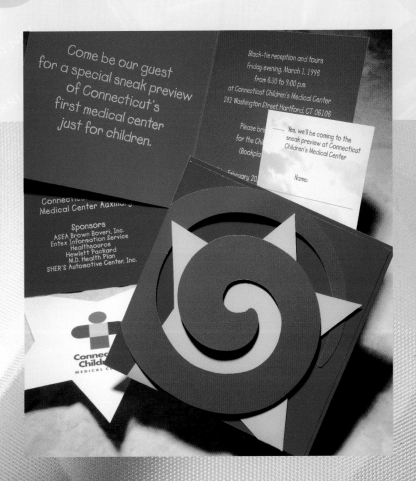

Come be our guest for a special sneak preview of Connecticut's first medical center just for children.

Black-tie reception and tours
Friday evening, March 1, 1996
from 6:30 to 9:00 p.m.
at Connecticut Children's Medical Center
282 Washington Street, Hartford, CT 06106

Please bri_____
for the Chil_____

(Bookpla_____

February 20_____

Yes, we'll be coming to the sneak preview at Connecticut Children's Medical Center

Name:

Connecticu_____
Medical Center Auxiliary's

Sponsors
ASEA Brown Boveri, Inc.
Entex Information Service
Healthsource
Hewlett Packard
M.D. Health Plan
SHER'S Automotive Center, Inc.

Connect_____
Children_____
MEDICAL C_____

Design Firm
J. Graham Design

Designer
J. Graham Design

Client
American Express

Purpose or Occasion
Holiday party

Paper/Printing
Zanders Ikonofix Dull

Number of Colors
Two

...................................

A nondenominational message
was required for the American
Express World Headquarters
holiday party. A seasonal
image accompanied by a
festive icon were utilized to
convey the message.

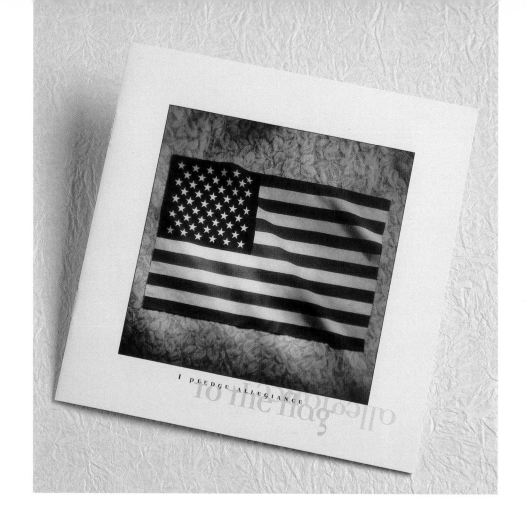

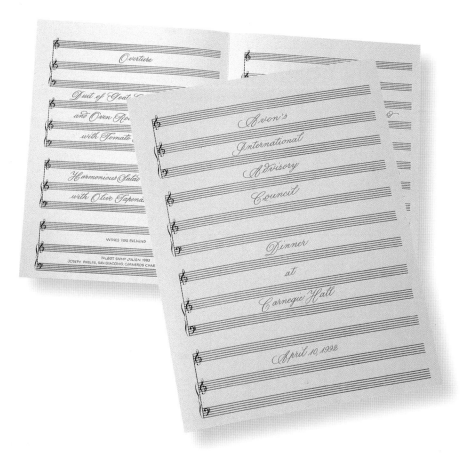

Design Firm
American Art Studio

All Design
Barbara Biondo

Client
Avon Products, Inc.

Purpose or Occasion
Dinner at Carnegie Hall

Number of Colors
Two

...................................

The invitation called for a
menu with a musical theme.
The piece was embellished
with hand-lettered, flourished
copperplate script, and used
G-clefs for ampersands.

Design Firm
McCullough Creative Group

Art Director
Mike Schmalz

Designer
Roger Scholbrock

Client
Dubuque Glass Company

Purpose or Occasion
Hospitality suite invitation

Paper/Printing
1/32" Acrylic Plexiglas/
Screenprinting

Number of Colors
Two

..

The invitation was used to invite
people to the client's hospitality
suite at a Home Builder's Show.
Since the client, Dubuque Glass
Company, sells Plexiglas, glass,
and windows, this unique
approach involved screenprinting
on clear Plexiglas, which was
well received by the recipients.

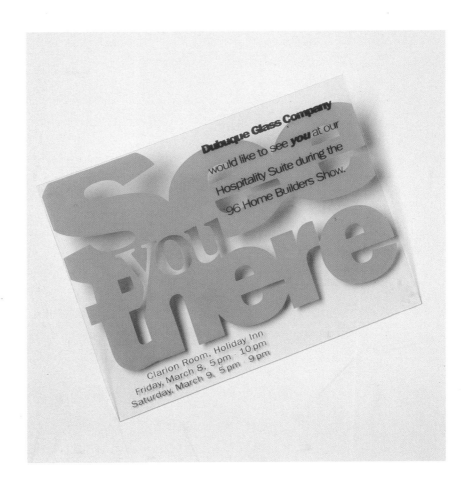

Design Firm
Mires Design

Art Director
José A. Serrano

Designers
José A. Serrano, Deborah Horn

Illustrator
Tracy Sabin

Client
Horizon

Purpose or Occasion
Invitation to a trade show

Number of Colors
Four plus one PMS

..

The purpose of the invitation
was to announce new multimedia
technology at a trade show.

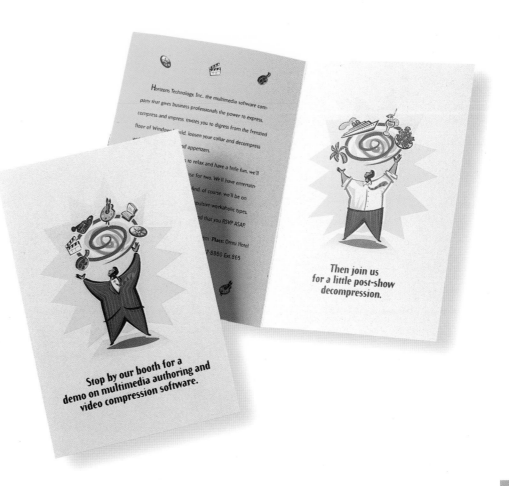

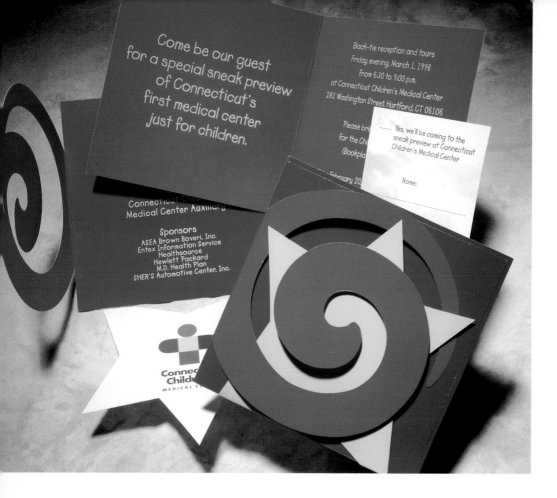

Design Firm
Rainwater Design

Designer/Illustrator
Jane Rainwater

Client
Connecticut Children's
Medical Center

Purpose or Occasion
Grand opening of new
hospital

Paper/Printing
LOE/Offset

Number of Colors
Five

The architecture of the
Connecticut Children's
Medical Center can only be
described as playful and
rollicking. The zany spiral on
the invitation was inspired
by the enormous red spiral in
the building's atrium.

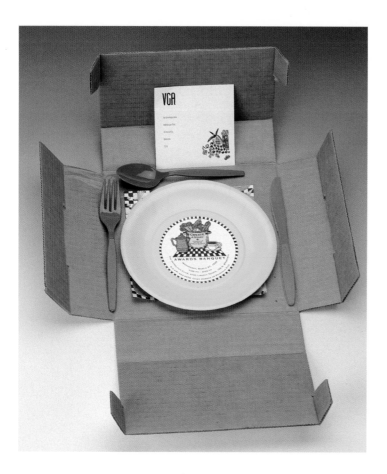

Design Firm
Val Gene Associates—Restaurant
Group

Art Director/Designer
Lacy Leverette

Illustrator
Shirley Morrow

Client
Val Gene Restaurants

Purpose or Occasion
Create a story banquet
invitation for outstanding servers

Paper/Printing
Barers Printing

Number of Colors
One

This is an invitation for waiters and
waitresses who have participated
in an exceptional act of service for
a customer (e.g., home delivery,
birthday surprise, providing a spe-
cial meal to a terminally ill patient
in the hospital). All participants are
invited to a banquet/cocktail party
awards presentation.

Design Firm
Metropolis Corporation

Creative Director
Denise Davis

Designer
Lisa DiMaio

Illustrator
Jose Ortega

Client
Booz, Allen and Hamilton, Inc.

Purpose or Occasion
Invitation to recruiting
briefing

Number of Colors
Four-color process

...................................

"Your Career—Face to Face"
was a recruiting briefing held
by Booz, Allen and Hamilton.
Metropolis designed the
invitation and information
package that was distributed
at the briefing.

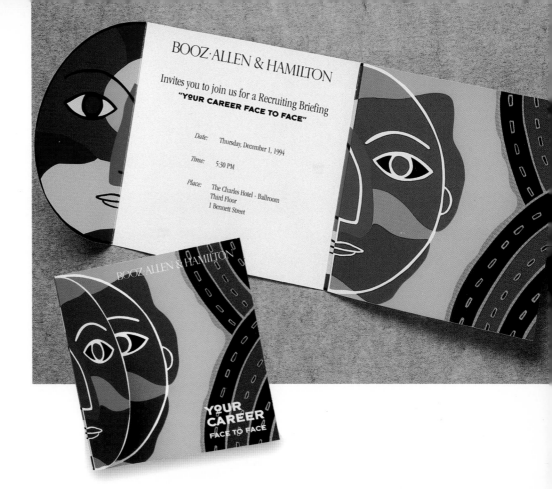

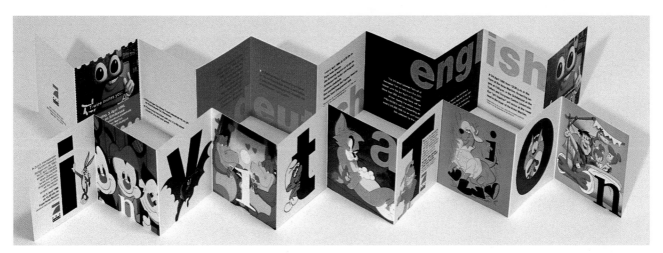

Design Firm
Tandem Graphics

Art
Director/Designer
Caren Schindelwick

Illustrator
David Weeks

Client
Pro Sieben Television

Purpose or Occasion
Invitation to a cartoon
festival

Number of Colors
Four

Mailed in a bright-red square
envelope, this invitation to a
cartoon festival for a German
TV company uses stills from
their current programming.
The lighthearted nature of the
subject is accentuated by the
small format and playful
"Leporello" folding.

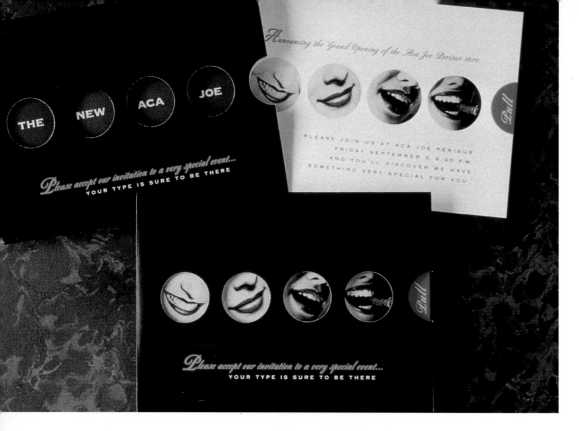

Design Firm
FRCH Design World Wide

Art
Director/Designer
Tim A. Frame

Photographer
Bray Ficken

Client
Aca Joe

Purpose or Occasion
Grand opening

Paper/Printing
Arnold Printing

Number of Colors
Four-color process

This special invitation was for the grand opening of Aca Joe's new prototype store. The invitation utilized photos that appeared in stores and on packaging to communicate various cuts of blue jeans. The invitation was placed in a die-cut sleeve that revealed the message "the new Aca Joe" when the invitation was removed.

Design Firm
Design Guys

Art Director
Lynette Sikora

Designer
Steven Sikora

Client
Design Guys

Purpose or Occasion
Holiday party invitation

Paper/Printing
Magnetic words/sheet metal

This holiday party was also an open house to show off a new office that has many sheet-steel surfaces. Since a client was involved with magnetic poetry, the designers relied on the client to produce the magnetic words. The invitation comes scrambled on a piece of sheet metal, and the potential guest must unscramble it. Care was taken to make the basic information clear, and each invitation came with one unique word magnet, which guests brought to the party to apply to the walls.

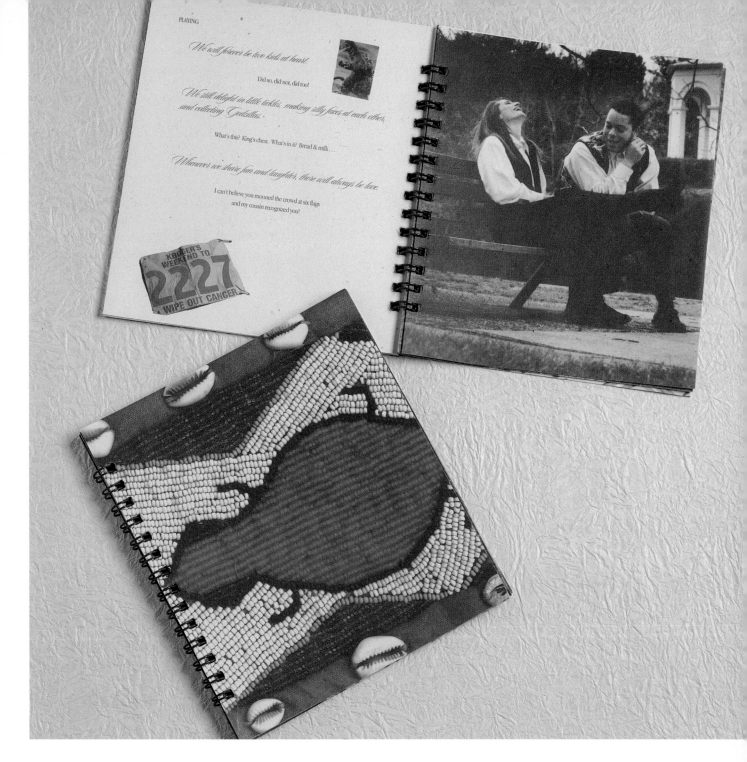

Design Firm
GAF Advertising/Design

All Design
Gregg A. Floyd

Client
Gregg and Debra Floyd

Purpose or Occasion
Wedding invitation

Paper/Printing
Concrete paper/Offset
printing

Number of Colors
Four

This invitation's theme was based on the e. e. cummings poem "He said/She said" and the movies "Annie Hall" and "When Harry Met Sally." It had to capture the differences and similarities of the couple in a humorous way as well as bring out their ability to coexist and really listen to each other. It's not that opposites necessarily attract, it's that unrelated objects make great a combination.

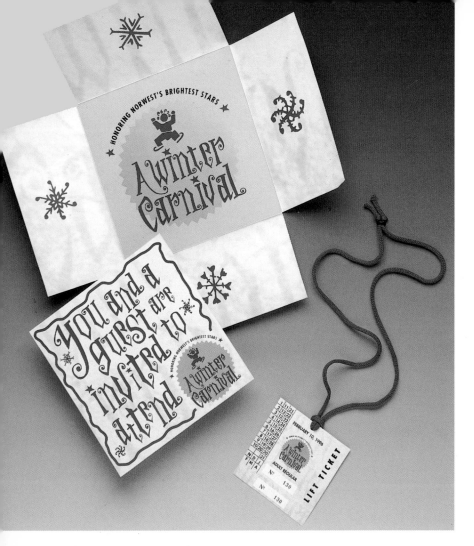

Design Firm
X Design Company

All Design
Alex Valderrama

Client
Norwest Bank

Purpose or Occasion
Regional recognition event

Paper/Printing
Knudsen Printing

Number of Colors
Two

A special invitation was needed to invite employees to a regional recognition event. Hand-lettering and a unique fold to set this invitation apart. The lettering reflects the winter-carnival theme. We also included an entrance ticket resembling a ski-lift ticket with a perforated tag that could be used in a drawing for giveaways.

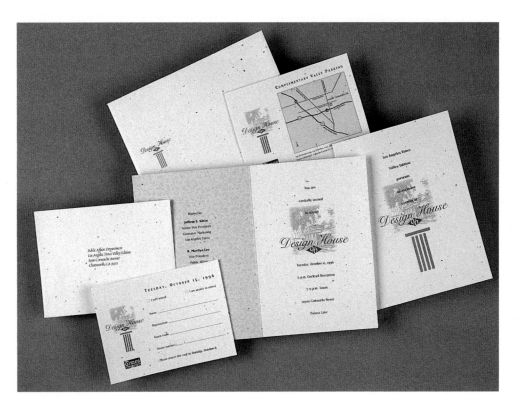

Design Firm
Julia Tam Design

All Design
Julia Chong Tam

Client
Los Angeles Times

Purpose or Occasion
Design-house invitation

Number of Colors
Two

Limited to using an existing illustration, the designers were able to break out of the initial confines by using Adobe Photoshop to enhance it. Much was done to achieve maximum effect on this two-color job. The design was right on target—even the event organization wanted to use it for their promotion.

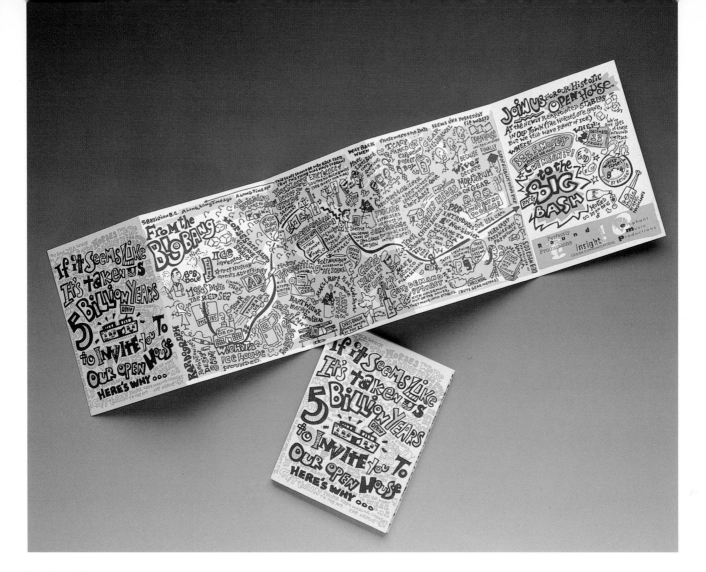

Design Firm
Insight Design
Communications

All Design
Sherrie Holdeman,
Tracy Holdeman

Client
The Stables

Purpose or Occasion
Open-house invitation

Number of Colors
Two

..

The Stables, a creative
cooperative consisting of
three individual companies,
needed something unique
to announce its first open
house. To achieve this, hand
illustrations were scanned
in and manipulated in Adobe
Photoshop using the stamp
filter to give the illustrations
a painted look.

Design Firm
Shook Design Group, Inc.

Designers
Ginger Riley,
Graham Schulker

Client
Shook Design Group, Inc.

Purpose or Occasion
Fifth annual Valentine's
Day ball

Paper/Printing
Mohawk 80 lb. cover

Number of Colors
Two

..

Shook Design Group, Inc.
designed an original invitation to
stimulate excitement surrounding
the firm's upcoming fifth annual
Valentine's Day ball.

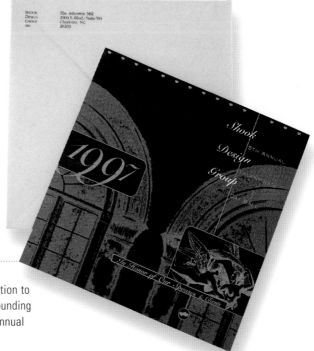

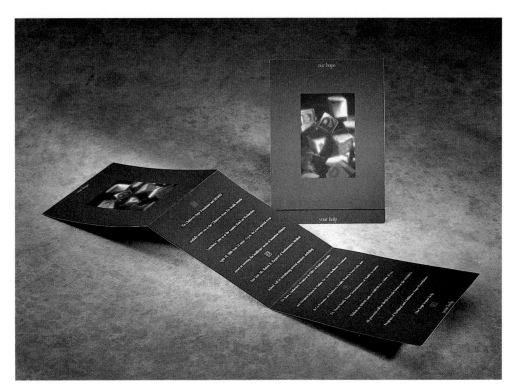

Design Firm
The Wyatt Group

Art Director
James Ward

Copywriter
Mike Maccioli

Creative Directors
Mark Wyatt, Mike Maccioli

Client
Homeless Outreach Medical
Services (HOMES)

Purpose or Occasion
Benefit luncheon

Number of Colors
Four

This invitation to potential corporate sponsors was created for HOMES, a non-profit organization that provides medical services to homeless women and children in Dallas, Texas.

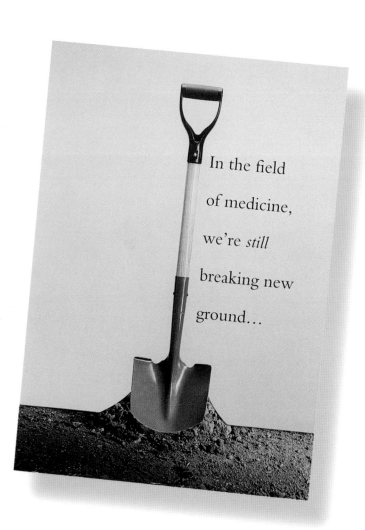

In the field of medicine, we're *still* breaking new ground...

Design Firm
Samaritan Design Center

Art Director/Designer
Al Luna

Photographer
Rick Ramen

Client
Samaritan West Valley Health
Center

Purpose or Occasion
Groundbreaking

Paper/Printing
Quintessence dull

Number of Colors
Two

The client wanted the invitation to make recipient feel like part of the ceremony. The invitation was designed to simulate a groundbreaking with die-cut shovel and a piece of dirt. The photograph was scanned, printed, and die-cut. Mud-pie pastries were delivered to city dignitaries with the invitations attached.

Design Firm
Smith Design Associates

Art Director
Martha Gelber

Designer/Illustrator
Dwight Adams

Client
Beth and Rodger Kruvant

Purpose or Occasion
Bar Mitzvah invitation

Paper/Printing
Sundance 65 lb. felt finish
cover

Number of Colors
Four

..

The client wanted an original
invitation for the Bar Mitzvah
of her sports-enthusiast son.
The photo/illustration montage
utilized actual tickets for
sports events attended by the
son, besides original illustra-
tive elements created in
Adobe Photoshop. The hockey
puck is utilized again on the
party invitation for continuity
and whimsy. The main invita-
tion was done in four-color
process and the additional
pieces are one and two color.

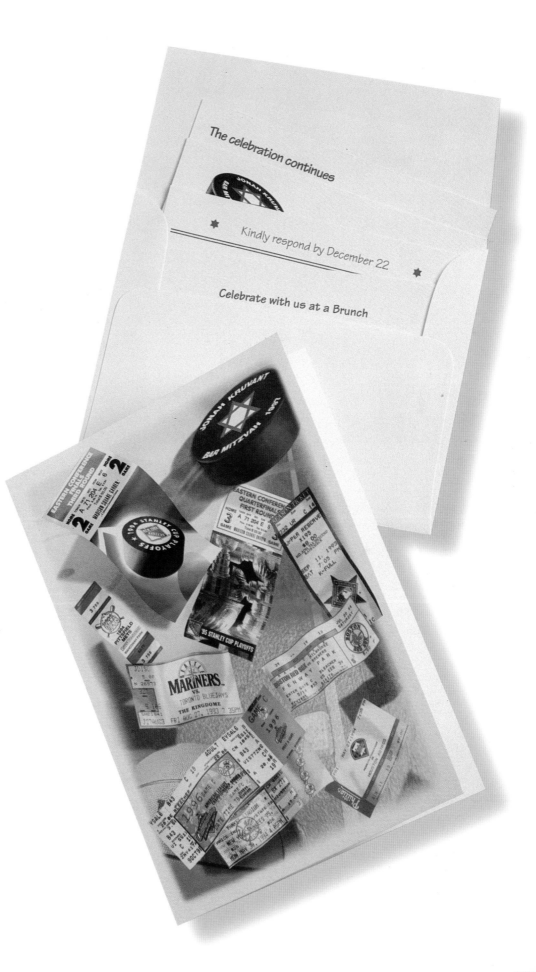

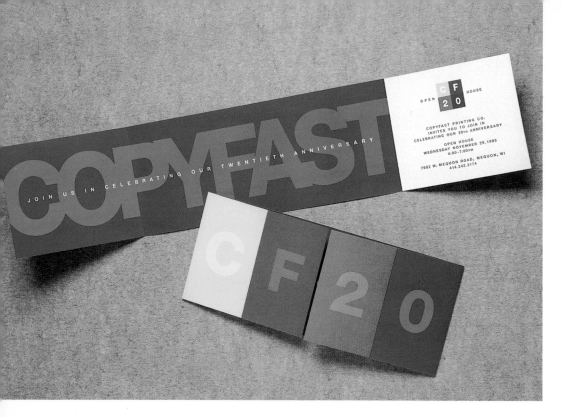

Design Firm
Becker Design

Art Director/
Designer
Neil Becker

Client
Copyfast Printing Company

Purpose or Occasion
Twentieth anniversary open house

Paper/Printing
Copyfast Printing Company

Number of Colors
Four

The invitation was for a printing company's twentieth anniversary open house.

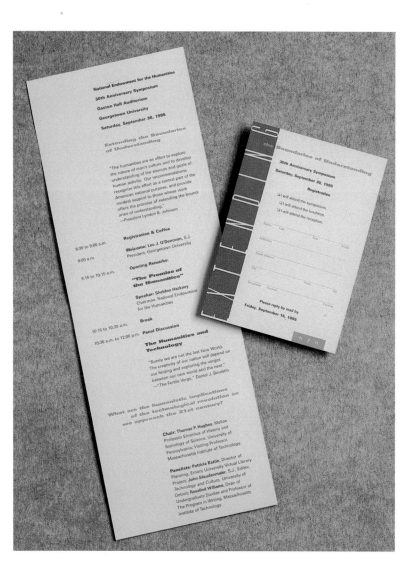

Design Firm
HC Design

Art Director
Chuck Sundin

Designer
Steve Trapero

Client
The National Endowment for the Humanities

Purpose or Occasion
Thirtieth anniversary symposium

Paper/Printing
Cougar cover, white

Number of Colors
Three

The client wanted something conceptual that would relate to the NEH's thirtieth anniversary symposium. Type was used along with the elongated format to emphasize the word "extending." An unusual color combination was used to further grab attention.

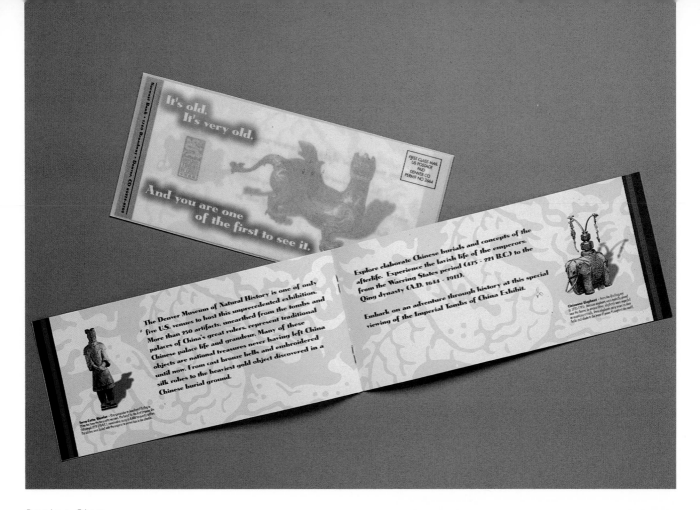

Design Firm
X Design Company

All Design
Alex Valderrama

Client
Norwest Bank

Purpose or Occasion
Client preview of museum exhibit

Paper/Printing
Richtman Printing

Number of Colors
Four

...

Premier clients were invited to this special previewing of the Imperial Tombs of China exhibit at the Museum of Natural History. The design reflected the preview theme through translucent envelopes and paper.

Design Firm
Allan Burrows Limited

Art Director/ Designer
Roydon Hearne

Client
Burrows/WCJ

Purpose or Occasion
Client entertainment

Paper/Printing
Proofing run onto skye silk stock

Number of Colors
Four

...

Each winter, the client holds an event at the Royal Albert Hall that includes the company of guitar virtuoso Eric Clapton and band. The invitation was created by a combination of photography and some modeling expertise. This involved Adobe Photoshop and QuarkXPress software as well as some guitar strings.

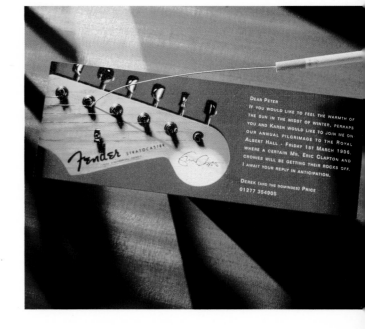

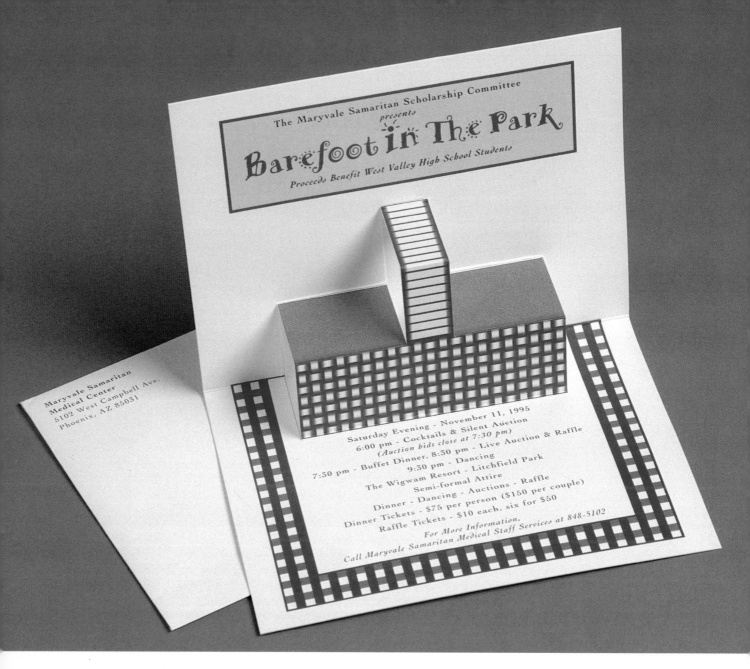

The Maryvale Samaritan Scholarship Committee
presents
Barefoot in The Park
Proceeds Benefit West Valley High School Students

Maryvale Samaritan
Medical Center
5102 West Campbell Ave.
Phoenix, AZ 85031

Saturday Evening - November 11, 1995
6:00 pm - Cocktails & Silent Auction
(Auction bids close at 7:30 pm)
7:30 pm - Buffet Dinner, 8:30 pm - Live Auction & Raffle
9:30 pm - Dancing
The Wigwam Resort - Litchfield Park
Semi-formal Attire
Dinner - Dancing - Auctions - Raffle
Dinner Tickets - $75 per person ($150 per couple)
Raffle Tickets - $10 each, six for $50
For More Information,
Call Maryvale Samaritan Medical Staff Services at 848-5102

Design Firm
Samaritan Design Center

Art Director
Al Luna

Designers
Al Luna, Louis Giordano

Illustrator
Louis Giordano

Client
Maryvale Samaritan Scholarship
Committee

Purpose or Occasion
Scholarship fund-raiser

Paper/Printing
Classic linen

Number of Colors
Three

The client requested something fun to accompany the picnic theme. A three-dimensional picnic basket with a pop-up feature adds interest for the recipient. The basket was created in Adobe Photoshop, printed, and die-cut. Other elements included large picnic baskets as center pieces and checkered tablecloths.

Design Firm
Frank Kunert

All Design
Frank Kunert

Client
Journal Frankfurt

Purpose or Occasion
Dinner for two

Number of Colors
Four

This invitation card visually portrays a first rendezvous: a hide-and-seek, a show, a looking in the mirror, asking, "Am I pretty enough?" "Will they show up, or won't they show up?" "Is he/she the right one?"

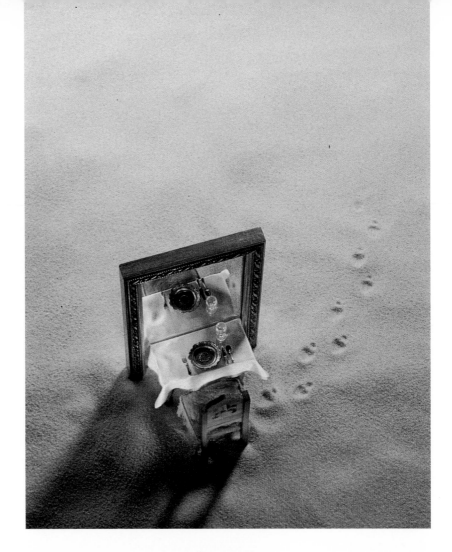

Design Firm
Frank Kunert

All Design
Frank Kunert

Client
Frank Kunert

Purpose or Occasion
Invitation for a male event

Number of Colors
Four

The shirt is made of flour and the tie is of real fruits. The light was set up to create a plastic atmosphere. Unfortunately you can't wear these clothes!

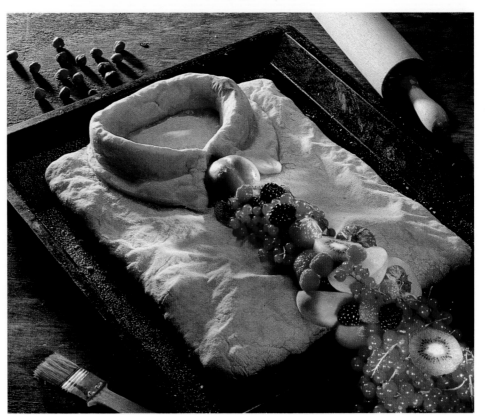

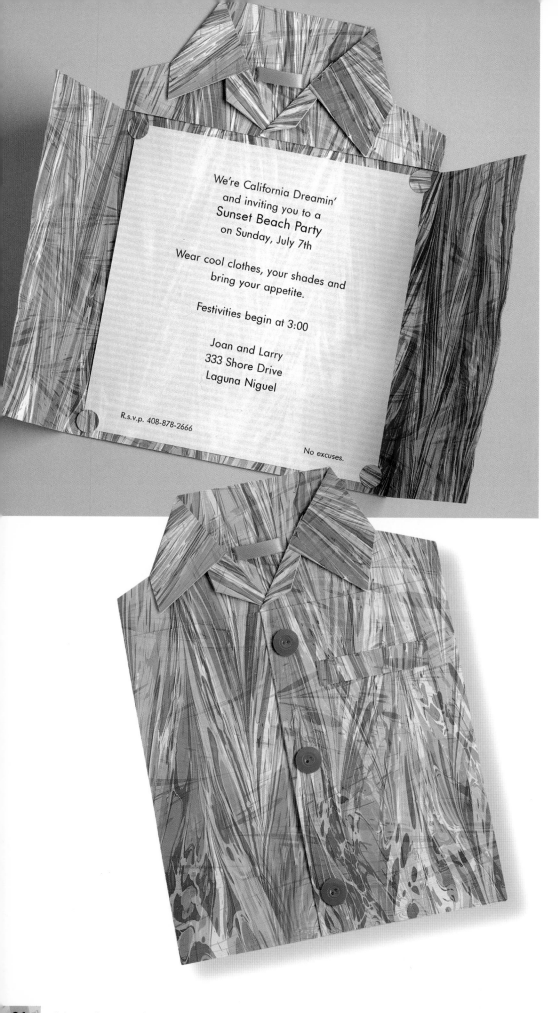

We're California Dreamin'
and inviting you to a
Sunset Beach Party
on Sunday, July 7th

Wear cool clothes, your shades and
bring your appetite.

Festivities begin at 3:00

Joan and Larry
333 Shore Drive
Laguna Niguel

R.s.v.p. 408-878-2666

No excuses.

Design Firm
American Art Studio

**Art Director/
Designer**
Barbara Biondo

Illustrator
Adam Murguia

Client
Joan and Larry Owen

Purpose or Occasion
Beach party

Paper/Printing
Hand-made paper/Laser-printed insert

Number of Colors
One

The client wanted a totally original concept to announce a beach party. The piece was based on a California casual, "beach-boy" look. Individual sheets of hand-made paper were put through a laser printer and then cut and folded to resemble a shirt. Buttons were chosen to match and a satin ribbon label was applied.

Design Firm
Muller and Company

Art Director
John Muller

Designers
John Muller, Scott Chapman

Client
Tivol

Purpose or Occasion
Diamond sale

Number of Colors
Two

....................................

This invitation is unlike any
other jeweler's promotions
because it speaks to a general
audience through rock-concert
imagery and language. To
achieve this effect, a brick
wall was actually spray-
painted, and later cleaned off.

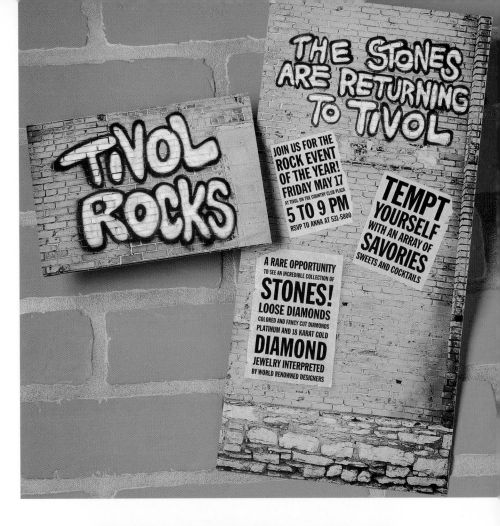

Art Director
Oliver Caporn

Illustrator
James Marsh

Client
RSCG Euro.

Purpose or Occasion
Invitation

Number of Colors
Four

....................................

The agency's blue star and red
line logo appear on the card
design for a Christmas party.

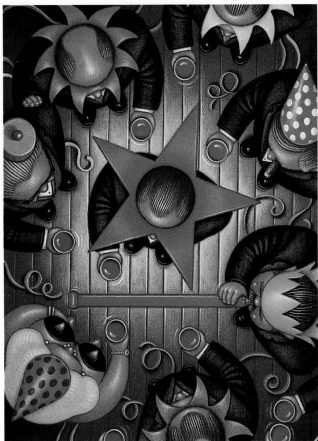

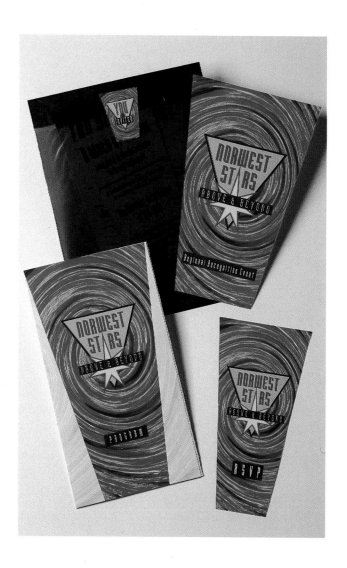

Design Firm
X Design Company

All Design
Alex Valderrama

Client
Norwest Bank

Purpose or Occasion
Employee-recognition event

Paper/Printing
Image Systems

Number of Colors
Four

...

A futuristic look that included unique cuts, a vellum envelope, and distinctive graphics was incorporated in the design for the invitation to an event honoring employees who have gone above and beyond their responsibilities. It was necessary to create a transparent envelope to expose the bright, colorful invitation. The client's objective was to have fun and create a unique look.

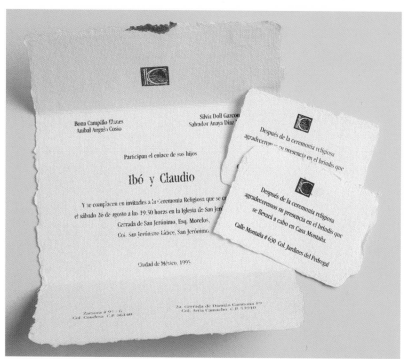

Design Firm
Zappata Diseñadores

Art Director/
Designer
Ibó Angulo

Client
Ibó and Claudio

Purpose or Occasion
Wedding invitation

Paper/Printing
Handmade

Number of Colors
One

...

This wedding invitation was for the art director of the company. Handmade paper printed in wine color replicates an old-style that suited the feeling of the event.

Design Firm
Design Guys

Art Directors
Steven and Lynette Sikora

Designer
Richard Boynton

Client
Design Guys

Purpose or Occasion
Holiday party invitation

Paper/Printing
Cougar opaque

Number of Colors
Two

..

The designers discovered that it was not easy to be the designer and the client during the production of this invitation. Despite the missed deadlines and the small budget, the end result was well received.

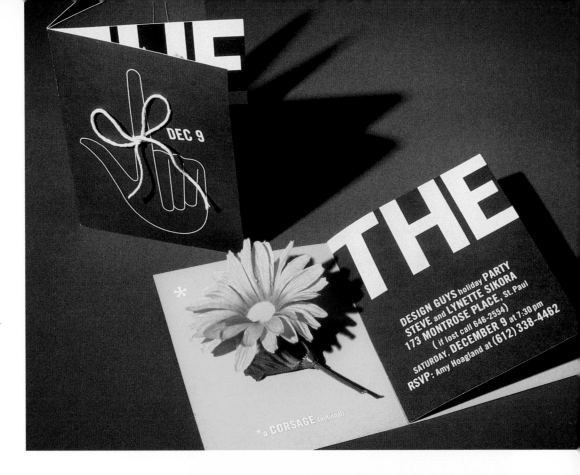

Design Firm
Design Guys

Art Director
Steven Sikora

Designer
Amy Kirkpatrick

Photographer
Darrell Eager

Client
Target

Purpose or Occasion
Wellness Expo Gala

Paper/Printing
Vintage in various weights/ Scored and die cut

Number of Colors
Five

..

This remarkable invitation arrives as a box and when the lid is removed, it opens into a flower. The flower is a symbol of wellness and was used as an icon for the event.

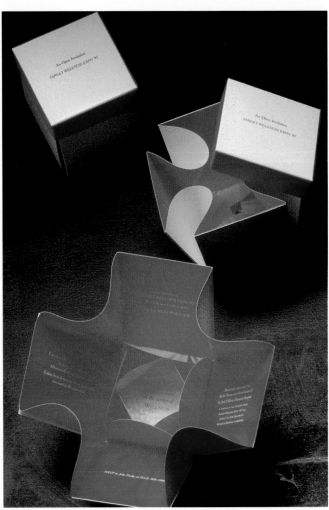

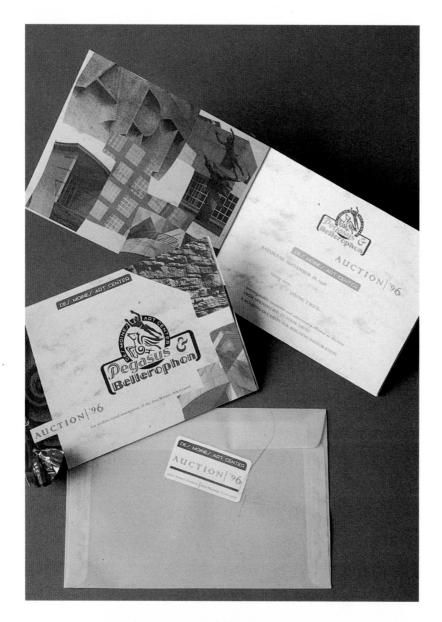

Design Firm
Sayles Graphic Design

Art Director/
Illustrator
John Sayles

Designers
John Sayles, Jennifer Elliott

Client
Des Moines Art Center

Purpose or Occasion
Invitation to a fine art auction

Paper/Printing
Offset printed on Curtis marble

Number of Colors
Three

For the invitation, photographs of the museum were cropped at angles and combined with text and graphics printed in purple, green, and copper. Printed on a green marble paper stock, the invitation is bound with a seven-inch length of copper raffia, threaded through four die-cut holes. Other materials in the campaign include letterhead and a wire-o–bound catalog of auction items.

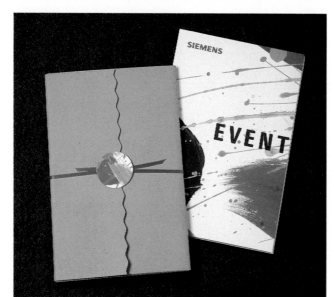

Design Firm
Sibley/Peteet Design

All Design
Art Garcia

Client
Siemens Wireless Terminals

Purpose or Occasion
Customer banquet

Paper/Printing
Voice/Patterson and Company

Number of Colors
Four

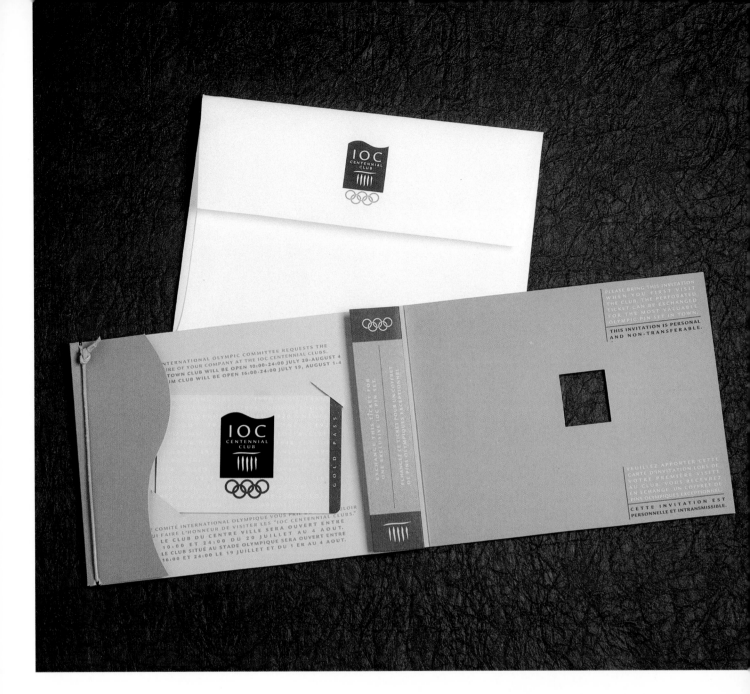

Design Firm
Copeland Hirthler design
and communications

Creative Directors
Brad Copeland,
George Hirthler

Art Director
Melanie Bass Pollard

2D Designers
Sean Goss, Melanie Bass Pollard

Copywriters
George Hirthler

Producers
Laura Perlee, Donna Harris

Client
International Olympic Committee

Purpose or Occasion
Invitation to the Centennial
Olympic Hospitality Club

Paper/Printing
Champion Benefit and
Gilbert Gilclear

Number of Colors
Three

This club provides a hospitable
and exclusive rendezvous point
for the business and marketing
partners of the Olympic move-
ment, as represented by the invi-
tation. A cool and relaxing color
palette was chosen to parallel
the event's relaxing atmosphere.
A card was included with the
invitation to serve as a pass into
the club. Adobe Photoshop, Adobe
Illustrator, and QuarkXPress were
used to create both the invitation
and the accompanying maps.

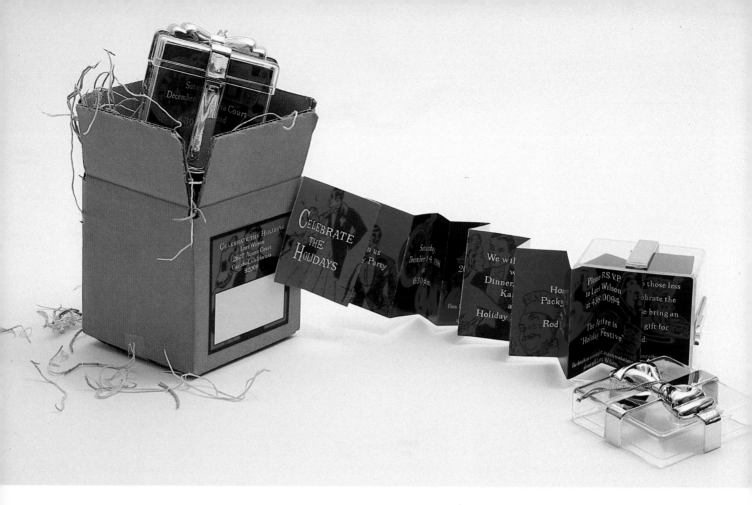

Design Firm
Mohr Design

All Design
Jack N. Mohr

Client
Jack N. Mohr

Purpose or Occasion
Birthday reception

Paper/Printing
Simpson Quest/Color laser
printer

Number of Colors
Four

The invitation announced the
event without publishing the
birthday occasion so guests
would not feel obliged to
bring presents.

Design Firm
This Gunn for Hire

Art Director
Leslie Gunn

Designers
Leslie Gunn, Sherry Ahern

Client
Lori Wilson

Purpose or Occasion
Holiday party invitation

Paper/Printing
Indigo press and paper

Number of Colors
Two

The two-color invitation, pre-
sented in a clear, acrylic gift
box/ornament, was packed for
shipping with excelsior and a
matching label. All pieces
were printed on one sheet,
using an indigo press with
hand assembly completed by
the client.

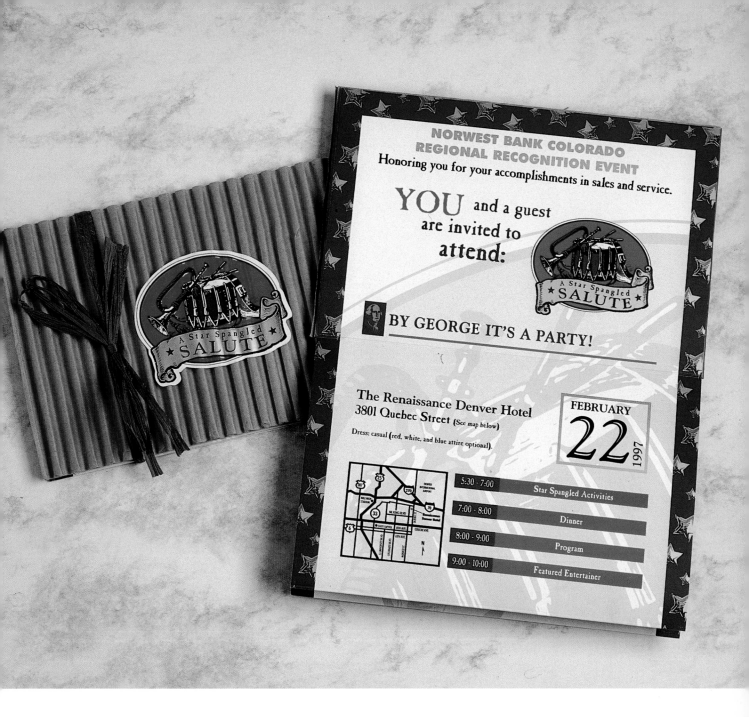

Design Firm
X Design Company

All Design
Alex Valderrama

Client
Norwest Bank

Purpose or Occasion
Employee recognition

Paper/Printing
Richtman's Printing of Colorado

Number of Colors
Four PMS

This was timed in conjunction with Norwest's sponsorship of the Liberty Event on PBS TV. The invitations had Civil War graphics and theme. Each invitation was handmade with corrugated cardboard, embossed stickers, and tie ribbons to give them a unique look that invitees would respond to.

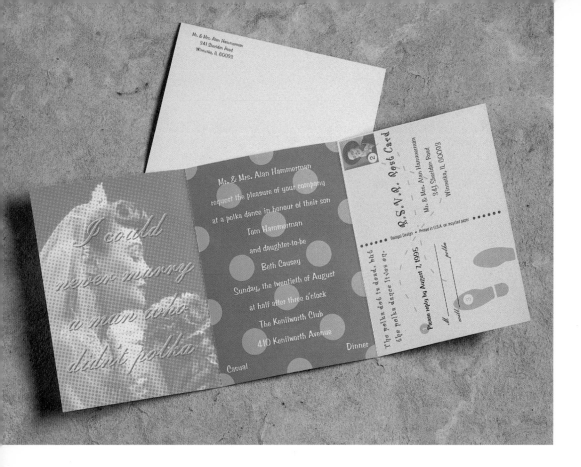

Design Firm
Bakagai Design

Designer/Illustrator
Michael M. Hammerman

Client
Parents

Purpose or Occasion
Polka engagement party

Paper/Printing
Strathmore Elements/Offset

Number of Colors
Two

This piece emphasized a nostalgic polka/polka-dot theme. The halftones were done in Adobe Photoshop by combining a coarse halftone version of the image with a normal photographic version. Other colors were produced by combining the cyan and magenta inks.

Design Firm
Toni Schowalter Design

Art Director/Designer
Toni Schowalter

Client
Torrence

Purpose or Occasion
Invitation to party

Paper/Printing
Pink card stock

Number of Colors
One

Inexpensive one-color printing on a pink stock set the tone for a retro look and feeling on this invitation.

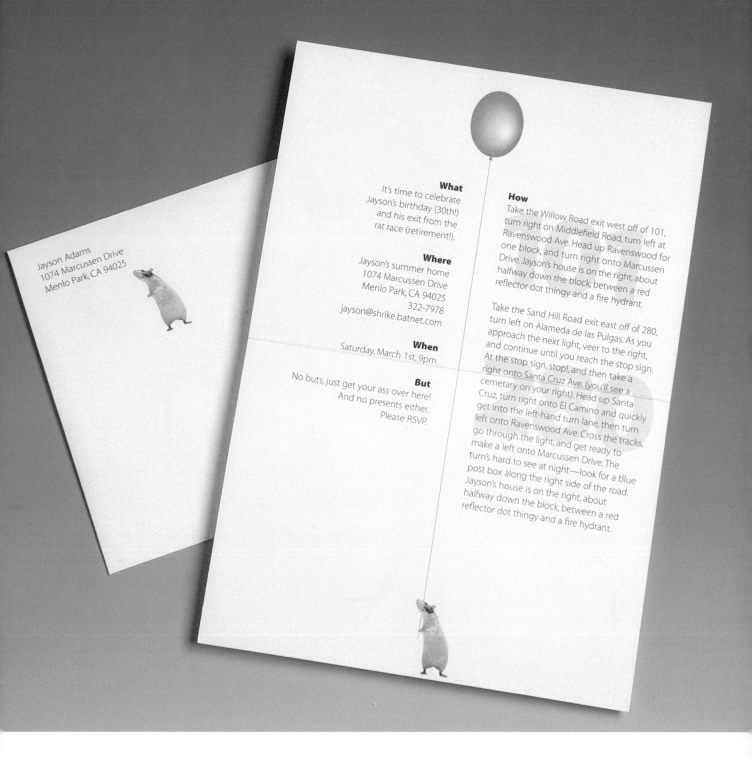

Jayson Adams
1074 Marcussen Drive
Menlo Park, CA 94025

What
It's time to celebrate
Jayson's birthday (30th!)
and his exit from the
rat race (retirement!).

Where
Jayson's summer home
1074 Marcussen Drive
Menlo Park, CA 94025
322-7978
jayson@shrike.batnet.com

When
Saturday, March 1st, 9pm

But
No buts, just get your ass over here!
And no presents either.
Please RSVP.

How
Take the Willow Road exit west off of 101,
turn right on Middlefield Road, turn left at
Ravenswood Ave. Head up Ravenswood for
one block, and turn right onto Marcussen
Drive. Jayson's house is on the right, about
halfway down the block, between a red
reflector dot thingy and a fire hydrant.

Take the Sand Hill Road exit east off of 280,
turn left on Alameda de las Pulgas. As you
approach the next light, veer to the right,
and continue until you reach the stop sign.
At the stop sign, stop!, and then take a
right onto Santa Cruz Ave. (you'll see a
cemetary on your right). Head up Santa
Cruz, turn right onto El Camino and quickly
get into the left-hand turn lane, then turn
left onto Ravenswood Ave. Cross the tracks,
go through the light, and get ready to
make a left onto Marcussen Drive. The
turn's hard to see at night—look for a blue
post box along the right side of the road.
Jayson's house is on the right, about
halfway down the block, between a red
reflector dot thingy and a fire hydrant.

Design Firm
Stowe Design

Designer
Jennifer Adams

Client
Jayson Adams

Purpose or Occasion
Birthday and retirement party

Number of Colors
Two

Our client was retiring and
turning thirty simultaneously
and needed an invitation for
both these events. He wanted
an equal focus on both
events, hence the rats for the
rat race he was leaving and
the hat and balloon for the
birthday party aspect.

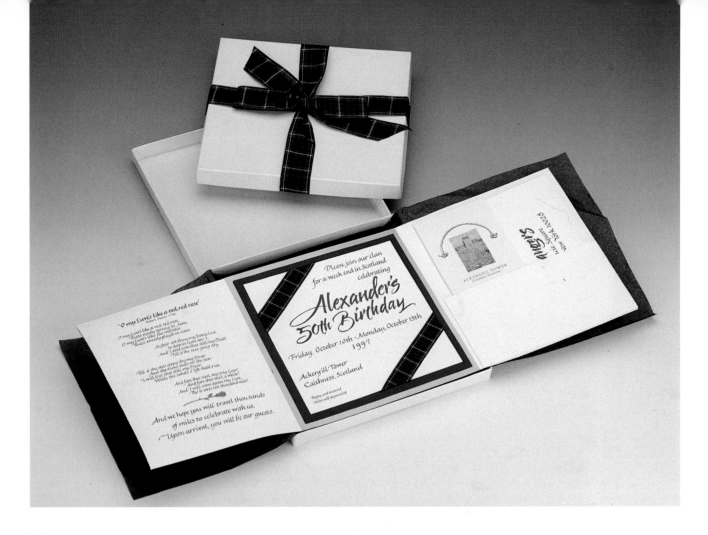

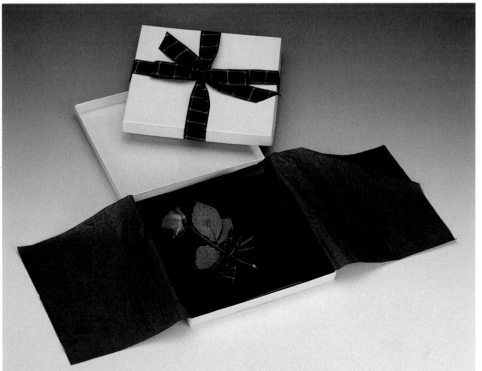

Design Firm
Nancy Stutman Calligraphics

Art Director/
Designer
Nancy Stutman

Client
Jeannette Watson Sanger

Purpose or Occasion
Alex Sanger's fiftieth birthday

Paper/Printing
Vicksburg/Offset

Number of Colors
One

Guests were invited to celebrate Alex's fiftieth birthday in a Scottish castle. Since his middle name is Campbell, Campbell plaid ribbon and a similar plaid fabric were chosen and laminated to the invitation to carry out the theme. Robert Burns' "Red Rose" added the final touch.

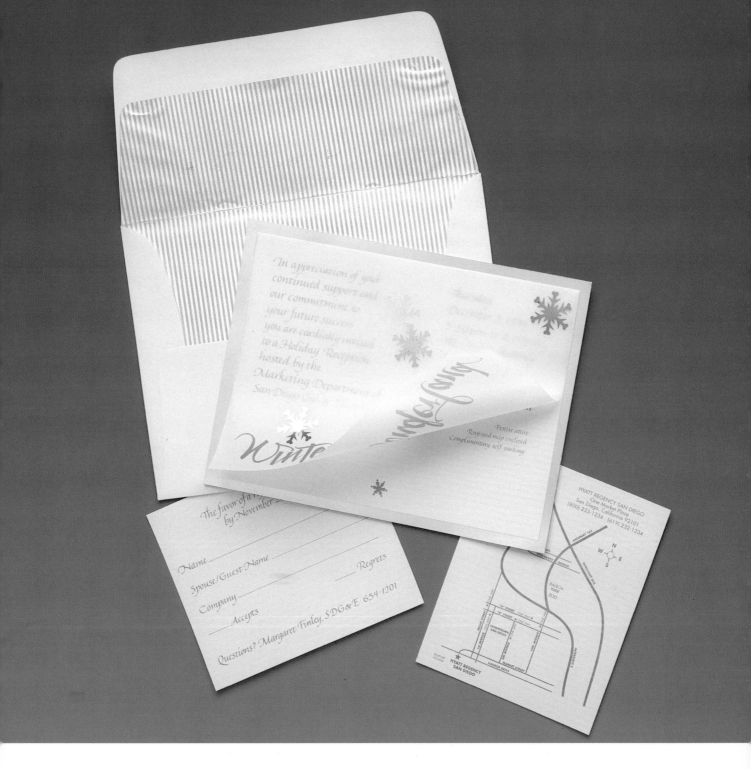

Design Firm
Nancy Stutman

Art Director/Designer
Nancy Stutman

Client
San Diego Gas and Electric

Purpose or Occasion
Holiday party

Paper/Printing
UV Ultra II/Columns/Offset

Number of Colors
One

SDG & E wanted an elegant look to their Winter Wonderland holiday party invitation. UV Ultra II with iridescent snowflakes was used to effectively achieve this goal.

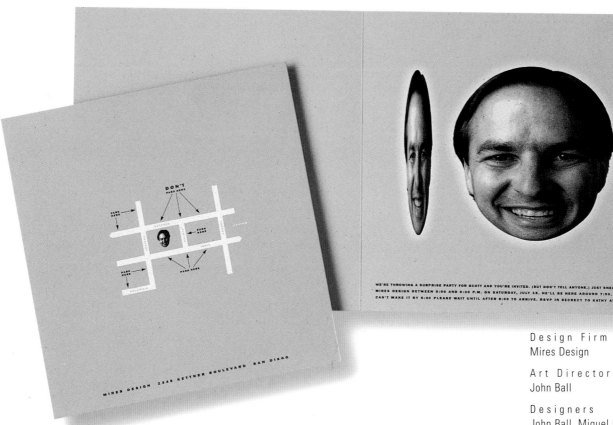

WE'RE THROWING A SURPRISE PARTY FOR SCOTT AND YOU'RE INVITED. (BUT DON'T TELL ANYONE.) JUST SNEAK OVER TO
MIRES DESIGN BETWEEN 6:00 AND 6:30 P.M. ON SATURDAY, JULY 25. HE'LL BE HERE AROUND 7:00, SO IF YOU
CAN'T MAKE IT BY 6:30 PLEASE WAIT UNTIL AFTER 8:00 TO ARRIVE. RSVP IN SECRECY TO KATHY AT 495-9171.

Design Firm
Mires Design

Art Director
John Ball

Designers
John Ball, Miguel Perez,
Kathy Carpentier-Moore

Copywriter
John Kuraoka

Client
Mires Design, Inc.

Purpose or Occasion
Invitation to a surprise party

Number of Colors
Two

Since it was the client's tenth
year in business, the number
ten was used throughout the
invitation and manipulated
using distortion, duotones,
and glows created in Adobe
Photoshop.

Design Firm
Design Guys

Art Director
Steven Sikora

Designers
Amy Kirkpatrick,
Mitchell Morse

Client
Target

Purpose or Occasion
Super Target Luncheon

Paper/Printing
Dull laminated offset

Number of Colors
Four-color process

This invitation, which opens
into a placemat, was sent to
grocery vendors to invite them
to attend a luncheon promot-
ing Super Target's combined
grocery/discount store.

Design Firm
Pollard Creative

**Art Director/
Designer**
Melanie Bass Pollard

Photographer
Jerry Burns

Copywriter
Jake Pollard

Producers
Laura Perlee, Donna Harris,
Melanie Bass Pollard

Client
Melanie Bass and Jake
Pollard

Purpose or Occasion
Wedding invitation

Paper/Printing
Karma/Offset

Number of Colors
Four

.................................

This wedding invitation was
created to invite forty close
friends and immediate family
to a small wedding in the
country for a full weekend
event. The invitation under-
scored the contrasting person-
alities of the couple through
style and a sense of humor.
Hand-binding combined with a
silk duponi added a personal
feel, which was appropriate
for both the concept and the
intimacy of the wedding.

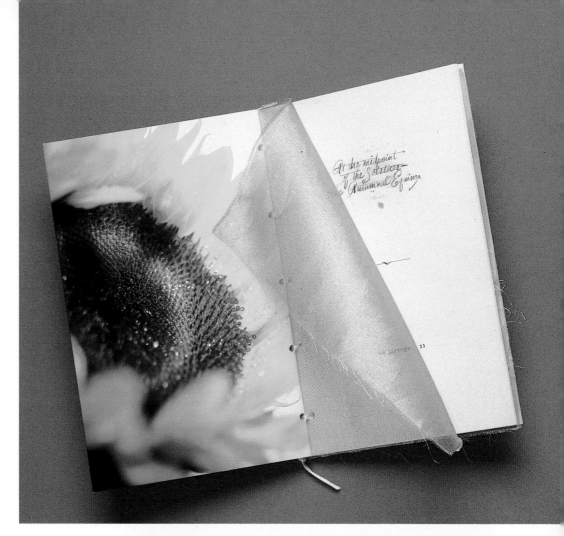

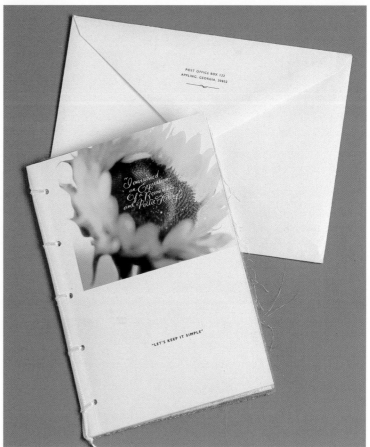

Design Firm
Austin Design

Art Director/
Designer
Wendy Austin

Client
Marcam Corporation

Purpose or Occasion
Invitation to founders' dinner

Paper/Printing
Confetti/Canson Satin/Four Star Printing

Number of Colors
Two

This invitation was produced for a Founders' Day dinner held at the JFK Library—thus the JFK quote. The piece was placed on the individual plates at the dinner and not mailed so that people would be encouraged to take it home.

Design Firm
Sayles Graphic Design

All Design
John Sayles

Client
Planned Parenthood

Purpose or Occasion
Invitation

Paper/Printing
Curtis linen cover/Offset

Number of Colors
Three

Great design takes center stage in this invitation, which features boldly illustrated musical graphics in metallic inks on richly-textured paper. To add visual excitement, the invitations were cut in three different sizes and bound by a single silver cord.

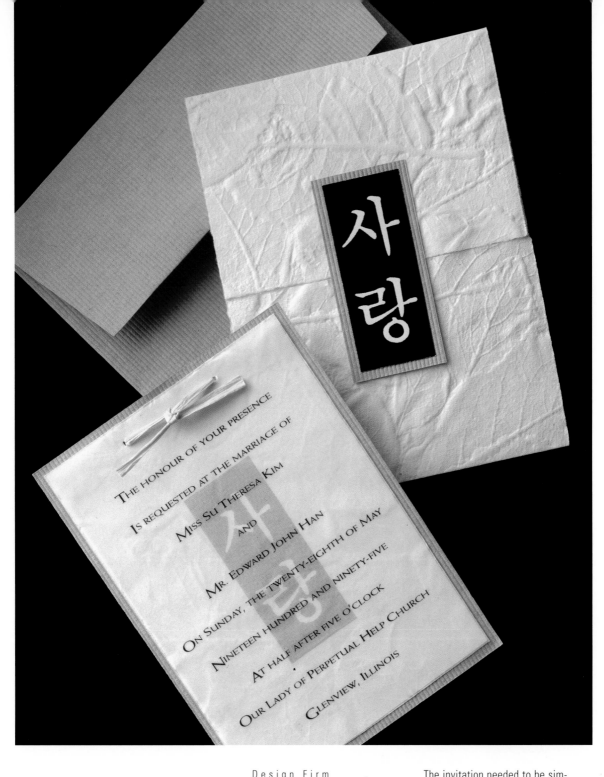

THE HONOUR OF YOUR PRESENCE
IS REQUESTED AT THE MARRIAGE OF
MISS SU THERESA KIM
AND
MR. EDWARD JOHN HAN
ON SUNDAY, THE TWENTY-EIGHTH OF MAY
NINETEEN HUNDRED AND NINETY-FIVE
AT HALF AFTER FIVE O'CLOCK
OUR LADY OF PERPETUAL HELP CHURCH
GLENVIEW, ILLINOIS

사랑

Design Firm
Han Design

All Design
Ed Han

Client
Ed Han/Su Kim

Purpose or Occasion
Wedding invitation

Paper/Printing
Feltweave/laser printing

Number of Colors
One

The invitation needed to be simple, elegant, and reflective of a Korean/American heritage. To achieve this effect, the couple selected handmade oriental papers and a wrap-style outer sleeve. The characters on the seal spell the Korean word for love and were used as a repeating design element on the invitation and on the wedding mass program.

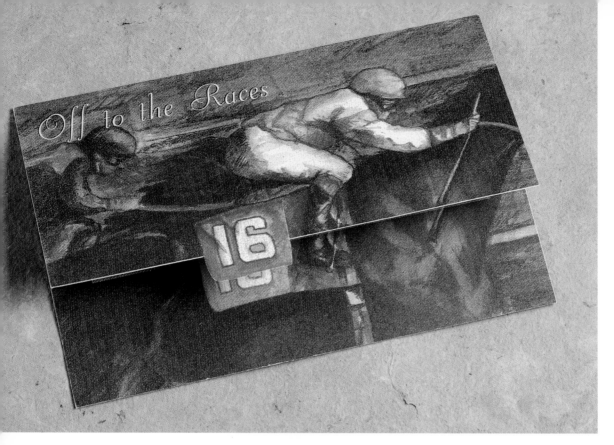

Design Firm
Towers Perrin

Designer
Liz Alonzo

Illustrator
Jason Niemoth

Client
Towers Perrin

Purpose or Occasion
Invitation

Paper/Printing
Neenah Environment

Number of Colors
Four

..

This is an invitation to a client event at the racetrack. The illustration was done by an in-house illustrator. The horse's number represents the date of the event and also serves as a seal to close the invitation.

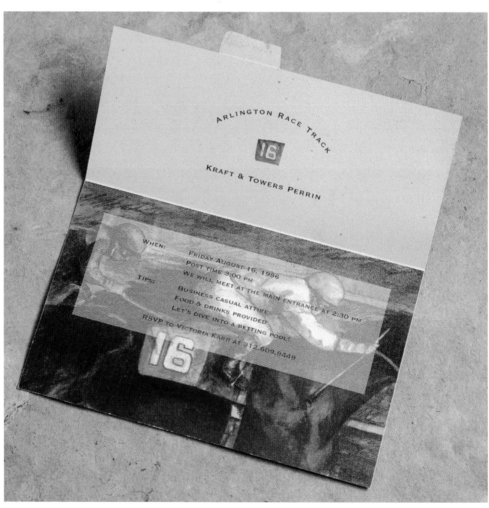

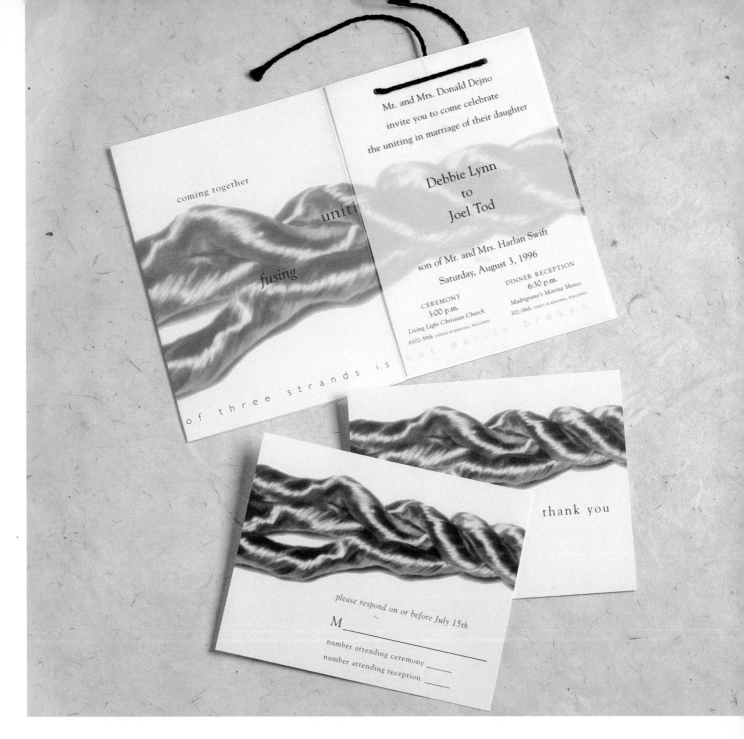

coming together

unitin...

fusing

of three strands is ...ot easily broke...

Mr. and Mrs. Donald Dejno
invite you to come celebrate
the uniting in marriage of their daughter

Debbie Lynn
to
Joel Tod

son of Mr. and Mrs. Harlan Swift

Saturday, August 3, 1996

CEREMONY
3:00 p.m.
Living Light Christian Church
6102-39th AVENUE IN KENOSHA, WISCONSIN

DINNER RECEPTION
6:30 p.m.
Madrigrano's Marina Shores
302-58th STREET IN KENOSHA, WISCONSIN

thank you

please respond on or before July 15th
M _____
number attending ceremony _____
number attending reception _____

Design Firm
Entheos Design

Art Director
Debbie Swift

Photographer
Debbie Swift

Client
Debbie and Joel Swift

Purpose or Occasion
Wedding invitation

Paper/Printing
Simpson 80 lb. Coronado

Number of Colors
Two

The client wanted the wedding invitation to be fresh, unusual, and meaningful. A verse that was to be read at the wedding, "a cord of three strands is not easily broken," was incorporated. Then came the task of finding the perfect cords to photograph. Choosing the right words and arranging them with the image in a Z-fold format was a challenging process. Each word was chosen and placed with purpose. The reception and thank-you cards carried the theme as well.

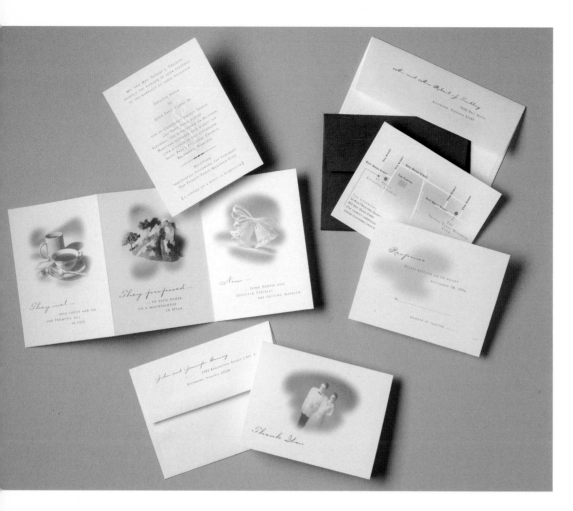

Designer
C. Benjamin Dacus

Photographer
Kip Dawkins

Copywriter
John Sarvay

Client
John Sarvay, Jennifer Treibley

Purpose or Occasion
Wedding invitation

Paper/Printing
Monadnock Astrobright/Offset

Number of Colors
Two

After hearing the clients' story, the designer proposed just that—a story. The figuring of the pagination revealed that a thank-you card could be done on the same run without extra expense.

Design Firm
Steve Trapero Design

Art Director/
Illustrator
Steve Trapero

Designers
Steve Trapero, Aikyoung Ahn

Client
Capitol Hill Seventh-Day
Adventist Church

Purpose or Occasion
Invitation to a series of
meetings

Paper/Printing
Navajo cover, ultra white

Number of Colors
Four

This youthful church congregation needed an invitation for a series of meetings on Bible prophecy that reflected the church's contemporary attitude. The client wanted something that did not look like it was from a church. The photomontages were custom-created for the subject matter using Adobe Photoshop filters, layers, and other techniques.

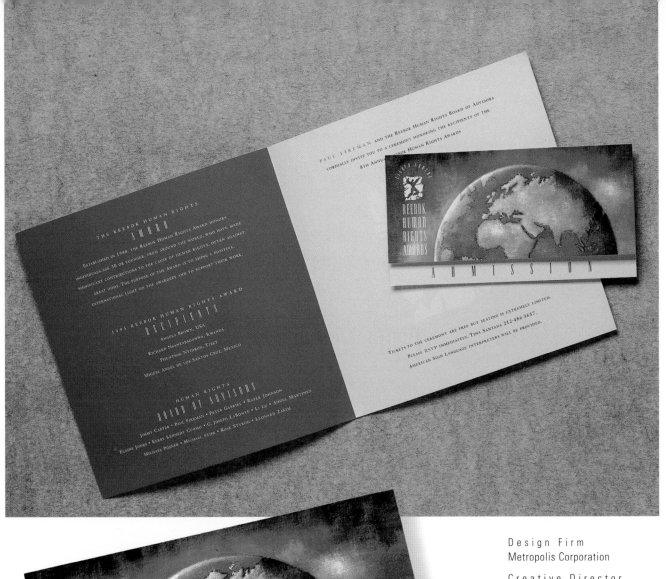

Design Firm
Metropolis Corporation

Creative Director
Denise Davis

Designer
Lisa DiMaio

Illustrator
Paul Z

Client
Reebok International, Ltd.

Purpose or Occasion
Human rights awards

Number of Colors
Five

The invitation and poster were designed to promote the Human Rights Awards, and show the spirit of a diverse group of people banding together to promote human rights awareness.

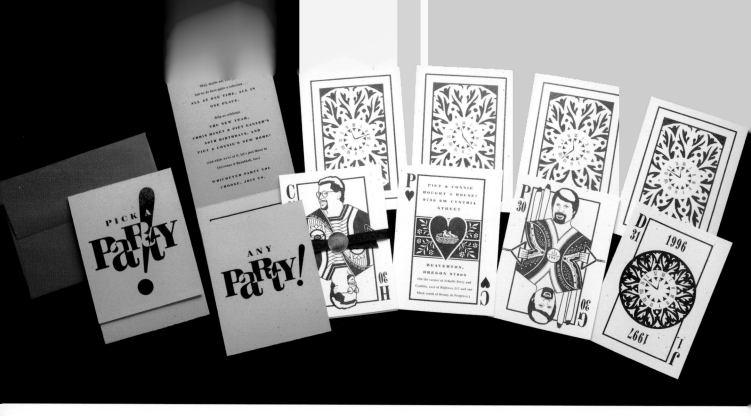

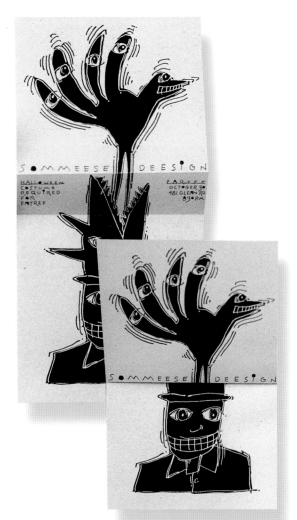

Design Firm
Sommese Design

All Design
Lanny Sommese

Client
Sommese Design

Purpose or Occasion
Halloween party

Paper/Printing
French Speckletone 80 lb.
cover/Offset

Number of Colors
One

...

The accordion fold allowed for surprise. The bird/hand image, which appears to sprout from the hat, is revealed to be trying to escape from the mouth of the Halloween goblin. The double "e" misspellings are there to pick up on "ee" in Halloween. Eye decoration in bird's feathers (or rings on hand) were a metaphor for the visual effects created at Sommese Design.

Design Firm
Lightner Design

All Design
Connie Lightner

Client
Connie Lightner

Purpose or Occasion
New Year's, house-warming, and thirtieth birthday party

Paper/Printing
Confetti/Thermography

Number of Colors
One

...

The invitation needed to emphasize all the events—the house warming, two thirtieth birthdays, and New Year's Eve. A separate card was created for each event, and then presented as a miniature deck of cards with the message "Pick a Party! Any Party!" Faces and other items in the cards were hand drawn. The printing is one-color thermography to create a raised, shiny look.

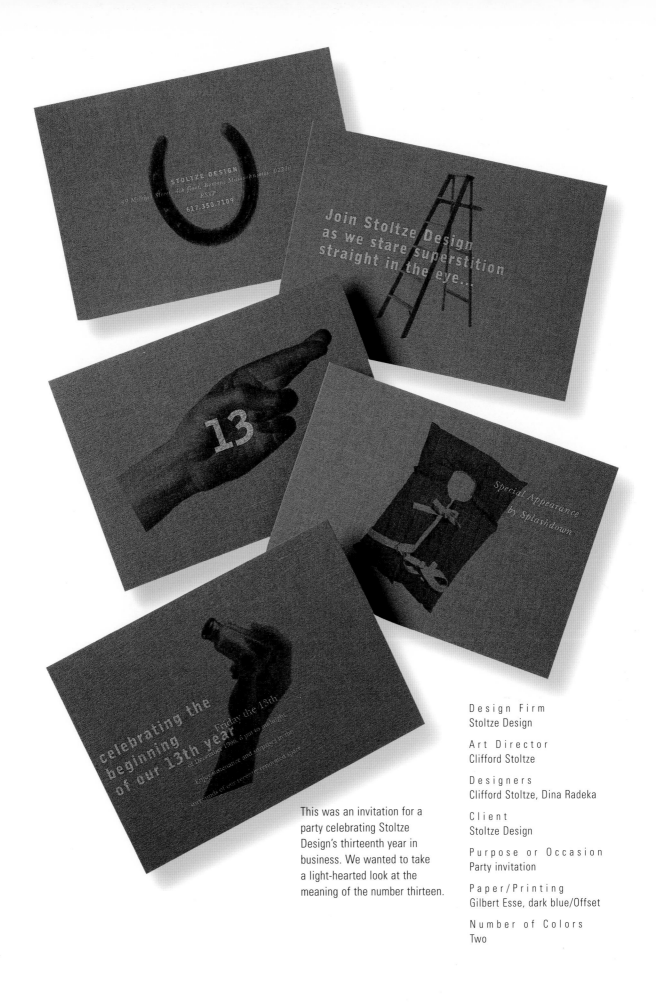

STOLTZE DESIGN
49 Melcher Street 4th floor, Boston, Massachusetts 02210
RSVP
617.350.7109

Join Stoltze Design
as we stare superstition
straight in the eye...

13

Special Appearance
by Splashdown

celebrating the
beginning
of our 13th year
Friday the 13th
of December 1996, 8 pm to midnight
RSVP (attendance and surprises) in the
surrounds of our recently renovated space

This was an invitation for a
party celebrating Stoltze
Design's thirteenth year in
business. We wanted to take
a light-hearted look at the
meaning of the number thirteen.

Design Firm
Stoltze Design

Art Director
Clifford Stoltze

Designers
Clifford Stoltze, Dina Radeka

Client
Stoltze Design

Purpose or Occasion
Party invitation

Paper/Printing
Gilbert Esse, dark blue/Offset

Number of Colors
Two

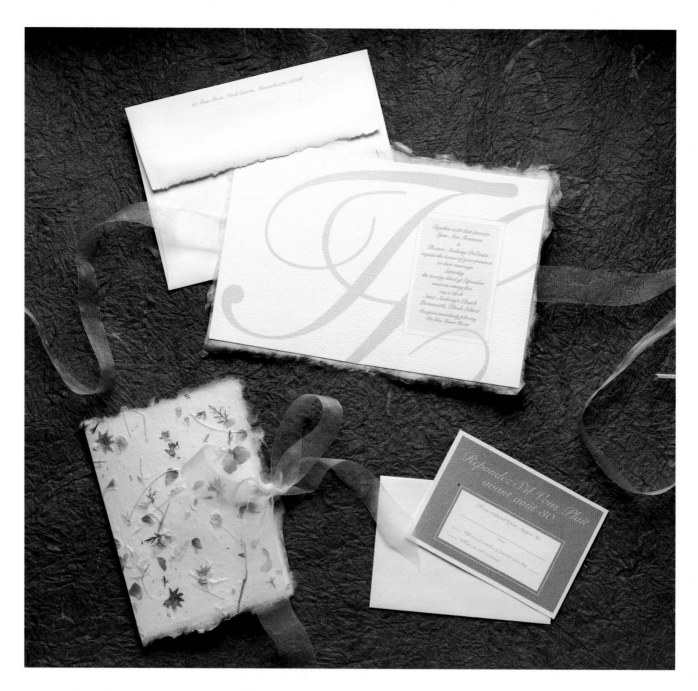

Design Firm
Clearpoint Communications

Art Director/Designer
Lynn Decouto

Client
Clearpoint Communications

Purpose or Occasion
Wedding invitation

Paper/Printing
Strathmore Pastelle/
Reacraft Press

Number of Colors
One

This invitation was created by gluing handmade paper from Rugg Road Paper and a ribbon to the invitation, which was printed on Strathmore Pastelle. The artwork was created in QuarkXPress and printed in one color.

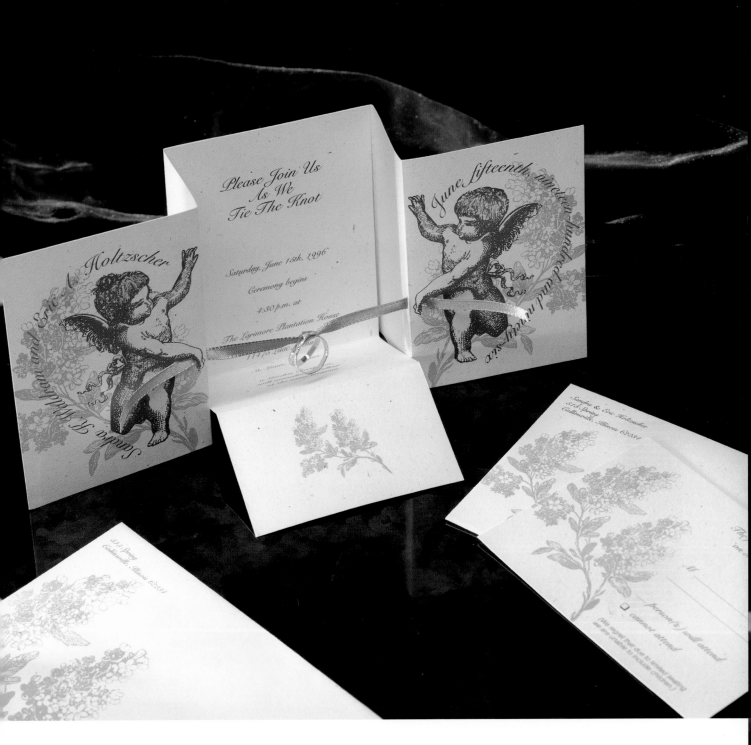

Please Join Us
As We
Tie The Knot

Saturday, June 15th, 1996

Ceremony begins

4:30 p.m. at

The Larimore Plantation House

Design Firm
Inland Group Inc.

All Design
Sandy Waldram-Holtzscher

Client
Sandy Waldram and Eric
Holtzscher

Purpose or Occasion
Wedding invitation

Paper/Printing
Speckletone/Wood River Printing

Number of Colors
Two

Using a tie-the-knot theme, the center fold-out is attached
to the card with double-sided tape. The aluminum wedding
bands were tied with satin ribbon, and slots were cut on
both sides of the card to slip the ribbon through and hold it
taut when unfolded. The bodies of the cherubs were lightly
tinted with colored pencil. The lilac art was found in a
copyright-free illustration book, scanned in, and manipulated
using Adobe Photoshop and Macromedia FreeHand. The invi-
tation reflects the intimate Victorian setting of Lilac Avenue
as well as being three-dimensional so it could stand on its
own as a table card to remind guests of the upcoming event.

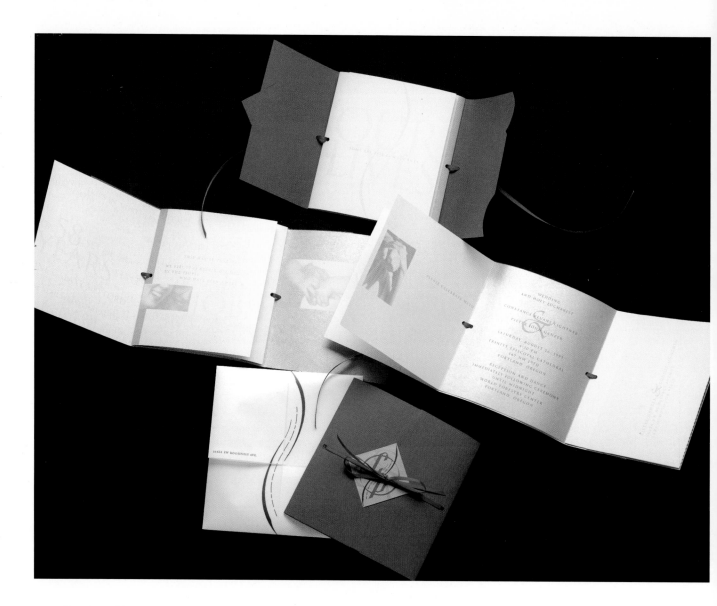

Design Firm
Lightner Design

Art Director/Designer
Connie Lightner

Client
Connie Lightner

Purpose or Occasion
Wedding invitation

Paper/Printing
Neenah Classic

Number of Colors
Two

This unique invitation was created from a list of events that happened in the couple's lives, which evolved into a tapestry behind the main message—life's a journey best defined by the people who have been a part of it. QuarkXPress, Adobe Illustrator, and Adobe Photoshop were used to design the piece. A metallic ink was used on an uncoated stock to create a subtle sheen. Label stock was coated with the metallic ink, and the emblems were printed with a Phaser laser printer. The vellum outer envelope wrap was also printed with a Phaser to help cut costs. The invitation cover was die-cut to accent the emblem.

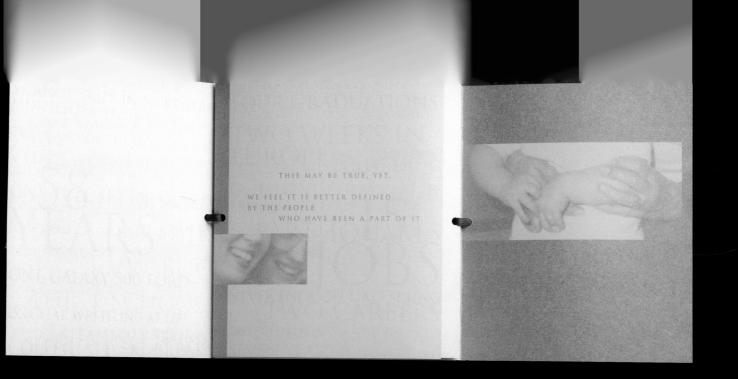

THIS MAY BE TRUE, YET.

WE FEEL IT IS BETTER DEFINED
BY THE PEOPLE
 WHO HAVE BEEN A PART OF IT.

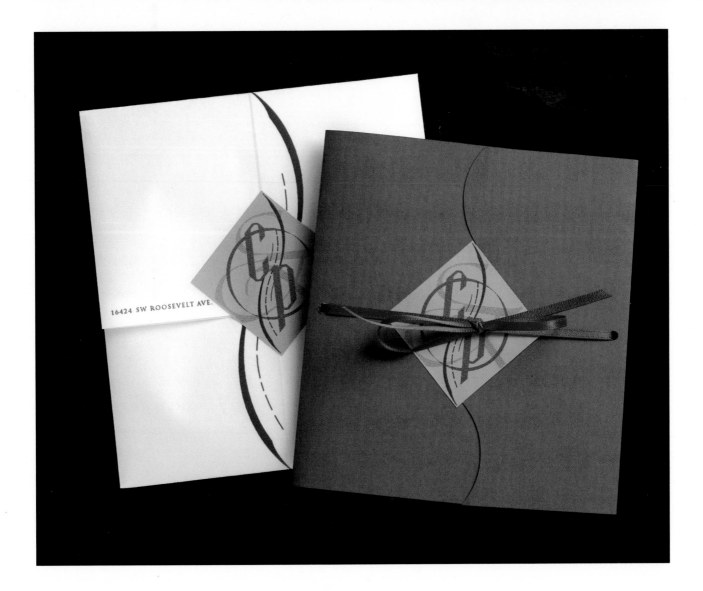

16424 SW ROOSEVELT AVE.

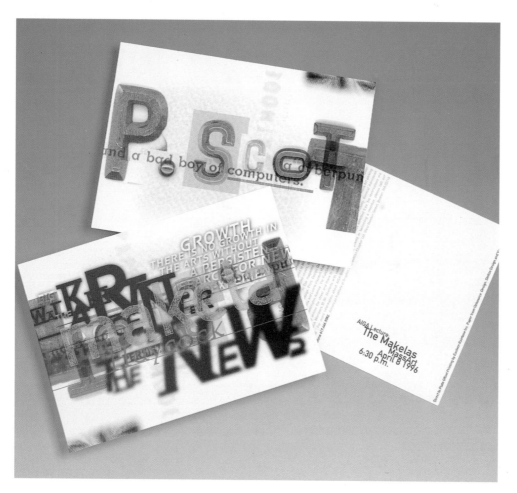

Design Firm
Stoltze Design

Art Director
Clifford Stoltze

Designers
Clifford Stoltze, Fritz Klaetke,
Eric Norman

Client
AIGA, Boston

Purpose or Occasion
Invitation to lecture series

Paper/Printing
Direct to plate offset/silk-
screened overlay

Number of Colors
Four

This was an invitation for a series of lectures sponsored by AIGA, Boston, featuring the extraordinary graphic designers Laurie and P. Scott Makela. The invitations were a series of post-cards sent together and printed digitally with the words "The Makelas" silk-screened in gold over the top.

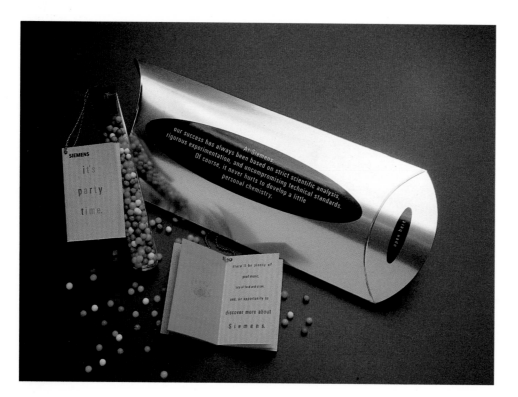

Design Firm
Sibley/Peteet Design

Art Director/
Designer
Art Garcia

Client
Siemens Wireless Terminals

Purpose or Occasion
Invitation for customer
banquet

Paper/Printing
Columns/Patterson and
Company

Number of Colors
Four

Design Firm
The Riordon Design Group, Inc.

Designer
Shirley Riordon

Client
Leanne James

Purpose or Occasion
Wedding invitation

Paper/Printing
Two Japanese Specialty papers and classic laid cover

Number of Colors
One

. .

Two beautiful Japanese papers were selected to do the work on this piece. Anstey Book Binding (Toronto) die cut the hearts, which were bound with a gold cord and riveted either side of the gate fold. The letterpress was done on a translucent flysheet revealing the black-and-white photo print beneath.

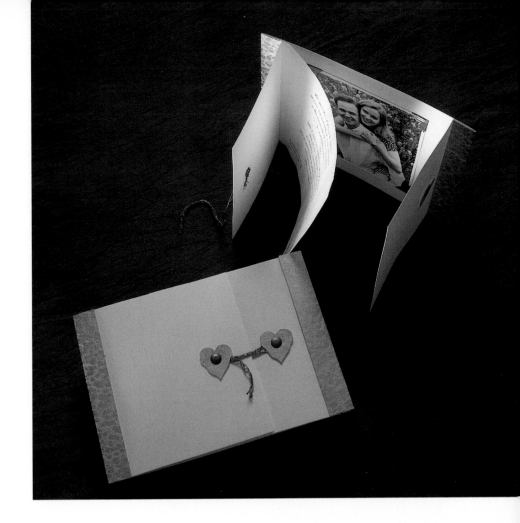

Design Firm
Muller and Company

Art Director
Jeff Muller

Illustrator
Jeff Muller

Client
Missouri Legislative Black Caucus

Purpose or Occasion
Golf outing

Number of Colors
Three

. .

The nostalgic art deco illustration supports the strength and traditions of the black caucus. The graphite drawing was scanned in and turned into a duotone using Adobe Photoshop. The font Bodega was chosen to reflect the period feel of the illustration.

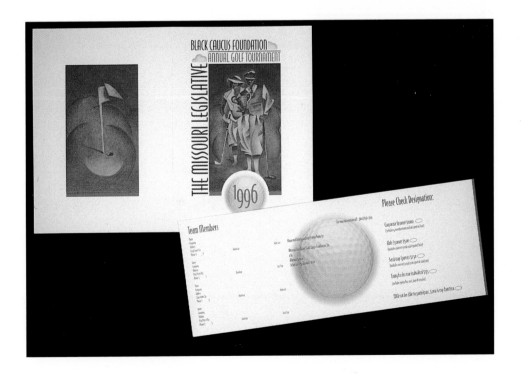

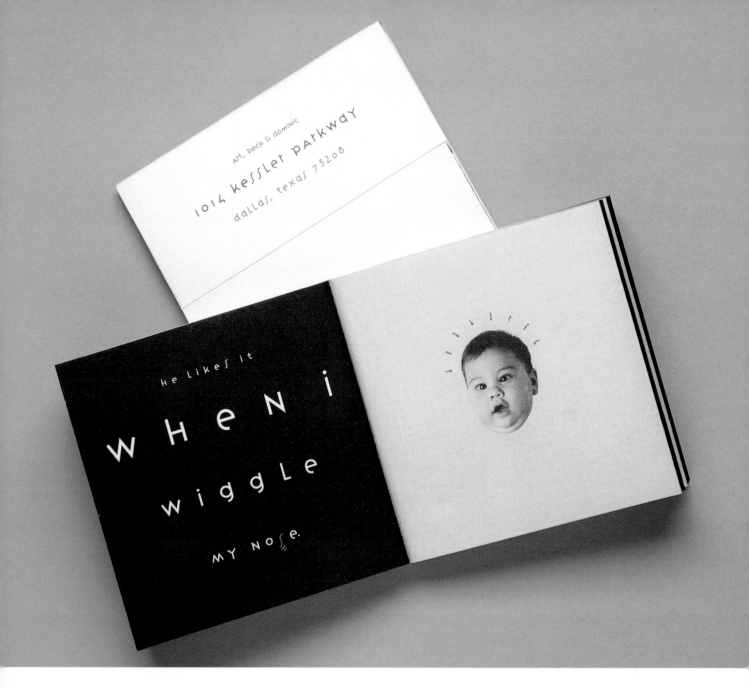

Design Firm
Melissa Passehl Design

Art Director
Melissa Passehl

Designer
Melissa Passehl, Charlotte
Lambrects, Jill Steinfeld

Client
San Jose Institute of
Contemporary Art

Purpose or Occasion
Invitation to the Monotype
Marathon

Paper/Printing
Evergreen

Number of Colors
Two

This invitation is designed to
introduce the viewer to the art
of monotype printing and to
invite artists and sponsors to
participate.

Design Firm
Melissa Passehl Design

Art Director/Designer
Melissa Passehl

Illustrator
Jill Steinfeld

Writer
Susan

Client
GTE Mobilnet

Purpose or Occasion
Ten-year anniversary

Paper/Printing
Gilclear vellum, Quintessence, brushed aluminum

Number of Colors
One

..

This invitation was designed to invite the top VIP clients of GTE Mobilnet to their ten-year anniversary party to be held at the San Francisco Museum of Modern Art. To capture the recipient's attention, the invitation was designed using thin, brushed aluminum with an accompanying mesh envelope.

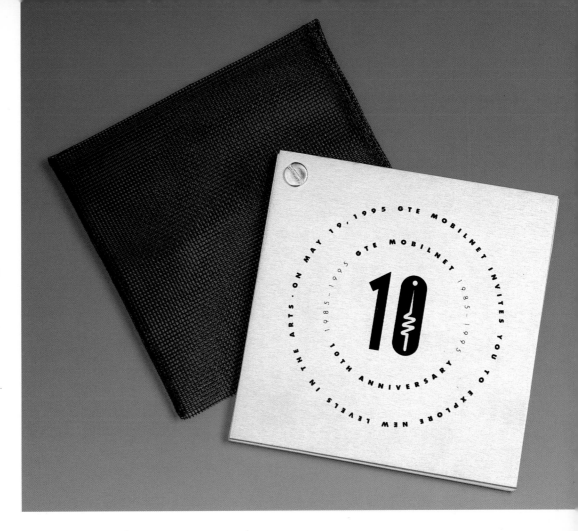

This fun, offbeat wedding invitation plays on the couple's lengthy long-distance relationship. The airline tickets were retouched in Adobe Photoshop, the champagne bottle was put into motion using Photoshop, and the piece was assembled in QuarkXPress.

Design Firm
Ellen Kendrick Creative, Inc.

Copywriters
John D. Spalding,
Ellen K. Spalding

Designer
Ellen K. Spalding

Photographer
Lee P. Thomas

Retouching
Jerri Self

Client
Ellen K. Spalding,
Michael R. Storeim

Purpose or Occasion
Wedding invitation

Paper/Printing
Potlatch 65 lb.
Quintessence cover

Number of Colors
One and three PMS metallics

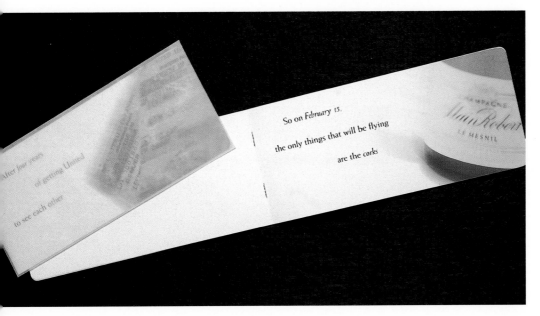

Design Firm
Sagmeister, Inc.

All Design
Stefan Sagmeister

Client
Tom and Tina Budewig/Schierlitz

Purpose or Occasion
Wedding invitation

Paper/Printing
100 lb. cover

Number of Colors
One

...

This wedding invitation contains
a sheet of vellum and a sheet of
white fabric. A round disc could
be detached and placed on the
fabric. The fabric was placed on
water to represent swimming,
which caused the disc to dance
and move on the fabric.

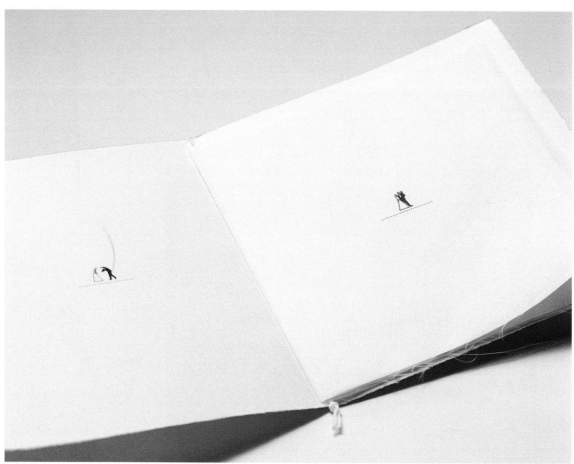

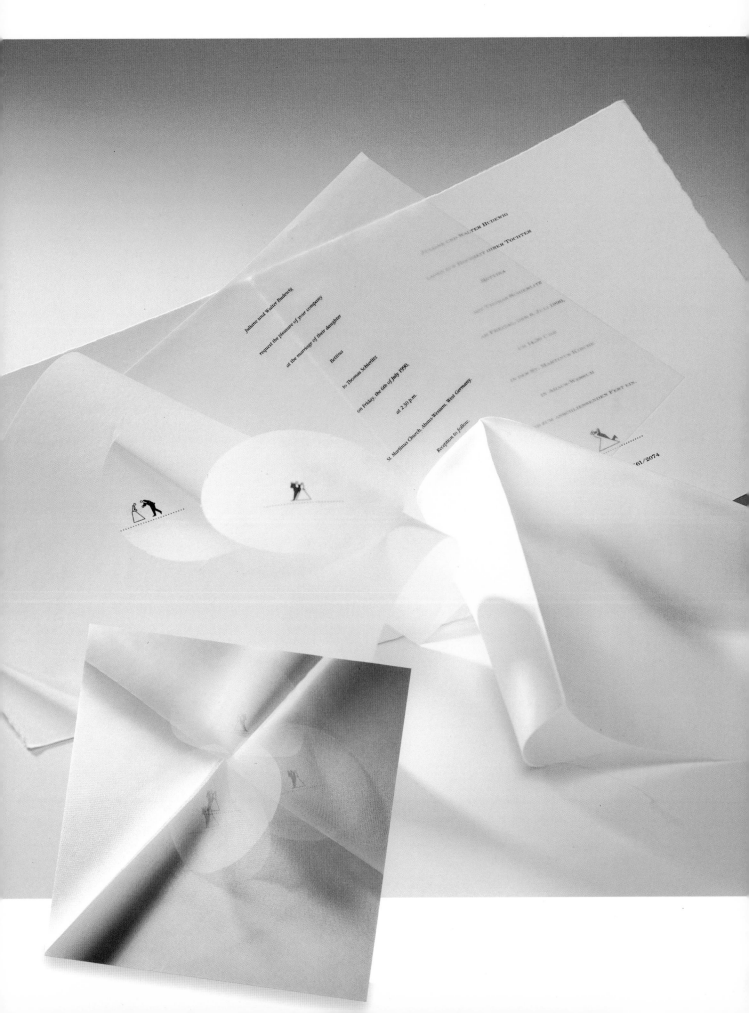

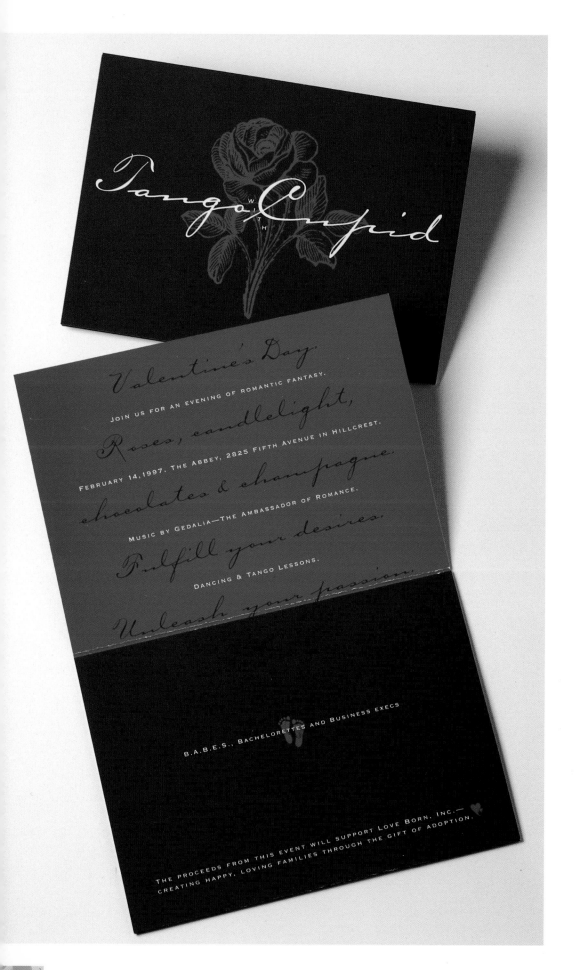

Design Firm
Mires Design

Art Director
John Ball

Designers
John Ball, Kathy
Carpentier-Moore

Client
B.A.B.E.S.

Purpose or Occasion
Valentine's Day party

Paper/Printing
Strathmore writing cover

Number of Colors
Two

The client requested script
and roses along with dramatic
black and red solids for a rich,
elegant look.

Design Firm
Shook Design Group, Inc.

Art Director
Ginger Riley

Designers
Ginger Riley, Graham Schulken

Illustrator
Graham Schulken

Purpose or Occasion
Invitation for Powerhouse
lecture series

Paper/Printing
Vintage

Number of Colors
Six

Shook Design Group, Inc.
invited members of the
Charlotte community to enjoy
a presentation by Mr. A.
Eugene Kohn of Kohn
Pederson Fox Associates,
highlighting many of the firm's
advances in "The Making of
World-Class Cities."

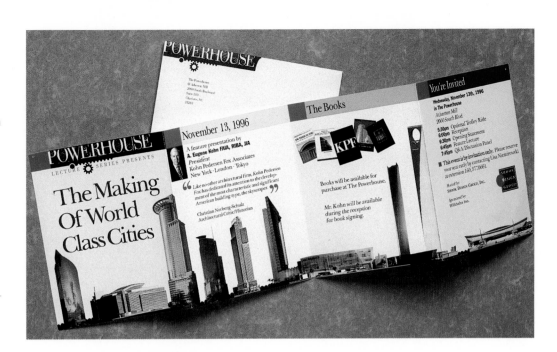

Design Firm
Sibley/Peteet Design

**Art Director/
Designer**
Don Sibley

Client
Judy Kaffenberger

Purpose or Occasion
Wedding announcement

Paper/Printing
Williamson Printing

Number of Colors
Four

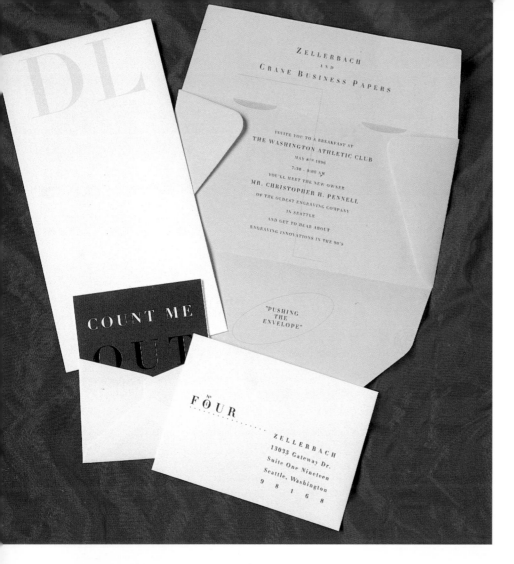

Design Firm
Rick Eiber Design (RED)

Art
Director/Designer
Rick Eiber

Calligrapher
Nancy Stentz

Client
Crane Business Papers;
Zellerbach Paper Company

Purpose or Occasion
Breakfast invitation

Paper/Printing
Offset litho, engraving,
and hot stamping

Number of Colors
Three

The client wished to show a range of paper stocks/colors. The designer developed the concept of an envelope within an envelope within an envelope. An ungummed/glued die-cut envelope was used as the invitation itself.

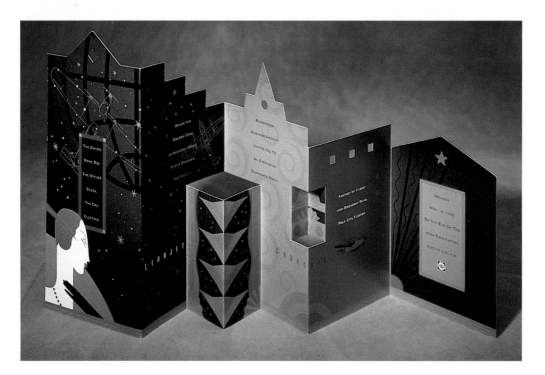

Design Firm
Greteman Group

All Design
Sonia Greteman, James Strange

Client
Learjet

Purpose or Occasion
96 NBAA invitation

Paper/Printing
Warren Lustro dull, die cut

Number of Colors
Five

The annual NBAA event was held in a World War II museum in Florida. The piece uses an art deco feel to emulate the period. Use of two black tones create a layered look that is highlighted with gold and silver metallics. A fun die-cut helps to complete the piece.

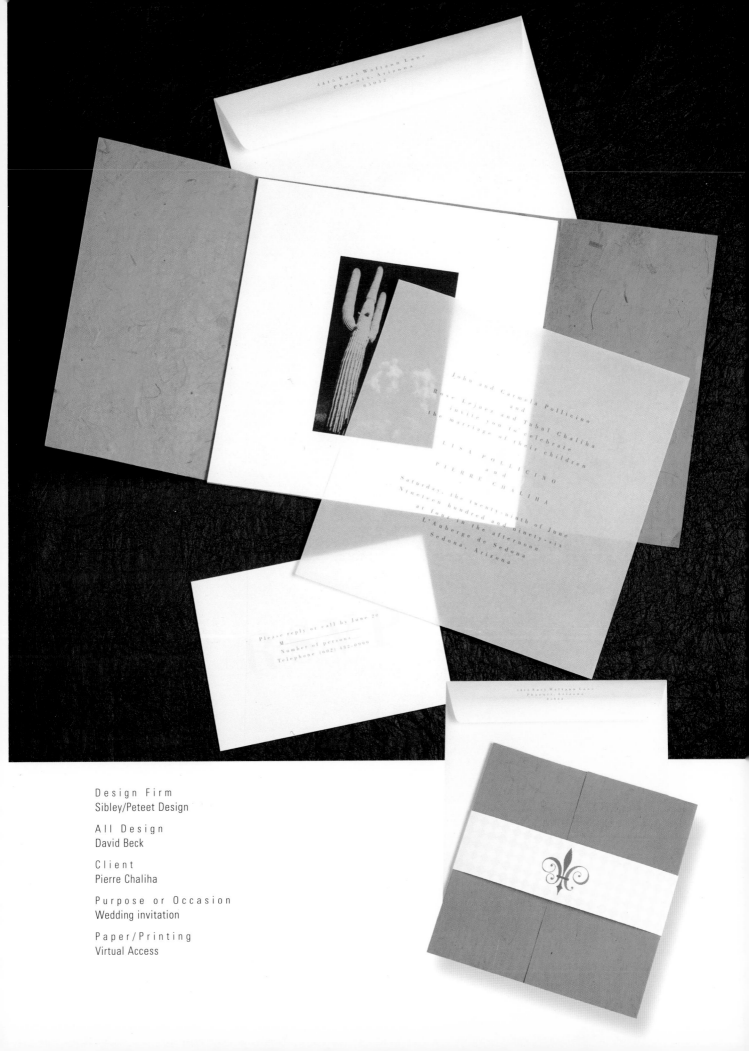

Design Firm
Sibley/Peteet Design

All Design
David Beck

Client
Pierre Chaliha

Purpose or Occasion
Wedding invitation

Paper/Printing
Virtual Access

Announc

amor • Tristeza, decepción,
...sica que tu contagia sentimien...
"El Tiempo es oro"
...La Reforma 483 • 9 de mayo • 20:0...

Announcements

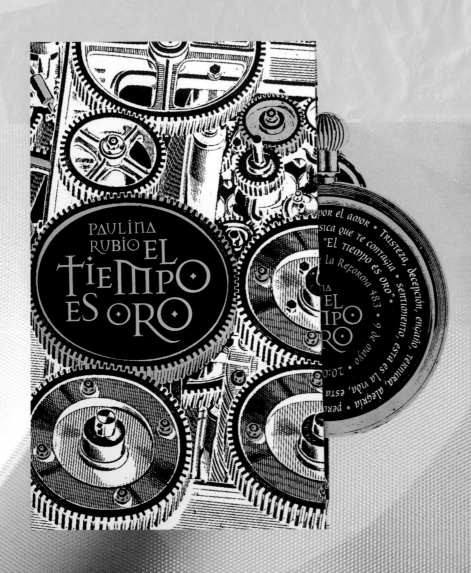

Design Firm
Teikna

Art Director/
Designer
Claudia Neri

Illustrator
Fabio Finocemioli

Client
Il Voltone

Purpose or Occasion
Opening announcement

Paper/Printing
Arjowiggins (recycled)
Vama Grafica

Number of Colors
Two

..

Il Voltone—a Renaissance villa
at the border of Tuscany—had
been converted into an exclu-
sive, all-organic spa and hotel.
The piece reflects the facility's
attention to quality, history, and
the environment.

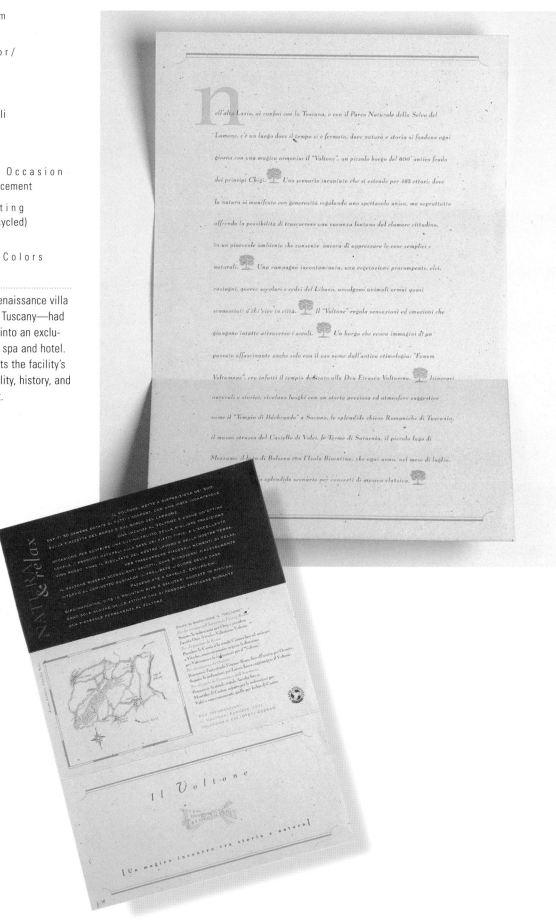

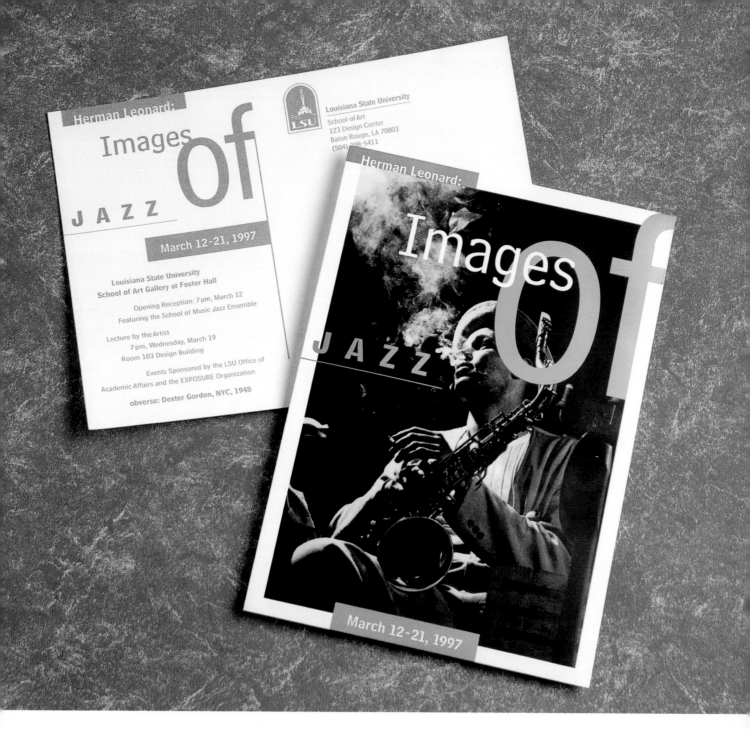

Design Firm
Paper Shrine

Art Director/
Designer
Paul Dean

Photographer
Herman Leonard

Client
LSU School of Art

Purpose or Occasion
Art Exhibition

Paper/Printing
LSU Graphic Services

Number of Colors
Two

This card, for an exhibition of photographs, was designed with the standard white border of photographic prints and postcards in mind. The border is broken only by the metallic copper typographic elements, thus establishing a respectful distance for the type from the fine-art photograph within the piece.

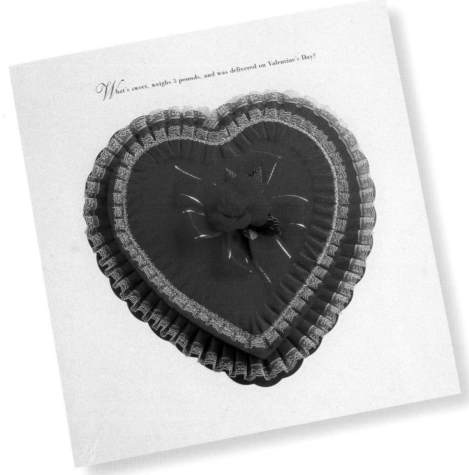

Design Firm
Nesnadny and Schwartz

Art Directors/
Designers
Mark Schwartz, Tina Katz

Photographer
Tony Festa

Client
Mark Schwartz, Tina Katz

Purpose or Occasion
Birth announcement

Paper/Printing
SD Warren Loe Dull/Fortran
printing

Number of Colors
Five

The birth announcement was created to communicate the fact that Mark Schwartz and Tina Katz had a baby. The combination of the design and photography made this an extremely well-accepted announcement.

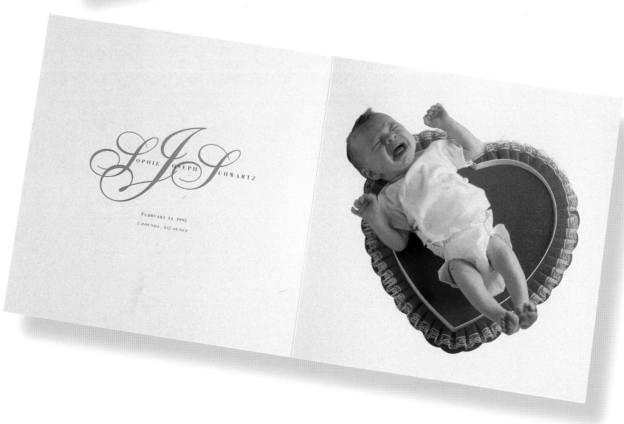

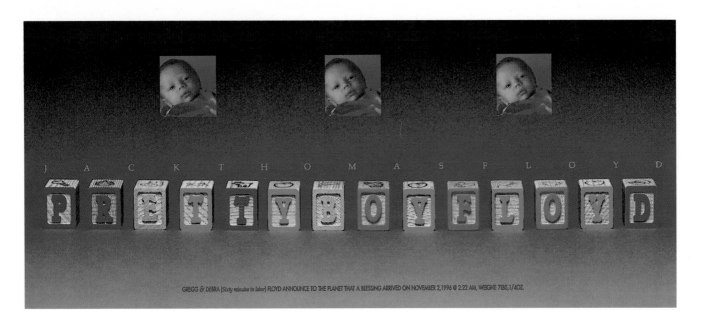

GREGG & DEBRA [Sixty minutes in labor] FLOYD ANNOUNCE TO THE PLANET THAT A BLESSING ARRIVED ON NOVEMBER 2, 1996 @ 2:22 AM, WEIGHT 7LBS, 1/4OZ.

Design Firm
GAF Advertising/Design

All Design
Gregg A. Floyd

Client
Gregg and Debra Floyd

Purpose or Occasion
Birth announcement

Paper/Printing
Mohawk /Offset

Number of Colors
Four

...

Having a baby boy born in Dallas, Texas with the last name of Floyd seems to naturally lead into an announcement with a gangster feel because of the association with the bank robber, Pretty Boy Floyd. Although the designer did not want the announcement to be associated with crime, the first impression upon seeing his son was how pretty he was. The solution was to spell out "pretty boy Floyd" in alphabet blocks and show his photo above each word to reinforce the positive experience of his birth.

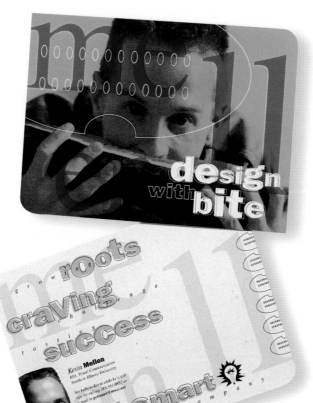

Design Firm
Get Smart Design Company

Art Director
Jeff Macfarlane

Designers
Tom Culbertson, Kevin Mellen

Illustrator
Tom Culbertson

Client
Get Smart Design Company

Purpose or Occasion
Announcement of new staff member

Paper/Printing
Union-Hoermann Press

Number of Colors
Three

...

The watermelon theme of this announcement of the hiring of a new staff member was used to keep people from incorrectly pronouncing the individual's name. Neon inks were used to help the announcement stand out in the mail.

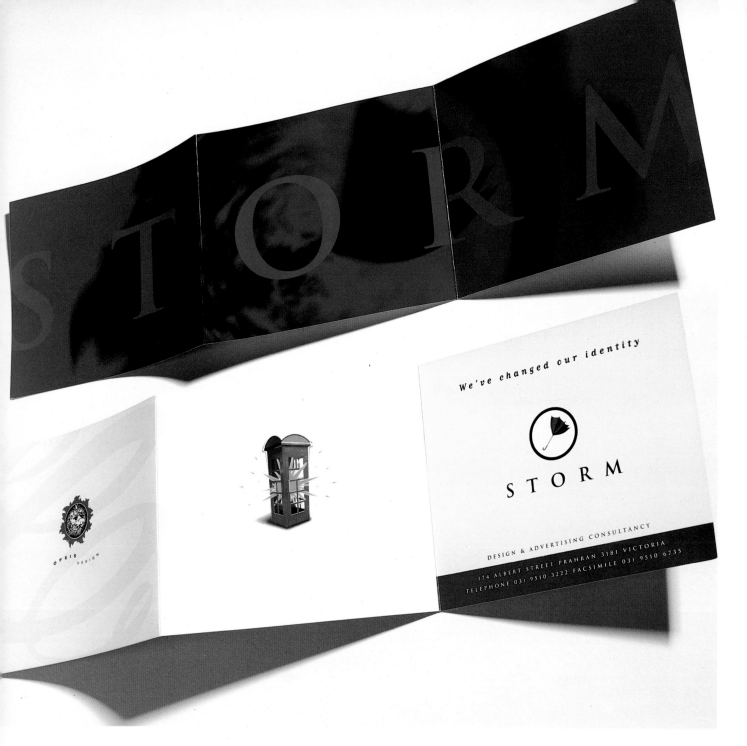

Design Firm
Storm Design and Advertising

All Design
David Ansett, Dean Butler, Julia Jarvis

Client
Storm Design and Advertising

Purpose or Occasion
Change of business name

Paper/Printing
Saxton smooth/Printelligent People

Number of Colors
Four plus one PMS

The change of the company identity required an announcement for clients and suppliers. This piece got the message across faster than a speeding bullet.

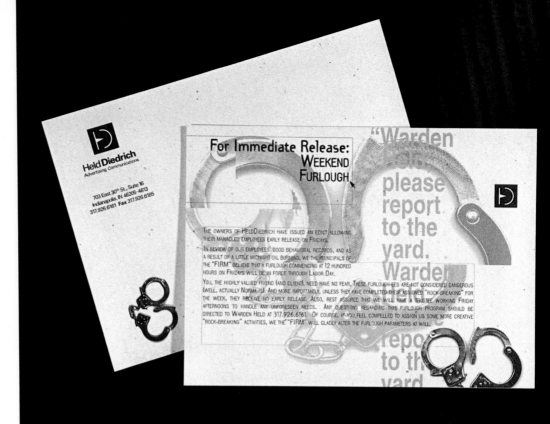

Design Firm
Held Diedrich

Art Director
Doug Diedrich

Designer
Megan Snow

Copywriter
Doug Diedrich

Client
Held Diedrich

Purpose or Occasion
Summer-hours announcement

Paper/Printing
Neenah Classic

Number of Colors
One

Using the inherent freedom a
self-promotion piece provides,
this summer-hours announcement
gave us the opportunity to utilize
a little more creative latitude.
The image of the handcuffs was
manipulated in Adobe Photoshop
and brought the piece together in
QuarkXPress.

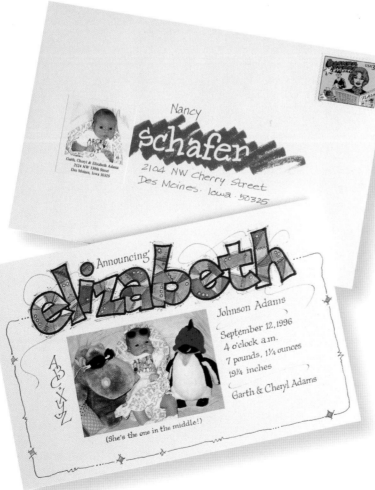

Design Firm
Adams Art Lettering and
Design

All Design
Cheryl O. Adams

Photographer
Cheryl O. Adams

Client
Elizabeth Adams

Purpose or Occasion
Birth announcement

Paper/Printing
Color Xerox

Number of Colors
Four

The original intention was to
design a gorgeous and serious
birth announcement until the
photo was an inspiration.
The fun photo inspired me to
play with the design of the
announcement as well as the
envelope. A childlike style
seemed very appropriate, and
after using watercolor, ink,
and the photo, it was color-
copied two up.

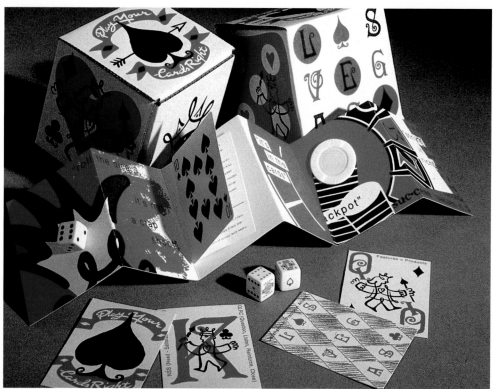

Design Firm
Sayles Graphic Design

All Design
John Sayles

Client
Principal Residential
Mortgage

Purpose or Occasion
Contest announcement

Paper/Printing
Corrugated/Screenprinting

Number of Colors
Two

Developed for Principal
Residential Mortgage, the
project is titled "Play Your
Cards Right" and features a
trip to Las Vegas as the grand
prize. To announce the pro-
gram to Principal's employees,
designer John Sayles devel-
oped a four-inch square box
screenprinted with graphics
inspired by playing cards—
spades, diamonds, and hearts.
Other original graphics on the
box are suggestive of dice.

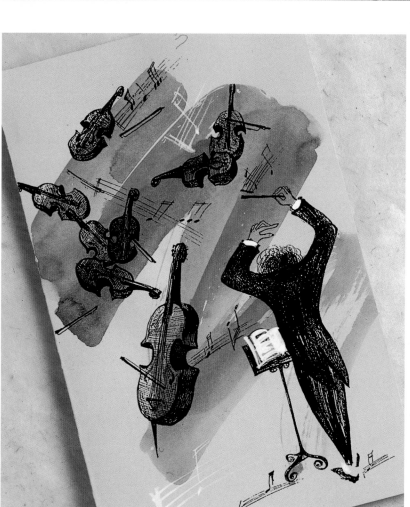

Design Firm
Misha Design Studio

Art Director
Michael Lenn

Illustrator
Michael Lenn

Client
Info Travel/Boston

Purpose or Occasion
Fund-raising event

Number of Colors
One

This announcement of a fund-
raising concert by a Russian
string quintet was done in one
color to minimize cost. Cards
were printed in black on gray
paper with additional strokes
of watercolor giving each card
a definitive uniqueness.

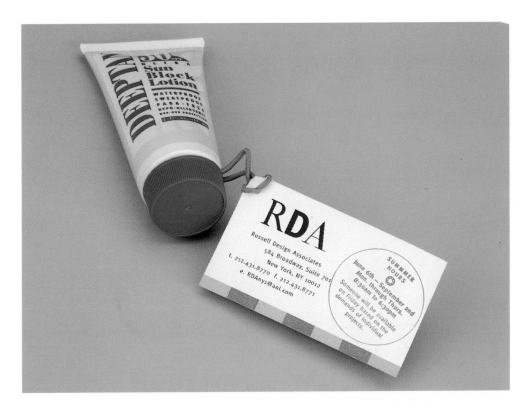

Design Firm
Russell Design Associates

Art Director
Anthony Russell

Designer
Mara Strasberg

Client
Russell Design Associates

Purpose or Occasion
Summer-hours announcement

Paper/Printing
Strathmore Writing/Offset

Number of Colors
Four

Using just a blank business card, rubber stamp, bottle of suntan lotion, and a hairband, Russell Design Associates was able to create a memorable direct-mail piece to announce the summer-hours schedule.

Design Firm
Val Gene Associates—
Restaurant Group

Art Director/
Designer
Lacy Leverett

Photographer
Mark Hancock

Client
Texanna Red's Restaurant
and Cantina

Purpose or Occasion
Grand reopening
announcement

Paper/Printing
Baker's Printing

Number of Colors
One

This announcement featured a photo of a 1949 bus, which was crashed into the side of the building during a recent remodeling. Tabasco, antacid, and a beer-bottle cap were a fun, whimsical way to give an idea about the restaurant's atmosphere. Date, time, and location were left blank until details became available.

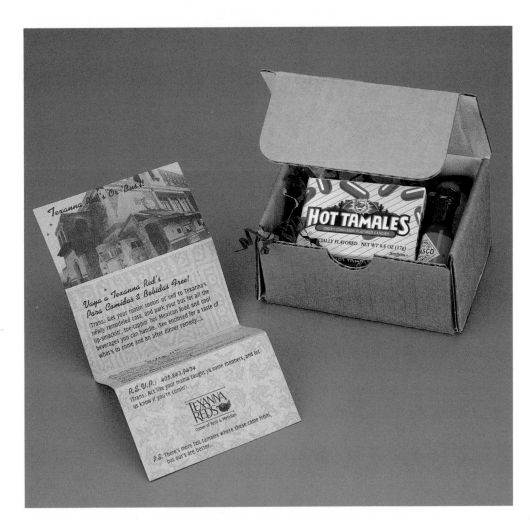

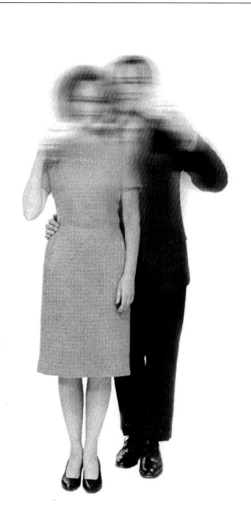

We Moved.

Delaney Matrix has a new address.
We're now located in the Opus One Center, Palm at Bullard.

DELANEY MATRIX

6033-B N. Palm Ave. • Fresno, CA 93704 • 439-5158 • Fax 439-9203

Design Firm
Shields Design

Art Director/
Designer
Charles Shields

Client
Delaney Matrix

Purpose or Occasion
Moving announcement

Paper/Printing
24 lb. text/Laser printer

Number of Colors
One

This simple moving announcement for a husband-and-wife partnership used a stock photo of the couple that was scanned and then blurred using Adobe Photoshop.

Design Firm
Rick Eiber Design (RED)

Art Director/
Designer
Rick Eiber

Photographer
Ron Rabin

Client
Ron Rabin

Purpose or Occasion
Establishment of business

Paper/Printing
Glasine/teton cover,
debossing and engraving
and photo prints

Number of Colors
One

. .

This card was created to
announce and promote the
work of a psychotherapist
who was initiating his
branching out as a portrait
artist. The piece also shows
his work and his sensitivity
to materials and processes
as well.

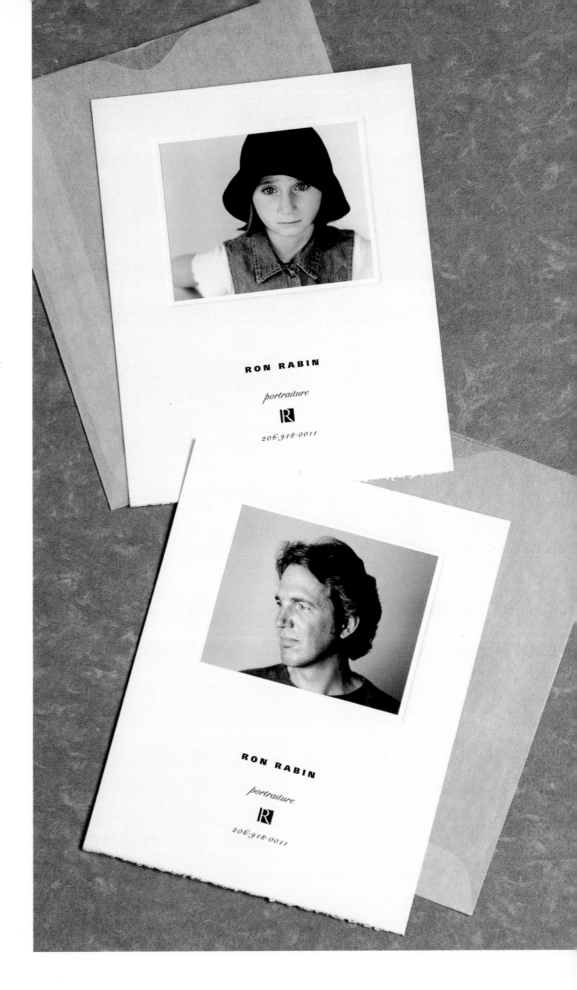

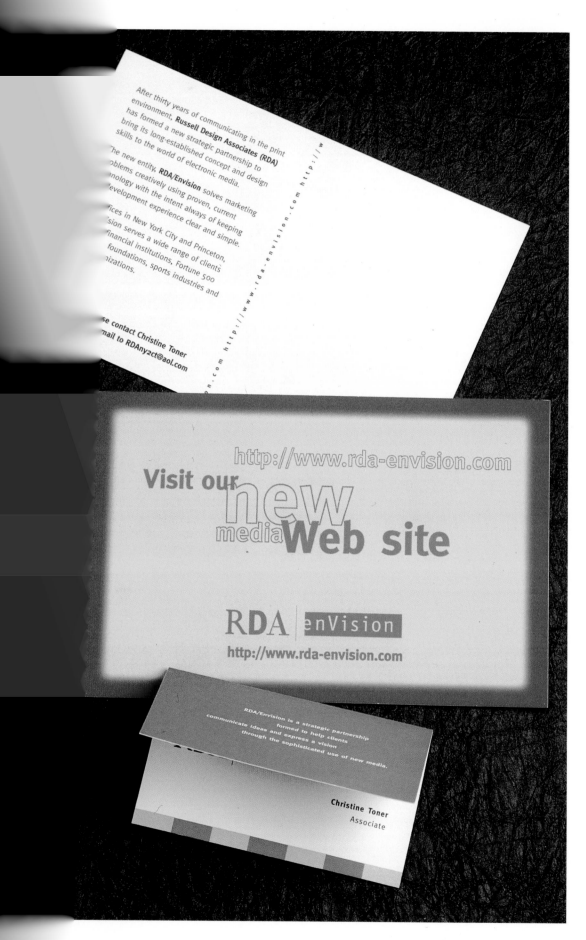

After thirty years of communicating in the print
environment, **Russell Design Associates (RDA)**
has formed a new strategic partnership to
bring its long-established concept and design
skills to the world of electronic media.

The new entity, **RDA/Envision** solves marketing
problems creatively using proven, current
technology with the intent always of keeping
development experience clear and simple.

...ices in New York City and Princeton,
...sion serves a wide range of clients
...financial institutions, Fortune 500
...foundations, sports industries and
...nizations.

...se contact Christine Toner
...mail to RDAny2ct@aol.com

Visit our **new**
media **Web site**
http://www.rda-envision.com

RDA | enVision
http://www.rda-envision.com

RDA/Envision is a strategic partnership
formed to help clients
communicate ideas and express a vision
through the sophisticated use of new media.

Christine Toner
Associate

Design Firm
Russell Design Associates

Art Director
Anthony Russell

Designer
Sofia F. de Ana Portela

Client
Russell Design Associates

Purpose or Occasion
Website announcement

Paper/Printing
Offset

Number of Colors
Two

The postcard was used to
announce the company's new
Website. It was developed to
coordinate with Russell
Design Associates' identity
program.

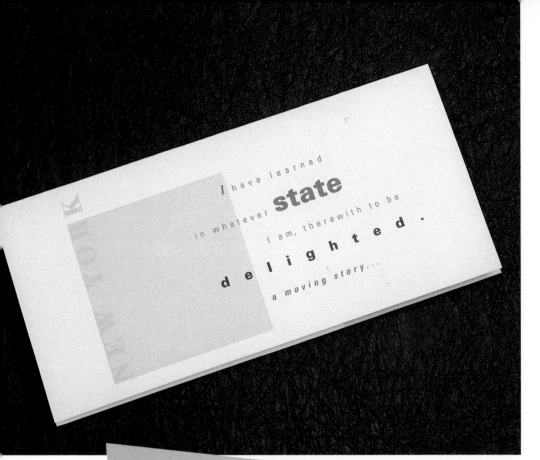

Design Firm
Toni Schowalter Design

Art Director/
Designer
Toni Schowalter

Client
Toni Schowalter Design

Purpose or Occasion
Moving announcement

Paper/Printing
Strathmore 28 lb. Writing card

Number of Colors
Three

Printed along with the other stationery materials to keep costs down, this die-cut card holds the new business card and announces the firm's new location.

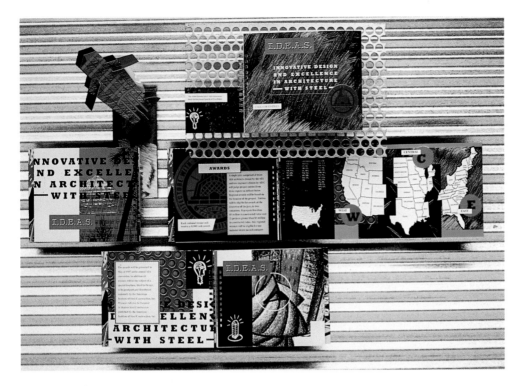

Design Firm
Sayles Graphic Design

Art Director/
Illustrator
John Sayles

Designers
John Sayles, Jennifer Elliott

Client
American Institute of Steel
Construction

Purpose or Occasion
Call for entries

Paper/Printing
Springhill 10 pt. coated/Offset

Number of Colors
Four

The name I.D.E.A.S.—Innovative Design and Excellence in Architecture with Steel—was developed to clearly express the purpose of the event (the first of its kind event in the industry to showcase and promote the beauty of the metal.) The circular logo, designed with bold and geometric lines, doubles as a seal for the event. The brochure also needed to function as a call-for-entry. For a touch of whimsy, a glassine envelope with die-cut shapes was included that, when assembled, forms a three-dimensional, free-standing building.

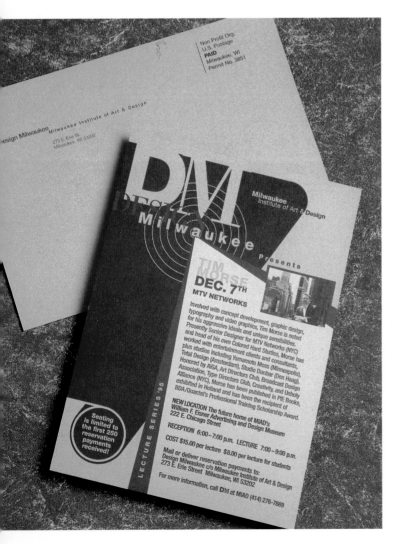

Design Firm
Becker Design

Art
Director/Designer
Neil Becker

Client
Milwaukee Institute of Art
and Design

Purpose or Occasion
Announcement of speaker

Paper/Printing
French Speckeltone/Burton
and Mayer, Inc.

Number of Colors
Three

Design Milwaukee, operating in conjunction with the Milwaukee Institute of Art and Design, is an organization that reaches the entire design community of Milwaukee. The challenge for this postcard was to design a look that would be appropriate for a wide range of disciplines yet still innovative.

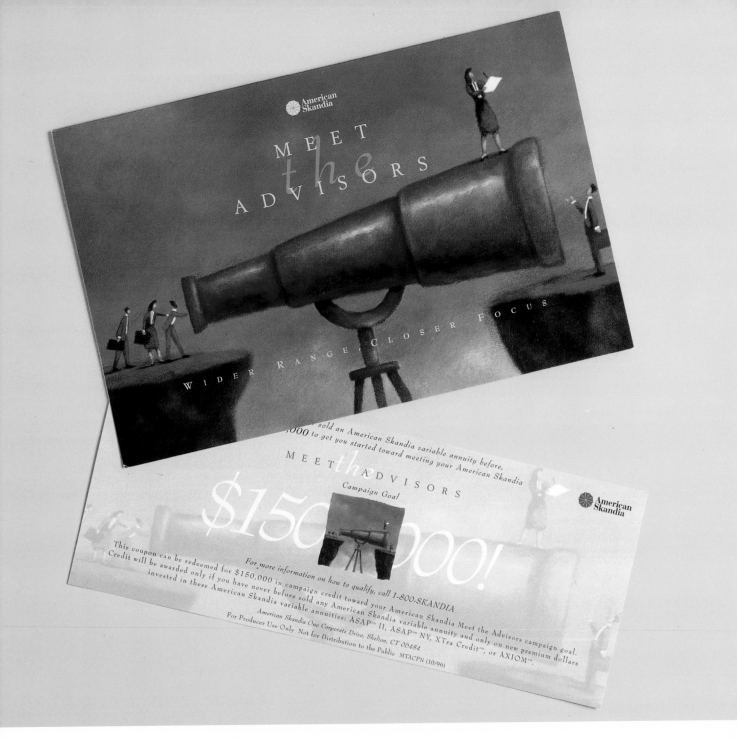

Design Firm
Metropolis Corporation

Creative Director
Denise Davis

Designer
Lisa DiMaio

Illustrator
Steve Dinnino

Client
American Skandia Marketing, Inc.

Purpose or Occasion
Announcement of program

Number of Colors
Five

This announcement of the "Meet the Advisors" program provided a way for American Skandia's brokers to meet their managers.

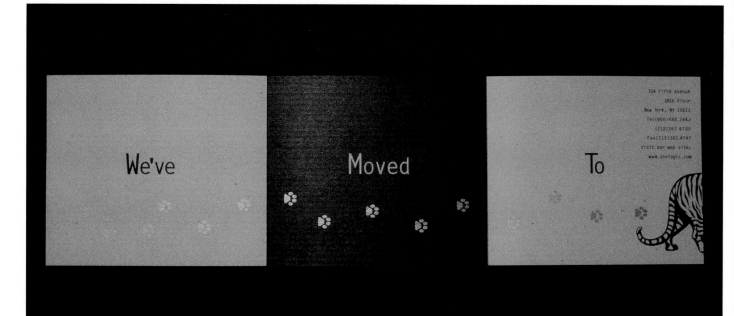

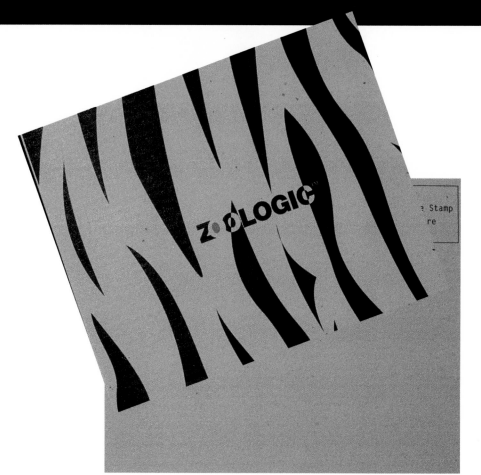

We've Moved To

104 Fifth Avenue
18th Floor
New York, NY 10011
Tel(800)482.2643
(212)367.4700
Fax(212)367.4747
Visit our web site:
www.zoologic.com

ZOOLOGIC

Design Firm
Graphic One, Inc.

Art Director/Designer
Michael T. Dizon

Client
Zoologic, Inc. (subsidiary of
Bankers Trust)

Purpose or Occasion
Moving announcement

Paper/Printing
80 lb. cover marigold/Offset

Number of Colors
Four

..

This unique moving notice pro-
motes the company's spirit of
strength and power in the soft-
ware arena. Using a tiger-stripe
pattern for the cover created a
strong graphic effect, and the
footprints served as a way of
directing the viewer's eye from
page to page. Total print run was
1,500 pieces.

Design Firm
Towers Perrin

Designer
Liz Alonzo

Illustrator
Carolyn Williams

Client
Towers Perrin

Purpose or Occasion
Private reception announcement

Paper/Printing
Mohawk Tomahawk/Offset

Number of Colors
Four

This postcard was mailed out as a teaser piece a month before the actual invitation was sent. The front displays a typographic treatment of the word "please." The word "It" was printed in four-color process with fluorescent inks. The back has an exclamation mark, the dot of which is a sticker to be placed on a calendar for marking the date of the event.

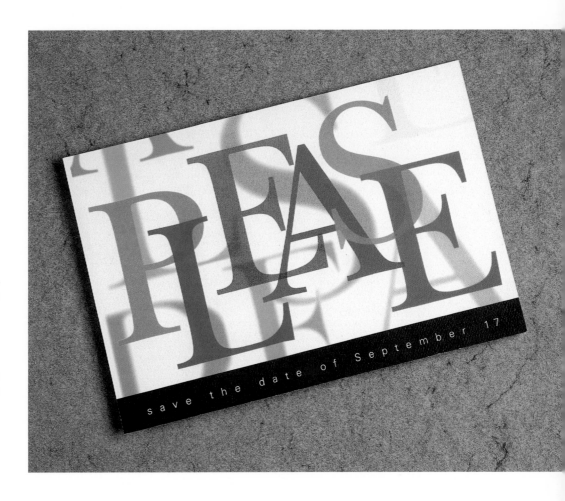

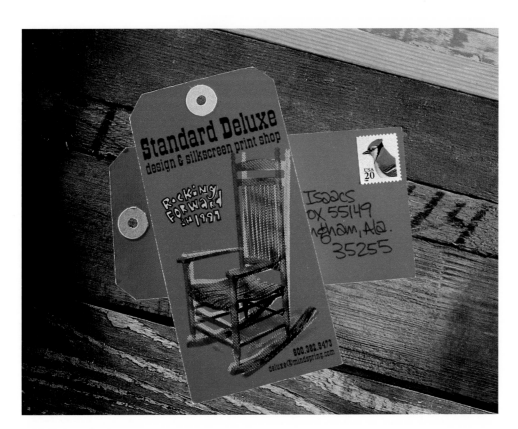

Design Firm
Standard Deluxe Design and
Silkscreen Print Shop

Art Director/Designer
Scott Peek

Photographers
Lee Isaacs, Dave Stueber

Client
Standard Deluxe Design and
Silkscreen Print Shop

Purpose or Occasion
New Year's greeting/reminder

Paper/Printing
Paper tag/Silkscreen

Number of Colors
Two

This New Year's announcement to clients and friends takes the form of a hand-addressed card stock tag. The card is two-color hand silkscreen and was mailed as a postcard.

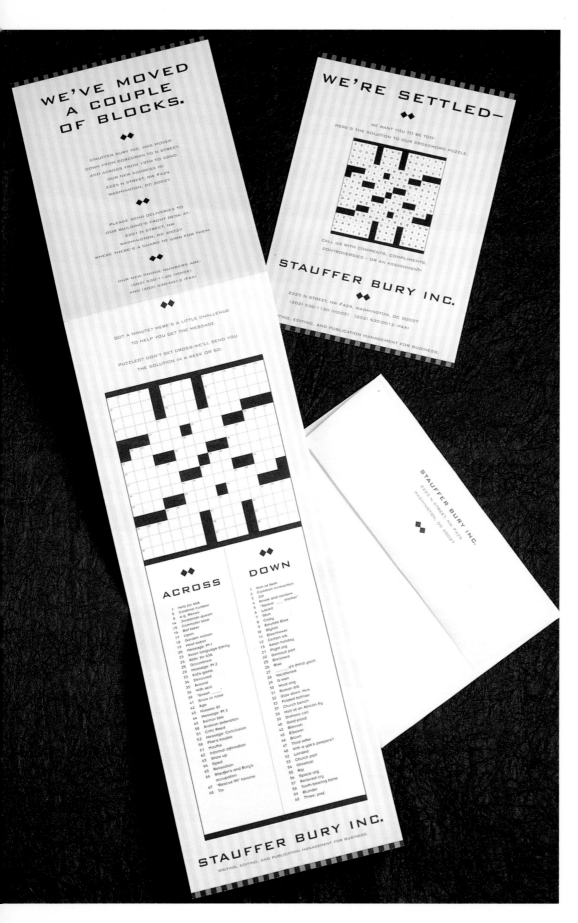

Design Firm
Franz and Company, Inc.

Art Directors
Jean Franz, Steve Trapero

Designer
Steve Trapero

Client
Stauffer Bury, Inc.

Purpose or Occasion
Moving announcement and promotion

Paper/Printing
Navajo cover, ultra white

Number of Colors
Two

A husband-and-wife writing team were moving down and across town, only a few blocks away, thus the idea for a crossword puzzle with an encrypted message hidden within the answers. The answer was sent about a week after the initial mailing.

All Design
R.E. Roehr

Client
Salem State College Art
Department

Purpose or Occasion
Faculty Show

Paper/Printing
LOE

Number of Colors
One

This show card announced
the annual art faculty exhibit
and was produced with a low
budget. Because the basic
concept was a group show
with many diverse works, an
illustration and play on the
word "feats" was chosen
rather than following the
standard practice of depicting
one work of art.

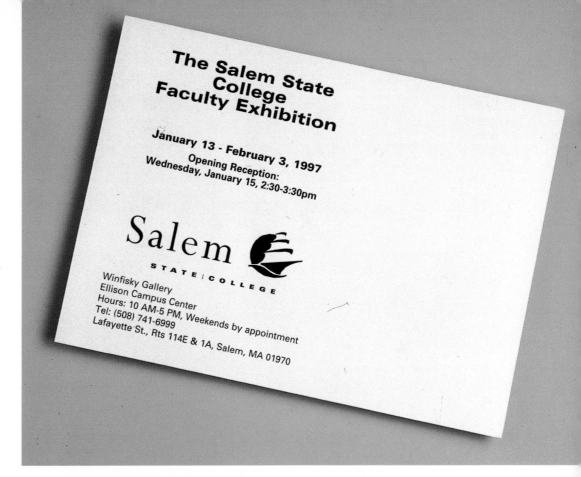

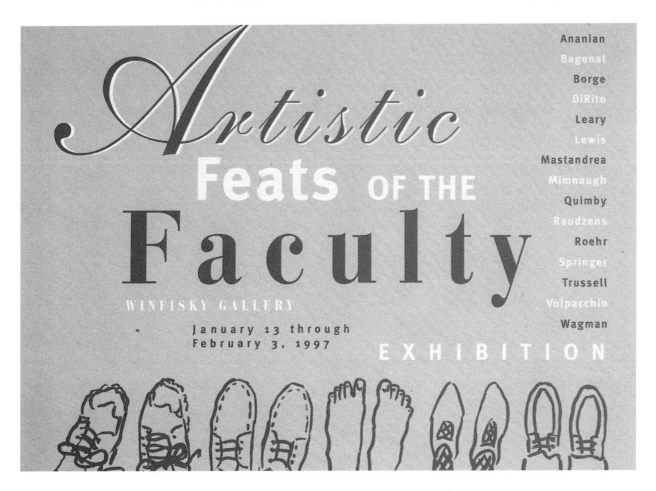

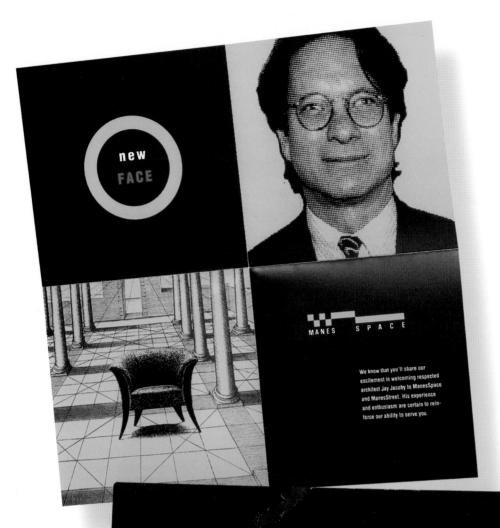

Design Firm
Toni Schowalter Design

Art Director/
Designer
Toni Schowalter

Client
Manes Space

Purpose or Occasion
Announcement of new partner

Paper/Printing
80 lb. coated text

Number of Colors
Three

A fold-out announcement to introduce a new partner in this furniture dealership. The archive illustration was scanned in and manipulated in Adobe Photoshop with the final piece coming together in QuarkXPress.

Design Firm
Toni Schowalter Design

Art Director/ Designer
Toni Schowalter

Client
Manes Space

Purpose or Occasion
Moving announcement

Paper/Printing
Die-cut duplex paper

Number of Colors
One PMS and one foil

This die-cut moving announcement was printed and foil stamped on a duplex stock that graphically plays with the similarity between Manes and Moves.

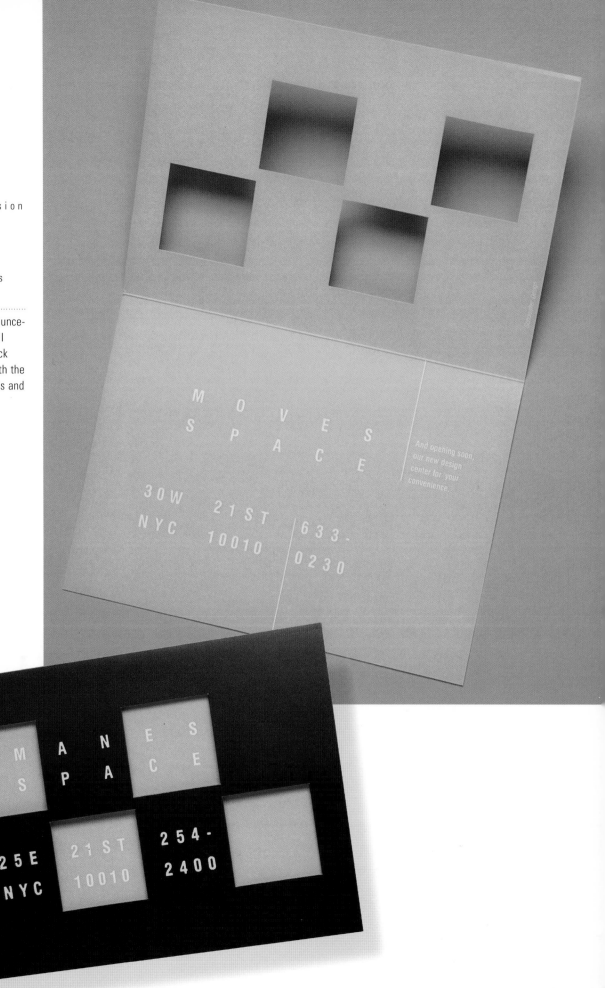

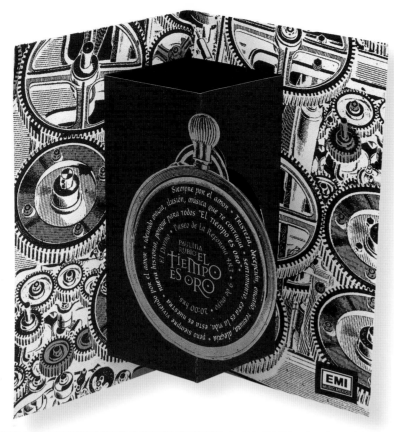

Design Firm
Zappata Diseñadores S.C.

Art Director
Ibo Angulo

Designers
Ibo Angulo, Ana Lavalle,
Silvia Hernandez

Illustrator
Silvia Hernandez

Client
Emi Music Mexico

Purpose or Occasion
New album presentation

Paper/Printing
Opaline

Number of Colors
Two

This piece was created to announce and present the new album of the recording artist El Tiempo es Oro (Time is Gold). The clock mechanism represents the process of elaboration and creativity that the album's music conveys.

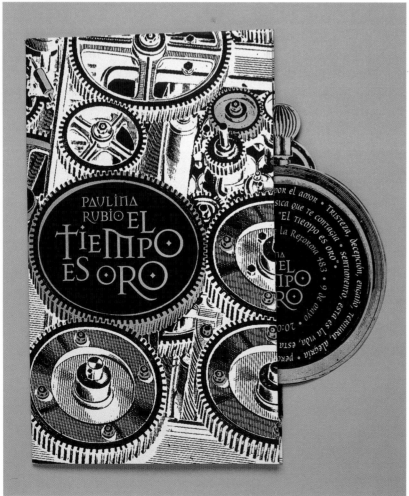

COMMERCIAL FURNITURE INTERIORS

We take pleasure in announcing

the opening of Commercial Furniture Interiors,

New York Metro Area's newest Haworth

dealership, committed to the highest standards

of service and performance.

R. Allen Blau

Stanley Persaud

Regina Daly

Jim Proia

Robin Thau

Lisa Jurick

Rose Moffa

1135 Spruce Drive Mountainside, NJ 07092

Phone 908 518 1670 Fax 908 654 8436

Design Firm
Toni Schowalter Design

Art Director/
Designer
Toni Schowalter

Client
Commercial Furniture Interiors

Purpose or Occasion
Announcement of new
business opening

Paper/Printing
Strathmore Writing

Number of Colors
Three

Printed along with the other
stationery materials to keep
costs down, this card announces
the opening of a new business,
combining the logo and other
typographical elements from
the program.

Design Firm
"That's Nice" L.L.C.

All Design
Nigel Walker

Client
Tracey Turner Design, Inc.

Purpose or Occasion
Moving announcement

Paper/Printing
Strathmore 60 lb. bright
white text

Number of Colors
Two

.......................................

This moving announcement
included a means for the
recipient to make their own
paper airplane.

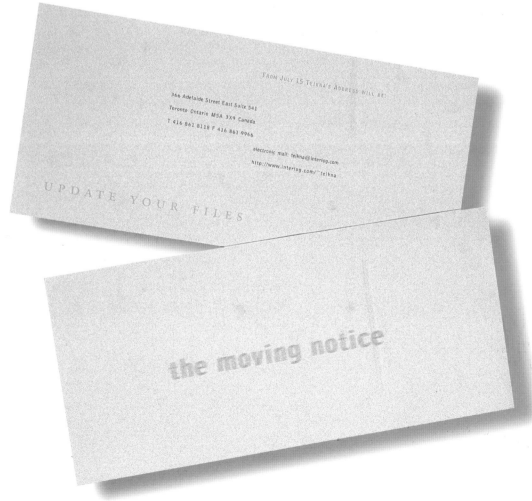

Design Firm
Teikna

**Art Director/
Designer**
Claudia Neri

Client
Teikna

Purpose or Occasion
Change of address

Paper/Printing
Strathmore Writing/
CJ Graphics

Number of Colors
Two

.......................................

This format seemed ideal
for a moving announcement.
The type treatment was done
in Adobe Photoshop, the rest
in QuarkXPress.

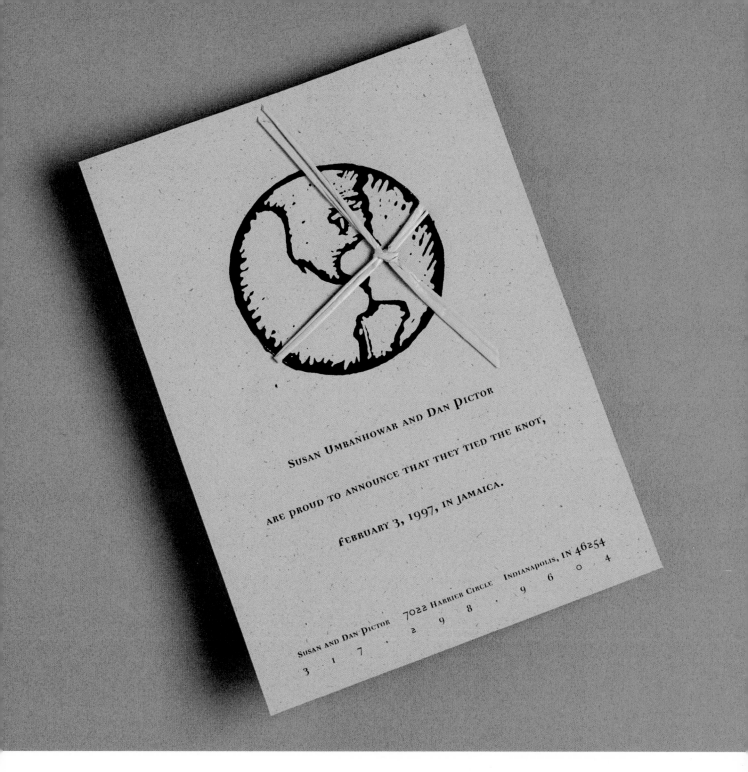

Susan Umbanhowar and Dan Pictor are proud to announce that they tied the knot, February 3, 1997, in Jamaica.

Susan and Dan Pictor 7022 Harrier Circle Indianapolis, IN 46254
3 1 7 2 9 8 9 6 0 4

Design Firm
Held Diedrich

Art Director/Designer
Megan Snow

Client
Susan and Dan Pictor

Purpose or Occasion
Wedding announcement

Number of Colors
One

A whirlwind romance resulted in a very non-traditional wedding ceremony on the sands of Jamaica. The client wanted an announcement representative of the ceremony's uniqueness. Voilá—raffia and laser output— a union of love and technology!

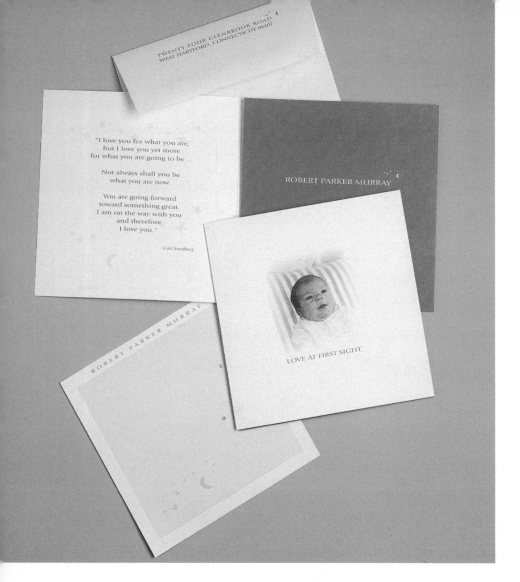

Design Firm
Atlantic Design Works

Art Director/Designer
Stacy Wright Murray

Client
Stacy Wright Murray

Purpose or Occasion
Birth announcement

Paper/Printing
65 lb. linen cover

Number of Colors
Two

Since so many people request photos of a baby when it's first born, the designer thought it appropriate to combine a birth announcement, thank-you note, photo, and a heartfelt quote into one card. The announcement was designed to fit into an envelope so that it could include other photos, or later use with the leftover note paper.

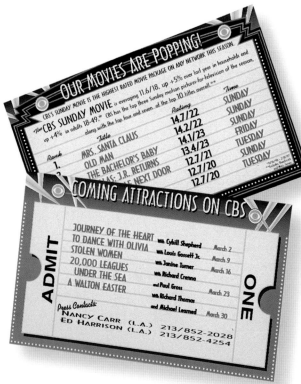

Design Firm
CBS Television City Graphics

Art Director
Vince Ellescas

Designer
Vince Ellescas, Charles Carpenter

Client
Advertising Club of Los Angeles

Purpose or Occasion
Announcement of ratings

Paper/Printing
White stock/Cyclone and Canon color copier

Number of Colors
Four

Taking what would normally be a routine movie-and-television card that would wind up in a trash can, the designers turned it into an eventful piece. Each card was attached to a bag of microwave popcorn that was popped before being delivered. Each announcement that was sent out was made on a computer and printed on a cyclone and Canon color copier, then spray mounted to thin bristol board and hand cut.

Design Firm
Copeland Hirthler design and communications

Creative Directors
Brad Copeland, George Hirthler

Designer
Mike Weikert

Client
Cooper Carry

Purpose or Occasion
Announcement of interior design group

Paper/Printing
Gilbert voice/Beckett Expression

Number of Colors
Cover and flysheets—two; white sheet—four

The piece is an announcement of an interior design group within an architecture firm, as well as introduction of a new director. The piece was printed at the same time a new corporate identity was introduced. As a result, the shape of the logo became a consistent visual focal point.

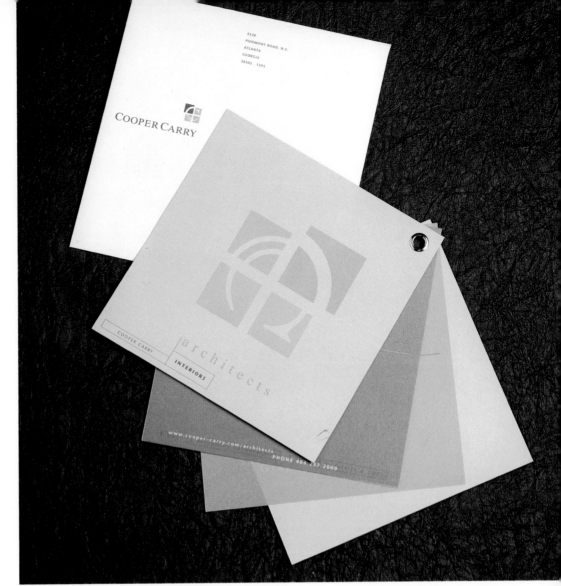

Design Firm
J. Graham Hanson Design

Designer
J. Graham Hanson

Client
Burke/Owens Family

Purpose or Occasion
Birth announcement

Paper/Printing
Strathmore

Number of Colors
One

Archival line art was utilized to convey a conservative yet playful solution. The images alone communicate the nature of the card and the typography serves only to convey the specifics.

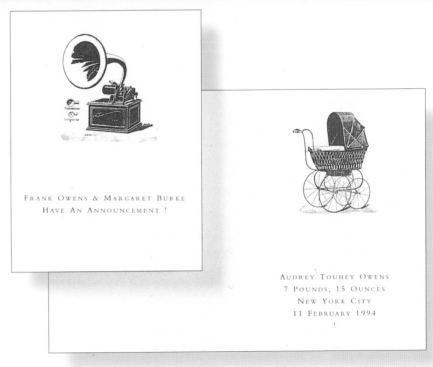

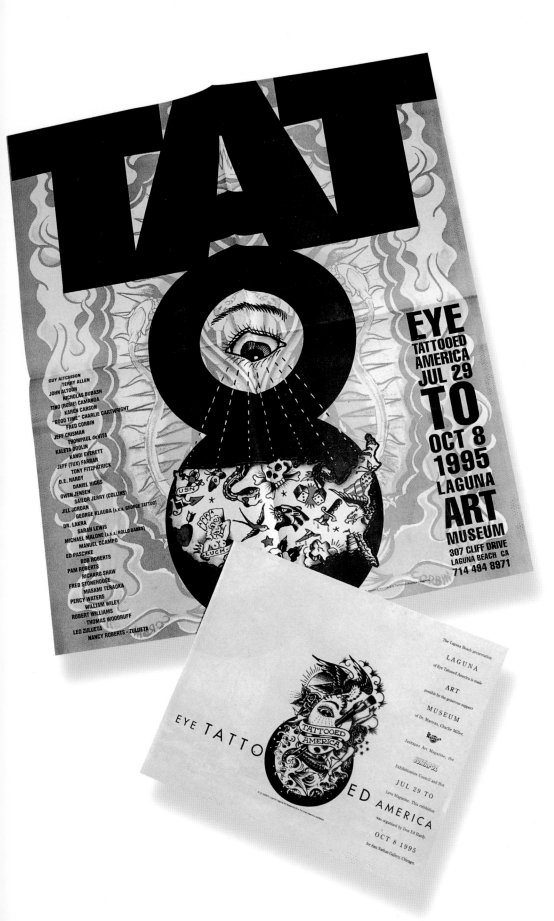

Design Firm
Mike Salisbury Communications
Inc.

Art Director
Mike Salisbury

Designer
Mary Evelyn McGough

Illustrator
Don Ed Hardy

Client
Laguna Art Museum

Purpose or Occasion
Exhibit opening

Paper/Printing
Newsprint

Number of Colors
One

The piece was compiled using
a combination of QuarkXPress,
Adobe Photoshop, and Adobe
Illustrator, with final output
on newsprint in one color.

Design Firm
Get Smart Design Company

Art Director
Jeff Macfarlane

Designer
Tom Culbertson

Client
Get Smart Design Company

Purpose or
Occasion
Moving announcement

Paper/Printing
Union-Hoermann
Press, Johnson
Graphics

Number
of Colors
Three

The purpose of the piece
was to announce the company's
relocation by including the
reason for the move as part
of the graphic effect. The
concept was to take what
may be a very ordinary event
and transform it into some-
thing special and funny. The
leatherette binding was used
to add a keepsake value to
the piece.

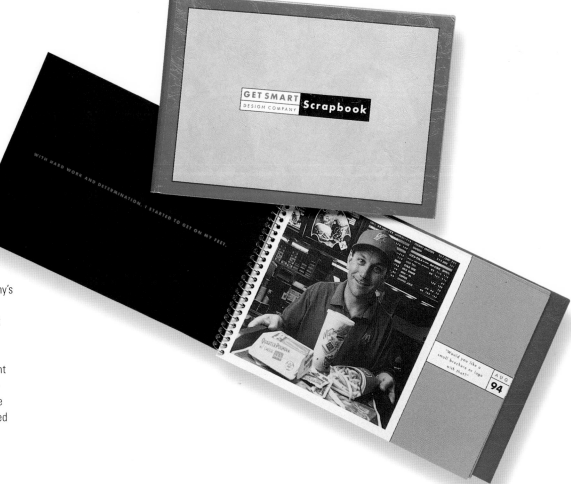

NINETEENTH CENTURY DECORATIVE ARTS

July 8, 1995 thru 1996

*An exhibition of fine decorative glass pieces including
Victorian overlay, European enamel, cut glass, Art Nouveau
and American cut glass. From the Museum's Snell,
Dinerstein, Rayniak and other collections.*

Milwaukee Public Museum
Erwin C. Uihlein Decorative Arts Gallery
Open daily 9 a.m. - 5 p.m.

Made possible through the support of the Rayniak Bequest Fund.
Design: Becker Design Printing: Burton & Mayer

Milwaukee Public Museum
800 West Wells Street
Milwaukee, WI 53233

Non-profit Organization
U.S. Postage
PAID
Milwaukee, Wisconsin
Permit No. 5378

Design Firm
Becker Design

Art Director/
Designer
Neil Becker

Client
Milwaukee Public Museum

Purpose or Occasion
Announcement of an exhibit

Paper/Printing
Burton and Mayer Inc.

Number of Colors
Four

The piece was created to announce a special exhibit of nineteenth-century decorative art. Various elements of this particular decanter are echoed in the scrolled rules and decorative type treatments.

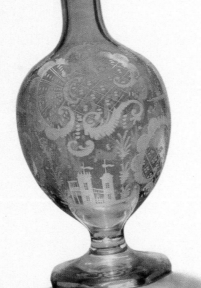

THE GLORY THAT WAS GLASS

NINETEENTH CENTURY DECORATIVE ARTS

19TH C.

JULY 8TH 1995 THRU 1996

MILWAUKEE PUBLIC MUSEUM

Amber decanter, engraved flashed glass. Bohemia (c. 1850). Donated by Mr. & Mrs. Robert Krikorian.

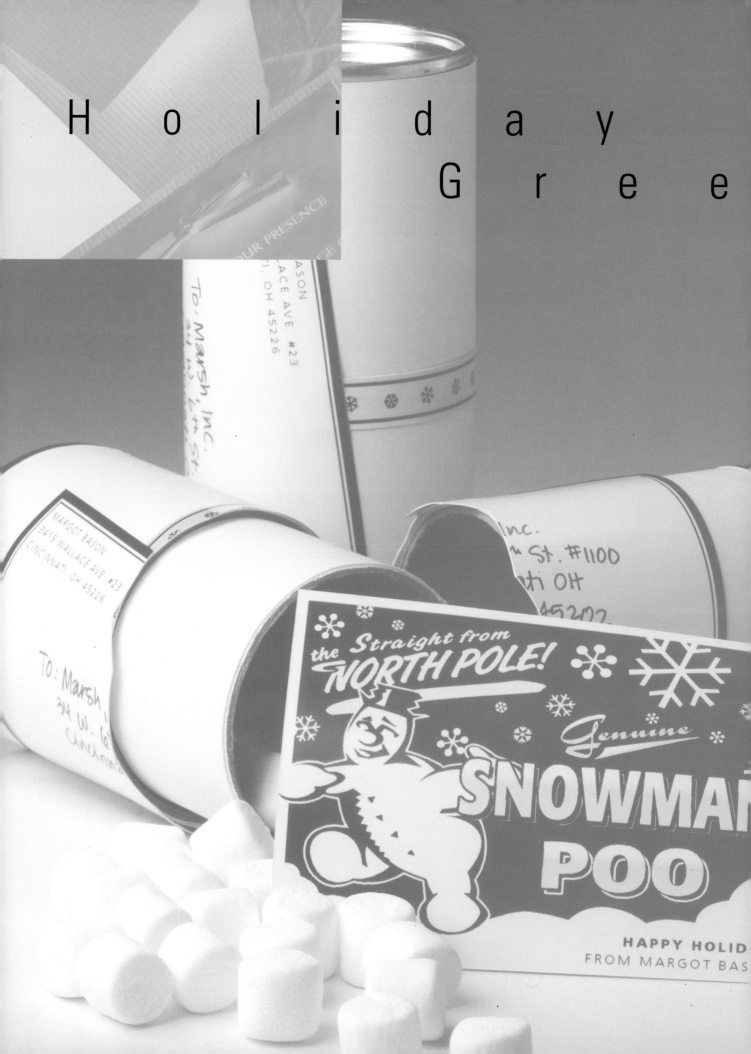

H o l i d a y

G r e e

Straight from the **NORTH POLE!**

Genuine

SNOWMA

POO

HAPPY HOLID

FROM MARGOT BAS

i n g s

Holiday Greetings

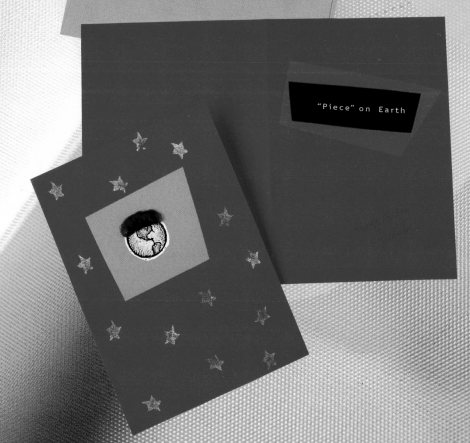

"Piece" on Earth

Design Firm
Sheehan Design

Art Director/
Designer
Jamie Sheehan

Client
Sheehan Design

Purpose or Occasion
Christmas greeting

Paper/Printing
10 pt. coated stock

Number of Colors
Three

...

Looking for low-cost
possibilities for a greeting
cards, the designer found
these air fresheners that
were already die-cut in the
shape of a Christmas tree.
Much of the piece was hand
rendered using clip art that
was scanned into the computer.

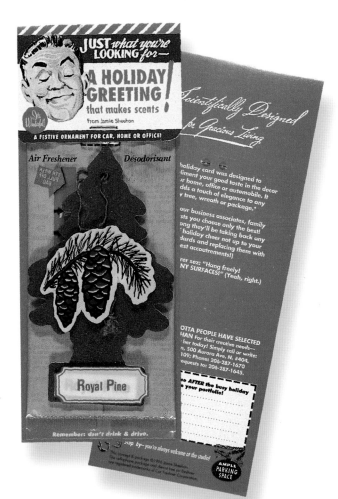

Design Firm
After Hours Creative

Client
Phoenix Advertising Club

Number of Colors
Two

...

This call-for-entries to the
annual Phoenix advertising
competition shows a star
getting shot out— a visual
representaton of the ideals
people strive for. Yet through it
all, sometimes good ideas sur-
vive everything, as witnessed
by the single complete star at
the end.

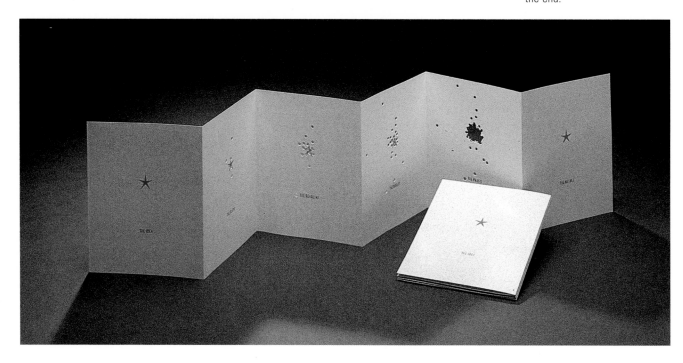

Design Firm
AWG Graphics B.C.I. LTDA

Art Director
Renata Claudia de Cristofaro

Client
AWG Graphics B.C.I. LTDA

Purpose or Occasion
Holiday greeting

Paper/Printing
TP 350 gm

Number of Colors
Four

..

This card was produced in Adobe Photoshop and Corel-Draw on a PC. The designers wanted to express that the AWG Christmas tree was unusual, modern, and beautiful and that the client who chooses AWG to work with would receive great results.

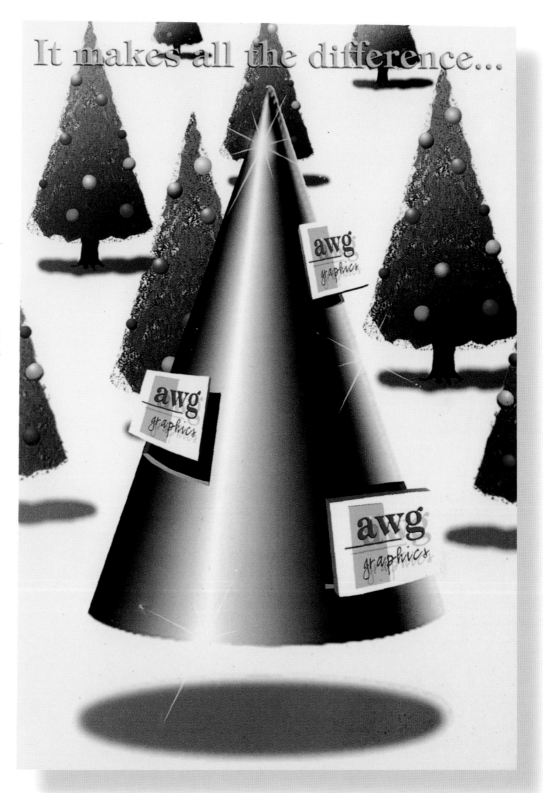

Eternal Father, strong to save,
Whose arm hath bound the
restless wave,

Navy Hymn

Merry Christmas
Happy New Year

Design Firm
Atlantic Design Works

Art Director/
Designer
Stacy W. Murray

Client
Private party

Purpose or Occasion
Holiday greeting

Number of Colors
Three

The client wanted a holiday card that would help depict his upcoming two-year sailing trip across the Atlantic. The card was designed to resemble an ancient map that included the name of each intended port as a border. This would help family, friends, and clients understand the trip's planned route.

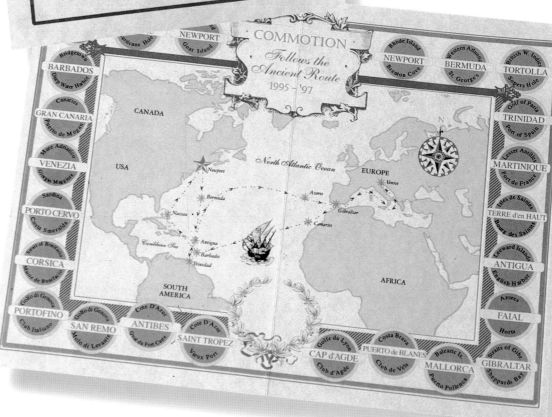

Design Firm
Copeland Hirthler design and communications

Creative Directors
Brad Copeland, George Hirthler

Art Director/ Designer
Todd Brooks

Illustrator
Robyn Beaverland

Client
APOC—Atlanta Paralympic Organizing Committee

Purpose or Occasion
Holiday greeting

Paper/Printing
Strathmore Americana

Number of Colors
Four plus two PMS

This holiday card was created to express holiday wishes to the client's corporate sponsors. The illustrator's folk-art style was carried out on plywood and then printed on Strathmore Americana to support the visual effect.

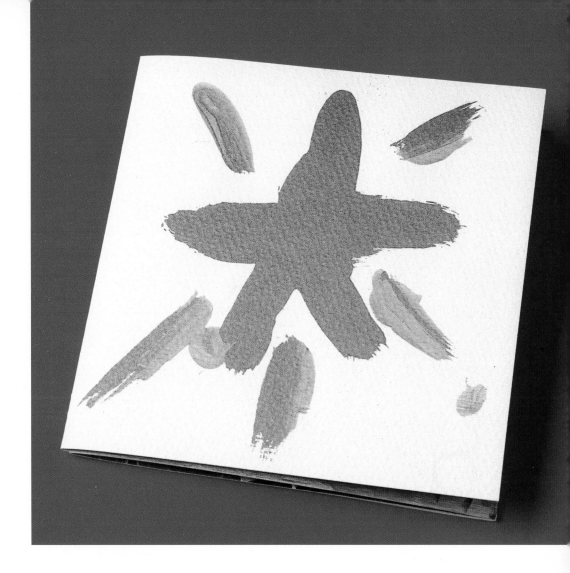

Design Firm
Sharp Designs

All Design
Stephanie Sharp

Client
Sharp Designs

Purpose or Occasion
Holiday greeting

Paper/Printing
Herald ivory/Laser printer

Number of Colors
One

..

A hand-drawn sketch of a dove
was traced in Macromedia
FreeHand and then laser printed.
Pinking shears were used for the
zigzag cut on the inside, reinforcing
the corporate identity of the
client. This zigzag pattern is
also included on business cards,
letterhead, and invoices.

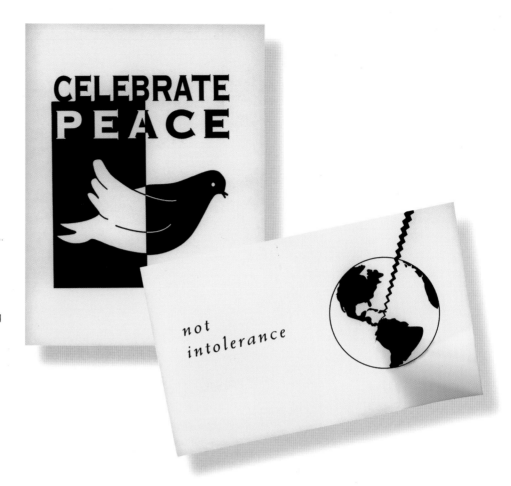

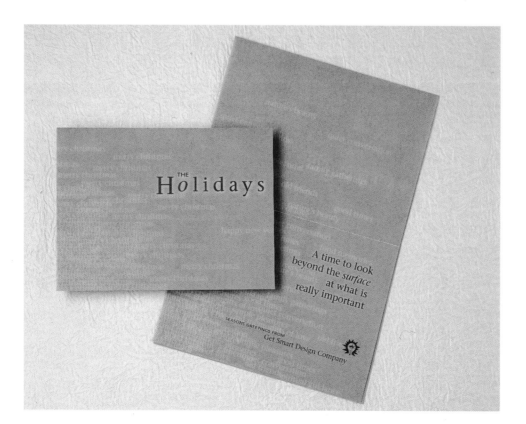

Design Firm
Get Smart Design Company

Art Director
Jeff Mcfarlane

Designer
Tom Culbertson

Client
Get Smart Design Company

Purpose or Occasion
Holiday greeting

Paper/Printing
Union-Hoermann Press

Number of Colors
Two

..

The idea behind this piece
was simplicity. The vellum
stock created an interesting
tactile effect that connected
with the copy. A time to look
beyond the surface at what is
really important.

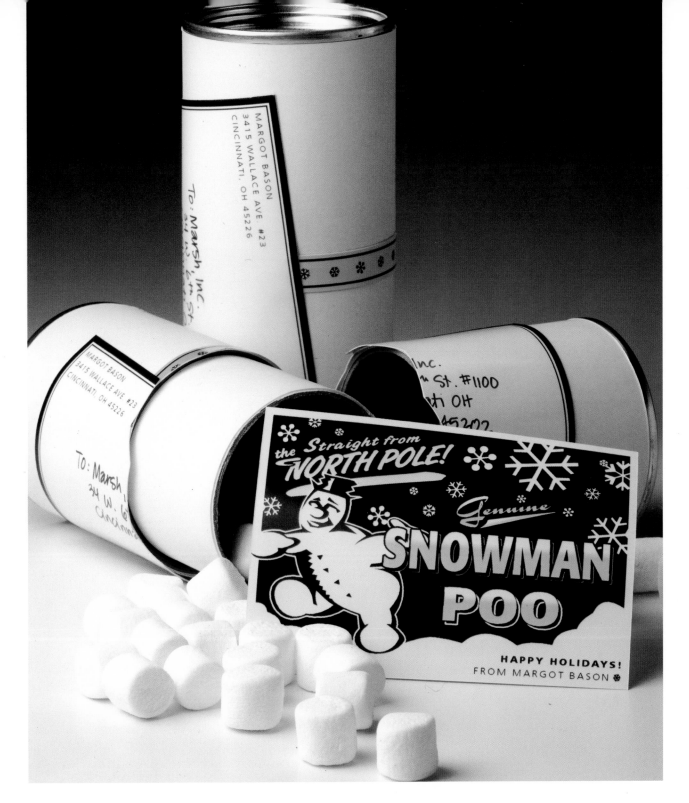

Design Firm
Marsh, Inc.

Art Director/Designer
Margot Bason

Purpose or Occasion
Holiday greeting

Number of Colors
Two

The project was a unique approach to the average holiday card. The package is a mailing tube filled with mini-marshmallows. A self-adhesive snowflake strip seals the container for delivery.

Design Firm
Perucho Mejia Graphic Design

All Design
Perucho Mejia

Client
Fundacion del Niño Leucemico

Purpose or Occasion
Promotion and Christmas card

Paper/Printing
Kimberly paper/Lithography

Number of Colors
Four

..

This card was sold to raise money for a children's foundation in Popayan. With an original drawing rendered in colored pencil, its sensitive message provides hope.

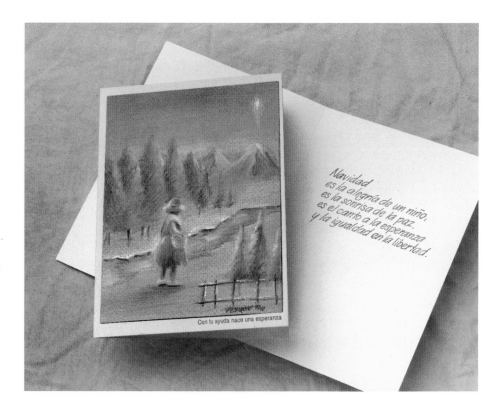

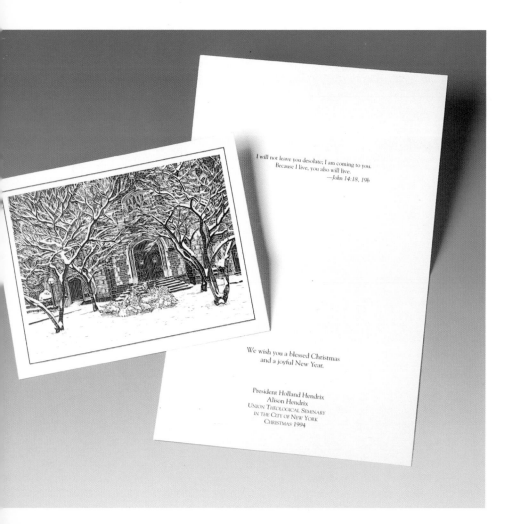

Art Director
Joann Anand

Designer/Illustrator
Joanna Roy

Client
Union Theological Seminary

Purpose or Occasion
Christmas greeting

Number of Colors
One

..

A series of photographs were taken on a snow-covered day. Sketches were done from the photos to bring out the effects of the whiteness of the snow, the tree-branch shapes, and the Gothic architecture.

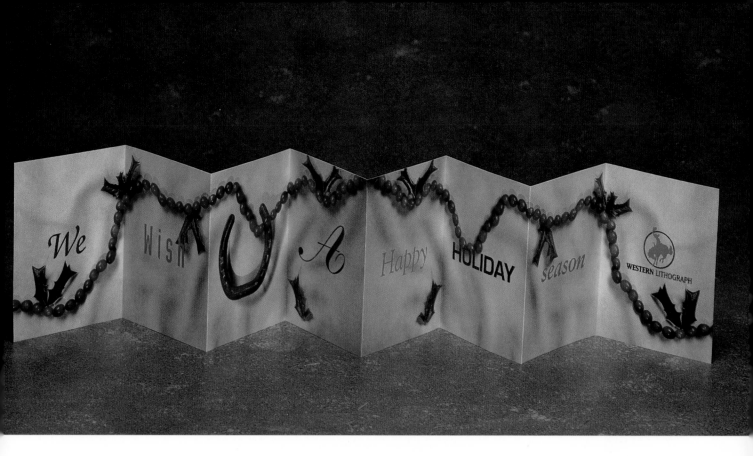

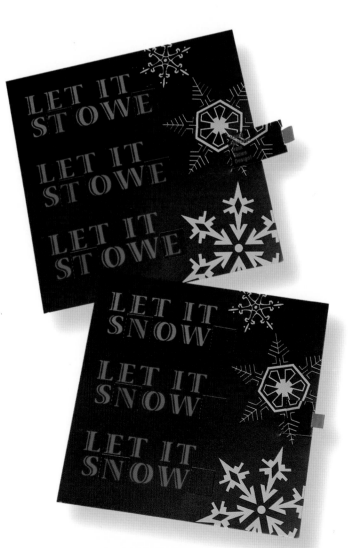

Design Firm
Stowe Design

Designers
Jodie Stowe,
Jennifer Alexander

Client
Stowe Design

Purpose or Occasion
Christmas card

Paper/Printing
Quintessence 80 lb. cover

Number of Colors
Two plus gloss varnish

This hand-assembled card
employs a moveable portion
to graphically connect Stowe
and snow.

Design Firm
MAH Design, Inc.

Art Director/
Designer
Mary Anne Heckman Navarro

Photographer
Jean Sheives

Client
Western Lithograph

Purpose or Occasion
Christmas Card

Number of Colors
Four

This Christmas card for a
printing company included a
western theme that tied in
directly with the client's name.

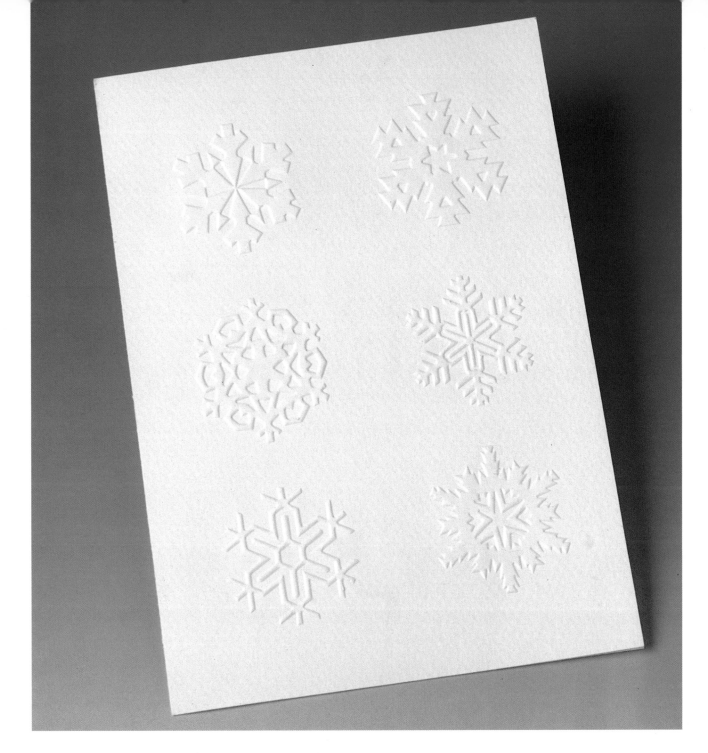

Design Firm
Toni Schowalter Design

Art Director/ Designer
Toni Schowalter

Client
IBF Group

Purpose or Occasion
Holiday card

Paper/Printing
Embossing and offset print

Number of Colors
Two

Blind embossed snowflakes represent a decorative but subtle white-on-white approach that relates to the profession of interior space design and planning.

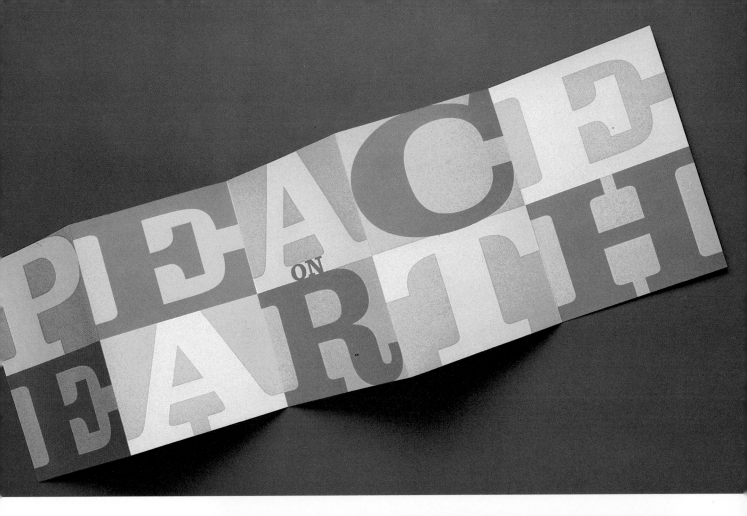

Design Firm
Planet Design Company

Art Directors
Dana Lytle, Kevin Wade

Designers
Dana Lytle, Ben Hirby

Copywriter
John Besmer

Client
Planet Design Company

Purpose or Occasion
Holiday greeting

Paper/Printing
French durotone primer gold 80

Number of Colors
Two

This Planet Design Company holiday greeting card suggests that the things associated with the holidays, such as children and peace on Earth, have lasting merit. This piece was created using QuarkXPress and Adobe Illustrator and was silk-screened for a more personal feel.

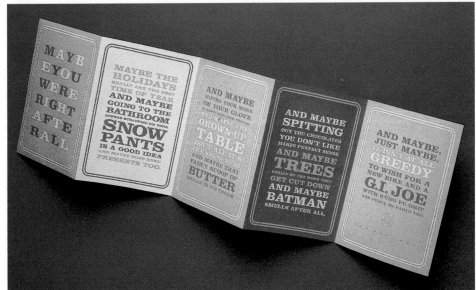

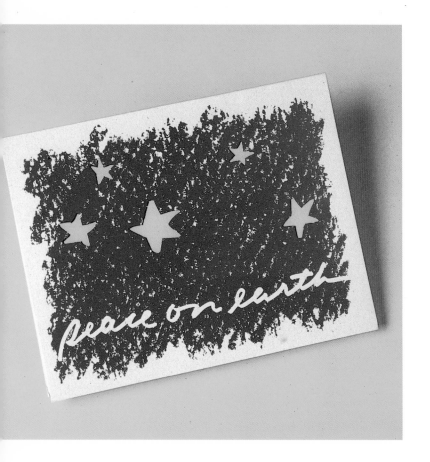

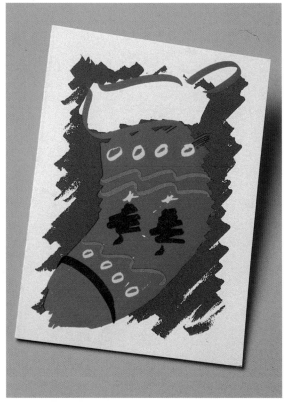

Design Firm
Greencards

All Design
Kim Beaty, Becky Lau

Client
Greencards

Purpose or Occasion
Greeting card

Paper/Printing
Simpson evergreen,
Champion Benefit/Offset
and thermography

Number of Colors
Two to five

Greencards is a line of
environmentally-friendly
holiday, special-occasion,
and all-occasion greeting
cards. Their bold, contem-
porary graphics are printed
on recycled papers using
soy-inks.

Design Firm
Lehner and Whyte

Art Directors/
Designers
Donna Lehner, Hugh Whyte

Illustrator
Hugh Whyte

Client
Silver Dog

Purpose or Occasion
Retail

Number of Colors
Four

.....................................

This collection of greeting
cards was created for a client
who wanted images with an
attitude. Patterns and other
effects were achieved using
the mask function in Adobe
Illustrator.

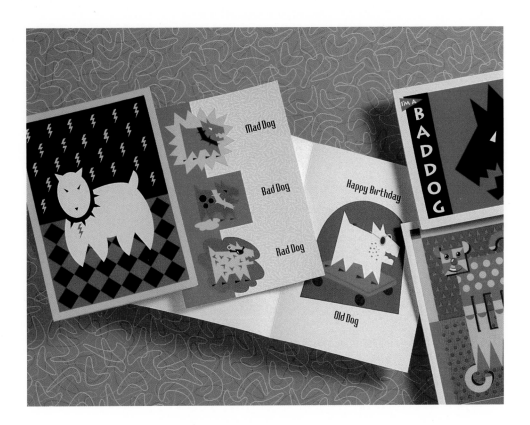

Design Firm
Lorraine Williams Illustration

All Design
Lorraine Williams

Client
Lorraine Williams Illustration

Purpose or Occasion
Christmas greeting

Paper/Printing
Offset Lithography

Number of Colors
Four

.....................................

The illustration, "Cat's
Christmas," is a mixed media
employing dyes, pastels, and
colored pencil. Sent as a
Christmas greeting to the
illustrator's clients, family,
and friends, the card was
printed and then mounted on
ivory laid cover stock.

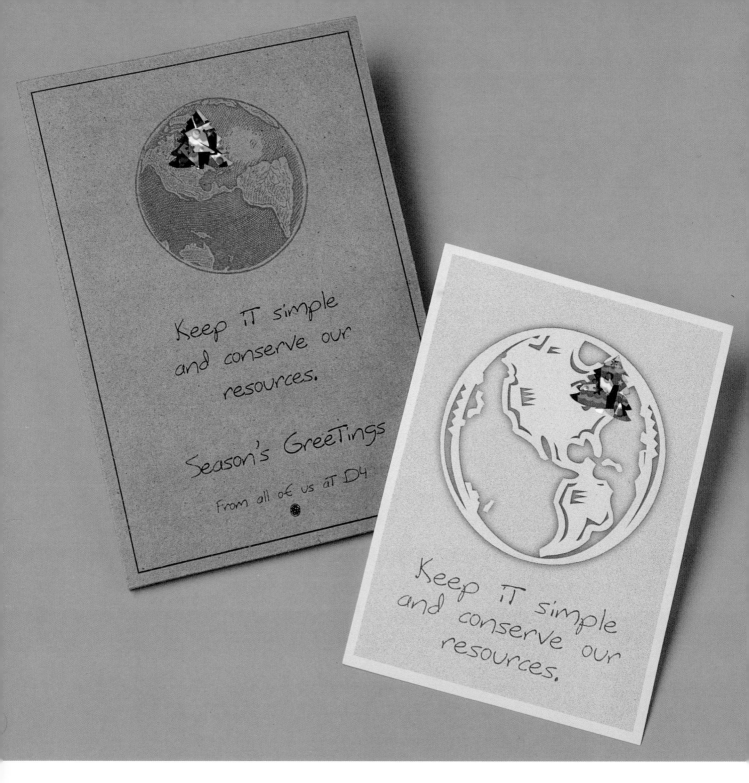

Design Firm
D4 Creative Group

Art Director/ Designer
Wicky W. Lee

Client
D4 Creative Group

Purpose or Occasion
Holiday greeting

Paper/Printing
Kraft paper/Laser printer

Number of Colors
One

The card was created by adding one-color type to Kraft paper on a laser printer. Inexpensive stickers portraying various holiday items were then added and the piece was mounted on corrugated board. A computer-generated version was also produced for corporate clients.

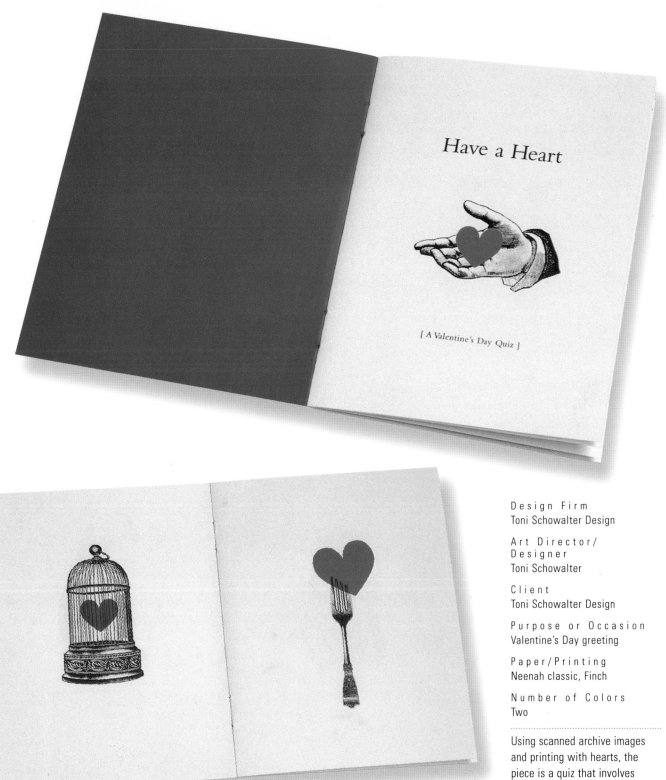

Have a Heart

[A Valentine's Day Quiz]

Design Firm
Toni Schowalter Design

**Art Director/
Designer**
Toni Schowalter

Client
Toni Schowalter Design

Purpose or Occasion
Valentine's Day greeting

Paper/Printing
Neenah classic, Finch

Number of Colors
Two

Using scanned archive images
and printing with hearts, the
piece is a quiz that involves
the viewer and creates visual
metaphors of well-known sayings
that include hearts.

JOY
HOPEACE
LOVE

ON
EARTH

Design Firm
Wood/Brod Design

All Design
Stan Brod

Client
Berman Printing Company

Purpose or Occasion
Holiday greeting

Paper/Printing
KromeKote/Offset

Number of Colors
Fourteen

The Berman Printing Company wanted a non-sectarian holiday card that would evoke the spirit of the season. The sequence of the words appearing on the first panel—JOY, HOPE, LOVE—are unified with those on the second and third panels—HOPE, PEACE ON EARTH—reinforcing the greeting's true meaning.

May your holidays be filled with wonderful surprises.

Stowe Design

Design Firm
Stowe Design

Designers
Jodie Stowe, Jennifer Alexander

Client
Stowe Design

Purpose or Occasion
Christmas card

Paper/Printing
Quintessence 100 lb. cover

Number of Colors
Four-color process

Knowing the previous year's holiday card would be difficult to top, the designers instead focused on a simple theme that would connect with the company's logo. The piece was kept visual, with square shapes carrying throughout.

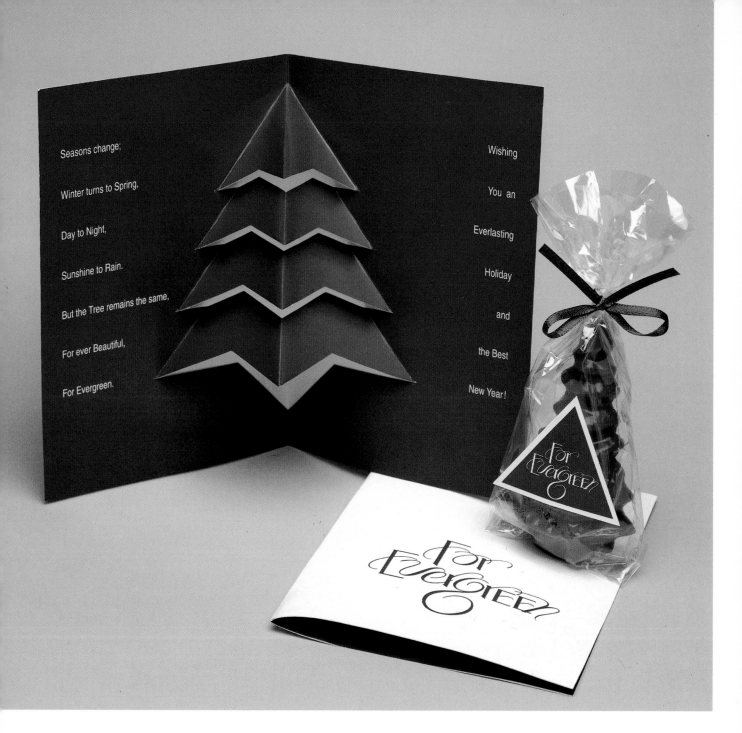

Seasons change;

Winter turns to Spring,

Day to Night,

Sunshine to Rain.

But the Tree remains the same,

For ever Beautiful,

For Evergreen.

Wishing

You an

Everlasting

Holiday

and

the Best

New Year!

Design Firm
Angela Jackson

Designer
Angela Jackson

Photographer
Calvin Fong

Client
Angela Jackson

Purpose or Occasion
Holiday greeting

Paper/Printing
Citadel Press

Number of Colors
One plus tinted varnish

A photograph of a pine tree is printed using tinted varnish throughout the card, and home-made chocolate trees are given along with the card to reinforce the evergreen-tree theme.

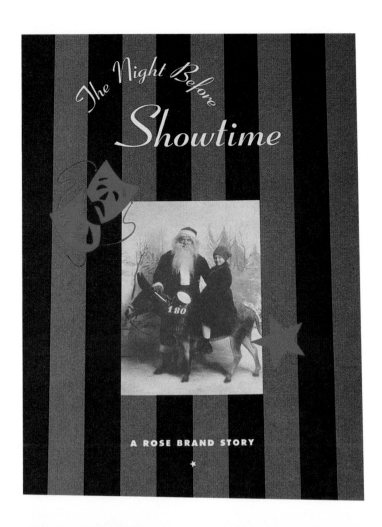

Design Firm
Toni Schowalter Design

Art Director/
Designer
Toni Schowalter

Client
Rose Brand

Purpose or Occasion
Holiday card

Paper/Printing
80 lb. text

Number of Colors
Three

The card's theme, "The Night Before Christmas," parodies the classic Clement Moore tale and was created in QuarkXPress with scanned photographic images. Use of overprinting and tints enhances and adds complexity to the three-color printing.

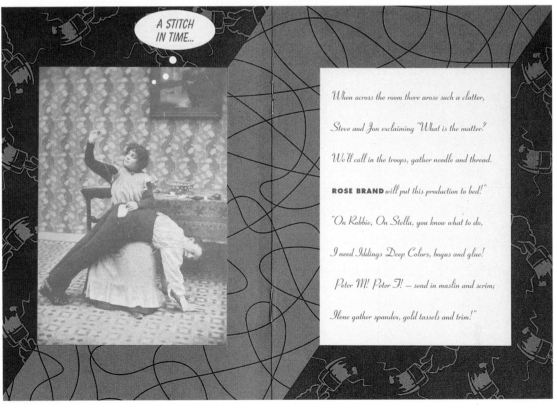

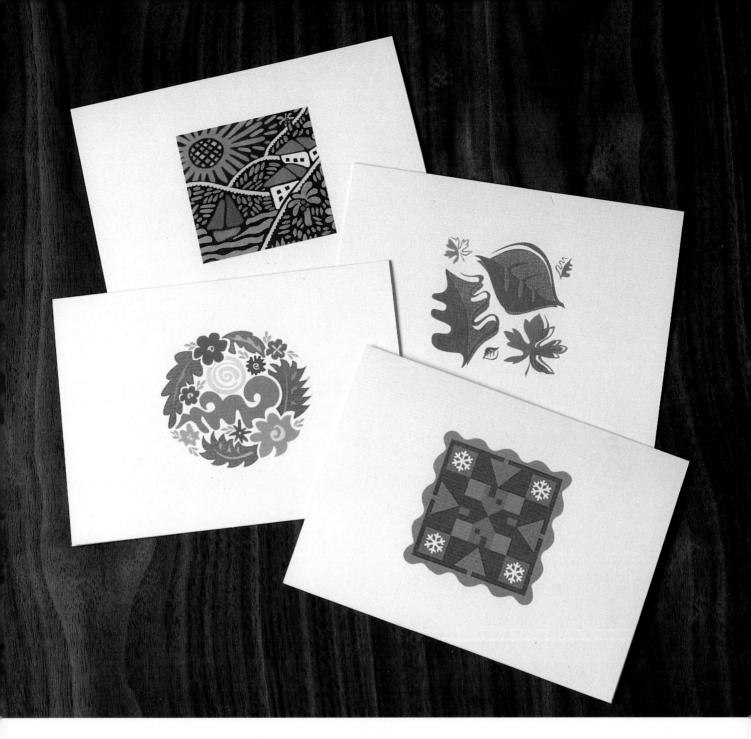

Design Firm
Toni Schowalter Design

All Design
Toni Schowalter

Client
Toni Schowalter Design

Purpose or Occasion
Holiday greeting

Paper/Printing
Strathmore Natural laid
100 lb. cover

Number of Colors
Four

This holiday greeting is printed on a translucent sheet that contains four reusable cards and envelopes. Designs were also recycled from previous jobs and combined with messages to evoke a holiday spirit.

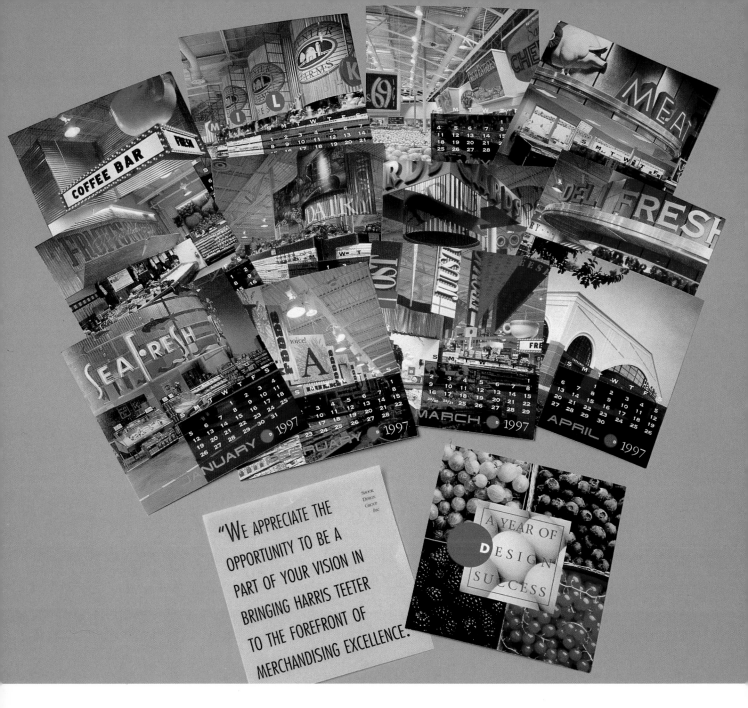

Design Firm
Shook Design Group, Inc.

Art Director
Ginger Riley

Designers
Ginger Riley, Graham Schulken

Photographer
Tim Buchman

Client
Shook Design Group, Inc.

Purpose or Occasion
New Year's greeting/gift

Paper/Printing
Vintage

Number of Colors
Six

Serving as both a greeting and gift for merchandising client Harris Teeter, Inc., the piece is a calendar that features photographs of designs executed by Shook Design Group for Harris Teeter throughout the state of North Carolina.

Design Firm
Sagmeister, Inc.

Art Director
Stefan Sagmeister

Designer
Veronica Oh

Client
Aerosmith

Purpose or Occasion
Christmas card

Paper/Printing
100 lb. cover

Number of Colors
One

..

This postcard utilizes a flexo disc and includes a regular pin attached to cardboard. When the disc is turned by hand, the cardboard serves as a loudspeaker and the card becomes a working record player. Aerosmith recorded a Christmas song especially for this card.

Design Firm
McGaughy Design

Art Director/
Designer
Malcolm McGaughy

Client
McGaughy Design

Purpose or Occasion
Holiday greeting

Paper/Printing
Laser paper/Laser printer

Number of Colors
Three

..

For an unexpected look, the designer ran out the cards on a Laserwriter, cut and ripped them by hand, and then applied color with a highlighter.

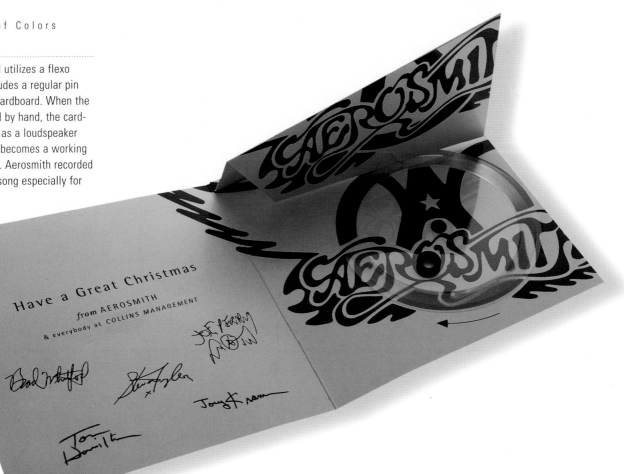

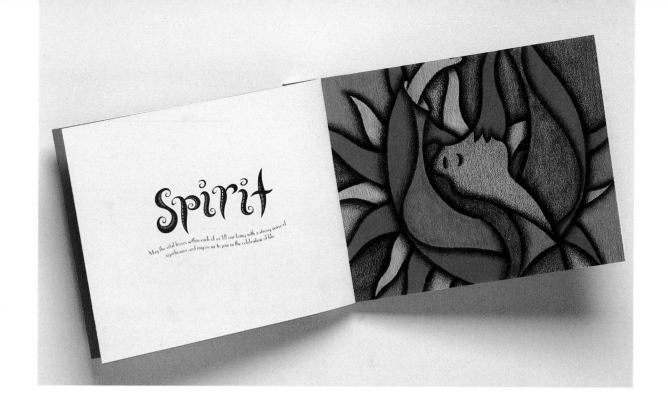

Design Firm
David Carter Design

Art Directors
Lori B. Wilson, David Carter

Designer/Illustrator
Rickey Brown

Client
David Carter Design

Purpose or Occasion
Holiday greeting

Paper/Printing
Starwhite Vicksburg 80 lb.
text/Buchanan Printing

Number of Colors
Seven

This holiday card was printed on
Starwhite Vicksburg 80 lb. text
vellum with a three-hundred line
screen. The pages were printed
waterless in an effort to achieve
greater ink coverage and color
saturation on the uncoated stock.
The text pages were side stitched
to the cover, folded into place, and
glued to the cover at the spine.
The capacity slip case was hand-
converted because of the ribbon
attached to its interior. Intended to
resemble thermography, the black
cover art was created by emboss-
ing the black foil stamp.

Design Firm
David Carter Design

Art Directors
David Carter, Lori B. Wilson

Designer
Tracy Huck

Illustrator
Donna Ingemanson

Copywriter
Melissa Gatchel-North

Client
David Carter Design

Purpose or Occasion
Holiday greeting

Paper/Printing
Simpson Quest, Starwhite
Vicksburg/Imperial Lithography

Number of Colors
Six

With a theme of "Decorate the World," the piece was designed to wish holiday greetings to friends and clients around the world. The illustrations reflect ornamentation/decorations for the various international celebrations. Fluorescent touch plates were utilized with water-less printing to maintain the intense pigments in the original artwork. Angel charms were tied on by hand.

Design Firm
Frank Kunert

All Design
Frank Kunert

Client
Frank Kunert

Purpose or Occasion
Easter greeting

Number of Colors
Four

The hare with its spoon ears is seen driving to Easter holiday festivities in a car built from an original German egg box. The illusion of motion is achieved using a gel in front of the lens.

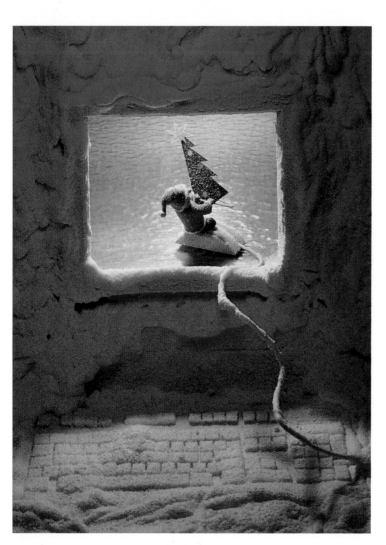

Design Firm
Frank Kunert

All Design
Frank Kunert

Client
Utimaco Safeware

Purpose or Occasion
Christmas card

Number of Colors
Four

The computer is built of millboard, Santa Claus out of clay, and he is seen surfing from the cold winter into the warm sun of a new year with scenery sprayed with artificial snow.

Design Firm
Tandem Graphics

Art Director/
Designer
Caren Schindelwick

Illustrator
David Weeks

Client
Tandem Graphics

Purpose or Occasion
Christmas card

Number of Colors
Four

..................................

This combination Christmas card
and puzzle was personalized with
a handwritten greeting on the
back. The recipient was confronted
with an envelope full of pieces,
and the greeting was readable
only after solving the puzzle.

Design Firm
Tandem Graphics

Art Director/Designer
Caren Schindelwick

Illustrator
David Weeks

Client
Tandem Graphics

Purpose or Occasion
Christmas card

Paper
Proxiedelmatt

Number of Colors
Four

..................................

Hanging from a balloon, Santa
Claus floats into the picture and
then disappears with a surprised
expression on his face when the
balloon suddenly deflates. After
developing the Santa character,
the flip-back story board was ani-
mated in Infini-D, and prepared
for print using Adobe Photoshop
and Illustrator. The finished book
was hand bound and mailed in a
custom-designed envelope.

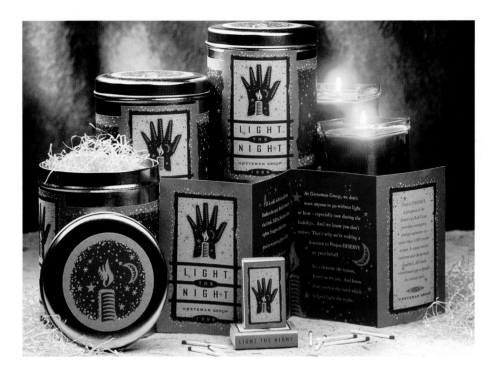

Design Firm
Greteman Group

Art Directors
Sonia Greteman,
James Strange

Designers
Sonia Greteman, James
Strange, Craig Tomson

Illustrator
James Strange

Client
Greteman Group

Purpose or Occasion
Holiday promotion

Paper/Printing
Passport/Offset

Number of Colors
Two

The promotion's intention
was to solicit donations to
the local power company to
benefit low-income utility cus-
tomers. The hand represents a
helping hand and the candle
represents the warmth of the
season with warm colors
included to enliven the piece.

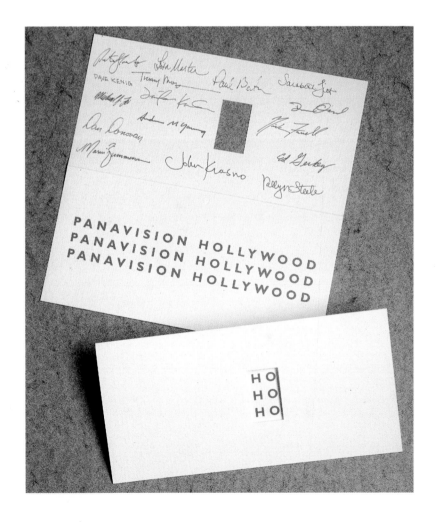

Design Firm
Design Art, Inc.

Art
Director/Designer
Norman Moore

Client
Panavision Hollywood

Purpose or Occasion
Christmas card

Number of Colors
Two

Created in QuarkXPress on
the Macintosh, this two-color
piece employs typographic
elements to convey a corpo-
rate Christmas greeting. The
die-cut cover brings attention
to Ho, Ho, Ho (as found in
client's name).

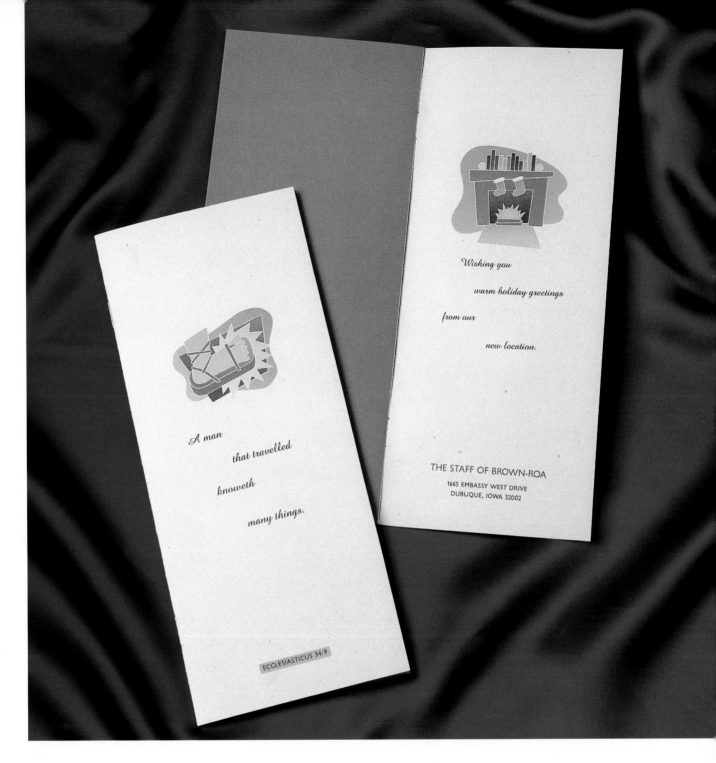

A man
that travelled
knoweth
many things.

ECCLESIASTICUS 34:9

Wishing you

warm holiday greetings

from our

new location.

THE STAFF OF BROWN-ROA
1665 EMBASSY WEST DRIVE
DUBUQUE, IOWA 52002

Design Firm
Get Smart Design Company

Art Director/Designer
Jeff Macfarlane

Illustrator
Tom Culbertson

Client
Brown-Roa

Purpose or Occasion
Holiday and relocation

Paper/Printing
Union-Hoermann Press

Number of Colors
Four

The purpose of the piece was to announce a new location while tying in the holidays. Brown-Roa, a publisher of religious learning materials, needed the piece to have religious undertones. Scriptural passages that related to the current events were used throughout. The palette and illustration style were kept modern to better reflect the age and personality of the Brown-Roa staff.

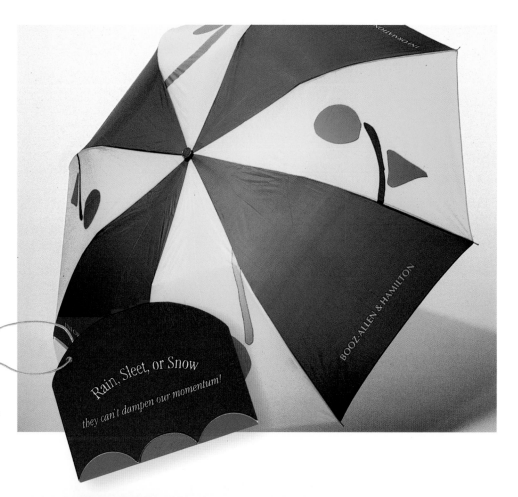

Design Firm
Metropolis Corporation

Creative Director
Denise Davis

Designer/Illustrator
Lisa DiMaio

Mobile Artist
Karen Rossi

Client
Booz, Allen and Hamilton, Inc.

Purpose or Occasion
Holiday greeting

Paper/Printing
Custom

Number of Colors
Five

Designed as a gift from the Information Technology Group Partners at Booz, Allen and Hamilton, the umbrella contains pieces of a mobile designed for the ITG group.

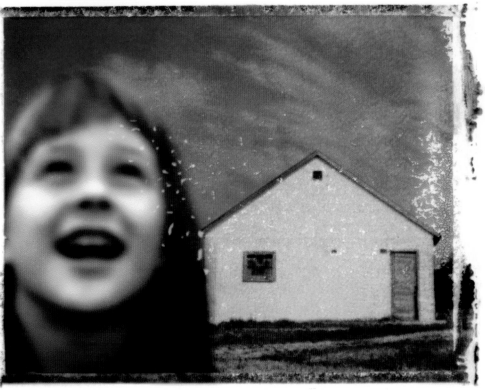

Design Firm
Larry Burke-Weiner

All Design
Larry Burke-Weiner

Client
Larry Burke-Weiner

Purpose or Occasion
Valentine's Day card

Paper/Printing
Warren Lustro gloss

Number of Colors
Four

To produce a card that celebrated Valentine's Day, the designer used a Polaroid transfer of my house and digitally included a colorized black-and-white photo of his wife as a child.

All Design
Paul Stoddard

Purpose or Occasion
Holiday greeting

Paper/Printing
Paper "Paperazzi"
laser paper

Number of Colors
One

The illustrator wanted to cre-
ate a limited-edition holiday
greeting card to send to past
and present clients. The piece
was laser-printed on silver-
metallic Paperazzi laser paper,
and hand assembled—an
inexpensive way to showcase
and remind clients of the
illustrator's unique style.

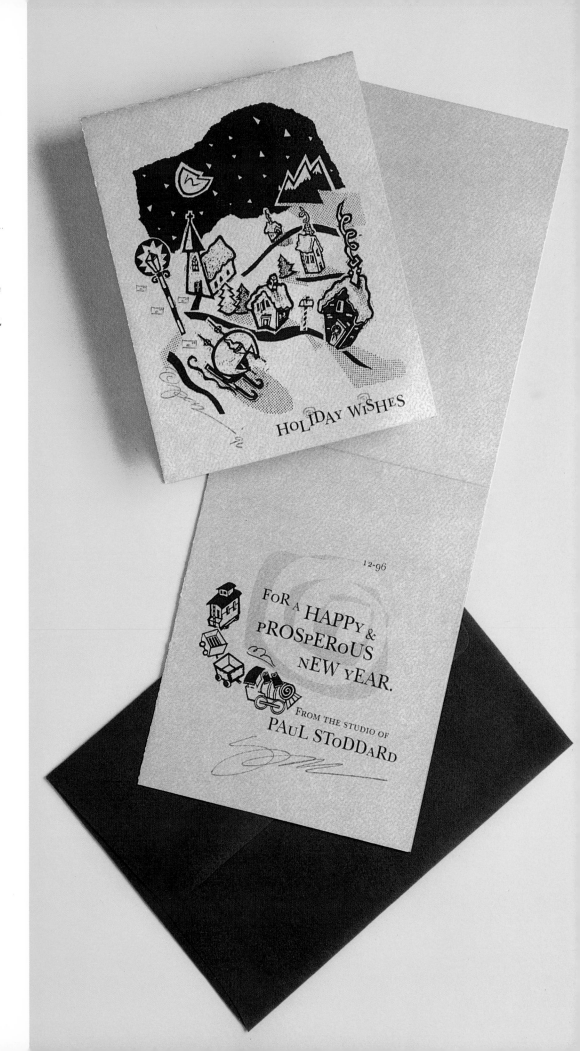

Design Firm
Marketing Services—Indiana
University

All Design
Larry Burke-Weiner

Client
Indiana University—Halls of
Residence

Purpose or Occasion
General birthday card

Number of Colors
Four

Due to the mix of students living
on campus, a birthday card was
needed that would not show any-
thing that specifically represents
a birthday. The fence is from
Martha's Vineyard, the faces—
our Research Analyst. The piece
was assembled using Adobe
Photoshop and Fractal Design
Painter.

Design Firm
Paresky Design

**Art
Director/Designer**
Laura Paresky

Photographer
Laura Paresky

Client
Key Press

Purpose or Occasion
Birthday card

Paper/Printing
12 pt. KromeKote

Number of Colors
Four-color process

For these birthday greetings,
candles and "sprinkles"
were photographed. The
inside is blank.

Há um brilho especial no ar...

Design Firm
AWG Graphics B.C.I. LTDA

Art Director
Renata Claudia de Cristofaro

Client
Mondial Excellence in VBA

Purpose or Occasion
Christmas card

Paper/Printing
Couche Fosco 240 gm

Number of Colors
Four

In Portuguese, mondial means "worldwide" and the client wanted to make a statement with their Christmas card that expressed that there was a special quality in the Mondial enterprise. The card was produced using Adobe Photoshop and CorelDraw on the Macintosh.

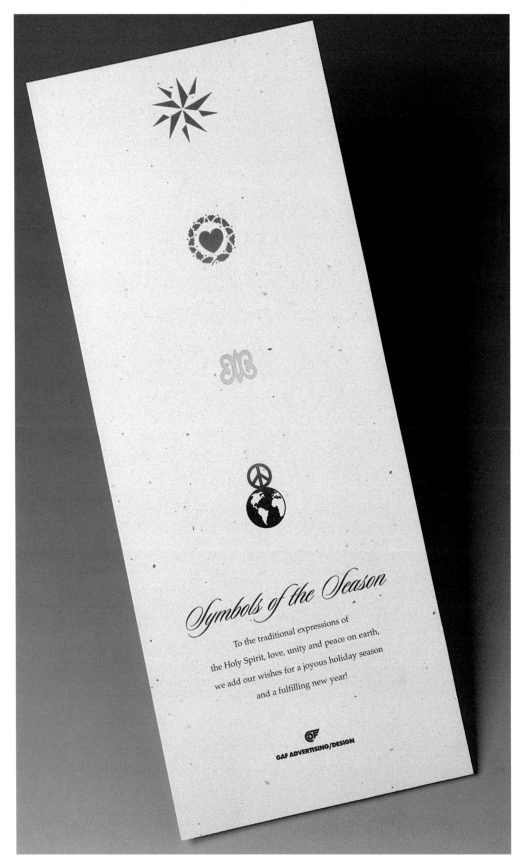

Symbols of the Season

To the traditional expressions of
the Holy Spirit, love, unity and peace on earth,
we add our wishes for a joyous holiday season
and a fulfilling new year!

GAF ADVERTISING/DESIGN

Design Firm
GAF Advertising/Design

All Design
Gregg A. Floyd

Client
GAF Advertising/Design

Purpose or Occasion
Holiday greeting

Paper/Printing
Confetti paper/Offset printing

Number of Colors
Four

To produce a card that was neither overly religious nor commercially driven, a series of graphic symbols was used to portray key themes of the season—the holy spirit, love, unity, and peace on Earth. A low-tech approach was used in producing the piece. First, four black-and-white line drawings of the symbols were created, which gave the illustration a soft edge. Then, all the symbols were scanned and aligned with the text in QuarkXPress. Finally, a traditional offset-printing process known as split-fountain was used to obtain a rainbow effect.

May your holidays be packed with wonderful surprises

MANCINI DUFFY

Design Firm
Toni Schowalter Design

Art Director/ Designer
Toni Schowalter

Client
Mancini Duffy

Purpose or Occasion
Holiday greeting

Paper/Printing
Strathmore 28 lb. ultimate white card

Number of Colors
Two

Using inexpensive two-color printing, the color photo was brought into Adobe Photoshop to isolate the nose. The card plays off the interior design firm's logo that incorporates a holiday motif in the snowman.

Art Director
Simon Mould

Illustrator
James Marsh

Client
Nemo Cards

Purpose or Occasion
Christmas card

Number of Colors
Four

This four-color Christmas card was designed to appeal to frog lovers.

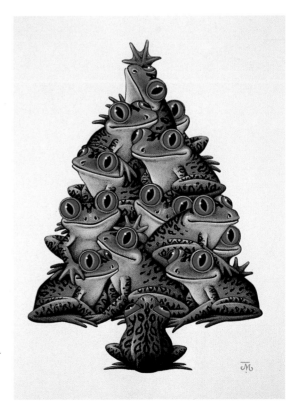

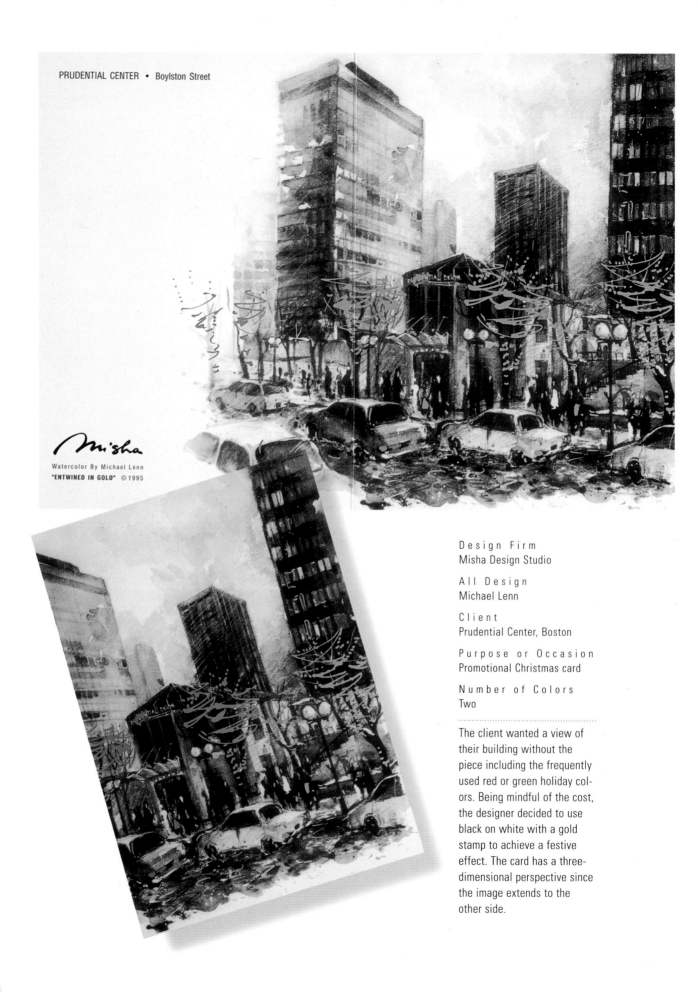

PRUDENTIAL CENTER • Boylston Street

Watercolor By Michael Lenn
"ENTWINED IN GOLD" © 1995

Design Firm
Misha Design Studio

All Design
Michael Lenn

Client
Prudential Center, Boston

Purpose or Occasion
Promotional Christmas card

Number of Colors
Two

The client wanted a view of their building without the piece including the frequently used red or green holiday colors. Being mindful of the cost, the designer decided to use black on white with a gold stamp to achieve a festive effect. The card has a three-dimensional perspective since the image extends to the other side.

Design Firm
Mires Design

Art Director
John Ball

Designers
John Ball, Deborah Hom

Illustrator
Tracy Sabin

Client
Mires Design

Purpose or Occasion
Holiday greeting

Paper/Printing
Arches/Hal Truschke

Number of Colors
Two

..

The designers used a woodcut illustration and letterpress printing to create a sincere, handmade feel.

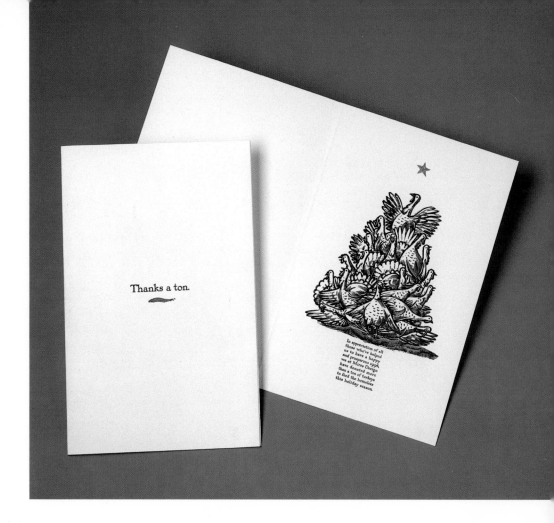

Design Firm
Schumaker

Illustrator
Ward Schumaker

Client
Autumn Leaves

Purpose or Occasion
Holiday greeting

Paper/Printing
Recycled white offset

Number of Colors
Four

..

Autumn Leaves, a manufacturer of cards, gift boxes, and writing papers, requested non-sectarian holiday images with heart. What could be cheerier than a snowman warming himself at a fire?

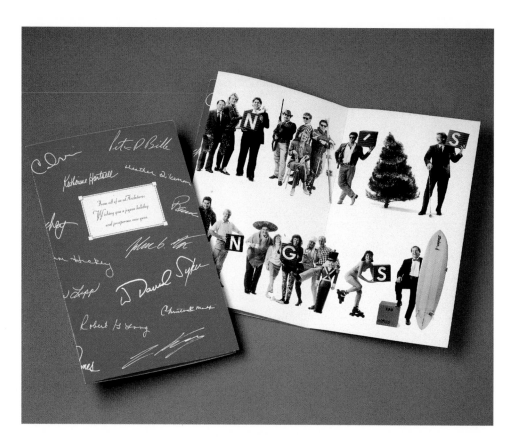

Design Firm
Mires Design

Art Director
Jose A. Serrano

Designers
Jose A. Serrano,
Gail Spitzley

Photographer
Mike Balderas

Client
Andataco

Purpose or Occasion
Holiday greeting

Paper/Printing
Rush Press

Number of Colors
Four plus one PMS

The purpose of this card
was to send holiday greetings
while having fun with the
concept and showing the
human side of the company.

Design Firm
Melinda Persing Design

All Design
Melinda Persing

Client
Melinda Persing Design

Purpose or Occasion
Holiday greeting

Paper/Printing
Confetti yellow, sihlclear
confetti/Color inkjet

Number of Colors
Five PMS colors (printed in
four-color on an inkjet printer)

The objective of this holiday
greeting card was to create
an interesting design with a
personal touch on a limited
budget. Textured stocks with a
corner-grommet binding makes
this hand-collated card unique.

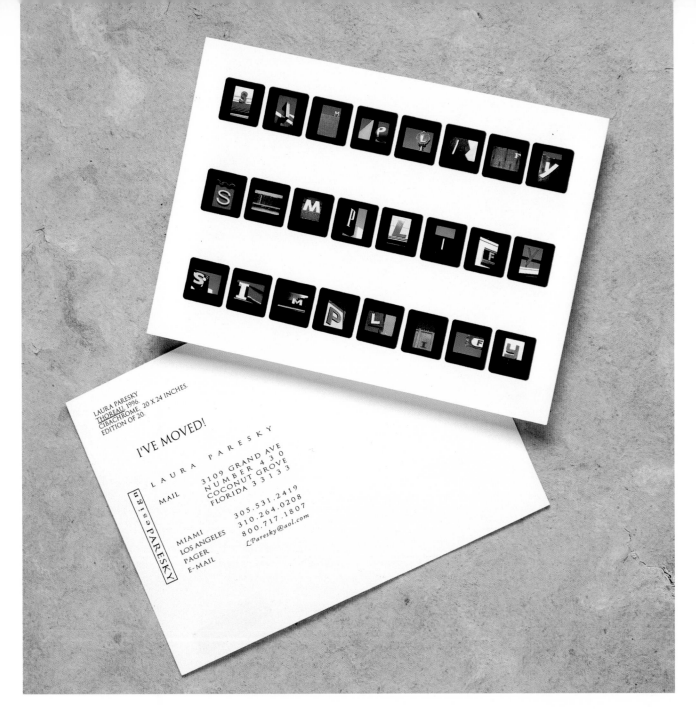

Design Firm
Paresky Design

Art Director/
Designer
Laura Paresky

Photographer
Laura Paresky

Client
Key Press

Purpose or Occasion
Alternative holiday card

Paper/Printing
12 pt. KromeKote

Number of Colors
Four

For this card, 35-millimeter slides of individual letters on various signs were shot and arranged in their mounts to spell out the Thoreau quote, "simplify, simplify, simplify." The slides were attached to acetate and made a contact cibachrome print. The original 20" x 24" limited-edition cibachrome prints are sold in galleries in Los Angeles, Boston, New York, and Miami. The quote was ironic because although it was a simplification of all addresses and numbers, it still has a complex array of phone numbers, a pager number, an e-mail address, and a mailing address.

Design Firm
Paresky Design

Art
Director/Designer
Laura Paresky

Photographer
Laura Paresky

Client
Key Press

Purpose or Occasion
1997 New Year's or 1997
graduation card

Paper/Printing
12 pt. KromeKote

Number of Colors
Four

For this card, 35-millimeter
slides of the numbers on red
Ferraris were shot. The slides
were unmounted and placed
on a pictrostat machine to
get the original print to be
used on the greeting cards.
The inside reads, "Celebrate!"
so the cards can be used
either for New Year's or a
graduation.

Design Firm
Tower of Babel

Designer/Illustrator
Eric Stevens

Purpose or Occasion
Holiday greeting

Paper/Printing
Color laser output

Number of Colors
Four

The original concept of this
humorous greeting card involved
a limited run of thirty pieces. To
avoid the high price of true four-
color process printing, the
designer output on color lasers.
The design highlights an original
typeface designed by Tower of
Babel called Slappy.

Design Firm
Sandy Gin Design

All Design
Sandy Gin

Client
Sandy Gin Design

Purpose or Occasion
Holiday greeting

Paper/Printing
Color Xerox

Number of Colors
Two

This postcard was designed to celebrate the Chinese Lunar New Year in a traditional but contemporary manner. Drawn with a felt-tip marker instead of the traditional Chinese ink brush, all work was done by hand to maintain the looseness and roughness of the lines. The card was reproduced on a photocopier with black and red toner.

In the
spirit
of the
season...

Toni Schowalter Design has donated
its entire holiday gift budget to the Children's
Aid Society. On behalf of those benefiting, we
thank our clients for the business that makes
this gift possible.

Our office will be closed for the week
from December 25 to January 2,

We wish you the happiest of holiday
seasons and all the best during the new year.

Design Firm
Toni Schowalter Design

Art Director/
Designer
Toni Schowalter

Client
Toni Schowalter Design

Purpose or Occasion
Holiday card

Paper/Printing
Strathmore Writing Natural

Number of Colors
Three

Printed along with the other
stationery materials to keep
costs down, the interior of the
card was later printed to carry
a holiday message and inform
clients of the office's holiday
closing schedule.

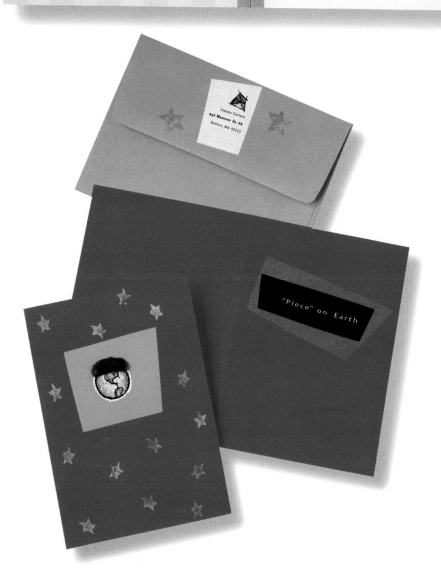

"Piece" on Earth

Designer/Illustrator
Lianne Cortese

Client
Lianne Cortese

Purpose or Occasion
Holiday greeting

Paper/Printing
Colored stock/Laser printer

Number of Colors
One

Instead of creating a traditional
greeting card with traditional
colors, the designer wanted to
show the brighter side of
Christmas with brightly colored
paper and a clever visual pun
(the inside reads "Piece on
Earth"). With only thirty-five
cards being produced, the
designer could inexpensively
print them on a laser printer
and hand assemble them.

Through all

the upcoming days

of 1997

We wish you

the Best

Larsen Design + Interactive

Sascha Boecker
Pam Borgman
Julie Cuddigan
Peter de Sibour
John Fertis
Julie Fortman
Catherine Gillis
Michael Haug
Kevin Heidemann
Ellen Huber
Richelle Huff
Gayle Jorgens
Marc Kundmann
Tim Larsen
Todd Mannes
Sean McKay
Ann Merrill
Todd Nesser
Bill Roah
Pepa Reimann
Donna Root
Wendy Ruyle
David Shultz
Jerry Stenback
Lori Vossler
Liz Wendt
Jon Wetterston
Nancy Whittlesey
Lisa Williams
Kevin Ylitalo
Dawn Zehr

Design Firm
Larsen Design and Interactive

Art Director
Tim Larsen

Designer
Jerry Stenback

Client
Self-Promotion

Purpose or Occasion
Holiday card

This New Year's Card was created to convey holiday greetings and a present a forward-looking message to clients, vendors, and friends. The message "soaring to new heights in the new year" was complemented by the numbers nine and seven used as independent, interlocking graphic elements. The upward movement of the background graphic, the translucent nature of the papers used, the bright colors, and the tilting and layering of the numbers all convey an airborne quality.

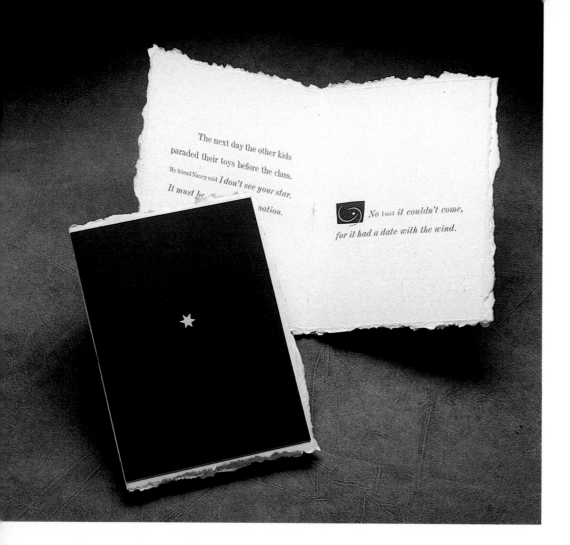

The next day the other kids
paraded their toys before the class.
My friend Nancy said *I don't see your star.*
It must be ~~~~~~~~~~~ nation.

No I said *it couldn't come,*
for it had a date with the wind.

Design Firm
Rapp Collins Communications

Art Director/
Designer
Amy Usdin

Illustrator
Kristen Miller

Copywriter
Brad Ray

Client
Rapp Collins Communications

Purpose or Occasion
Holiday greeting

Printing
Phil Gallo

Binding
Jill Jevne

Number of Colors
Two

In keeping with the holiday tradi-
tion of giving clients a gift that
focuses on communication, a
warm holiday story to share with
loved ones is handcrafted and
letterpressed into the card.

Design Firm
Our Mind's Eye Creation

Designer/Illustrator
Ryanne Sebern

Purpose or Occasion
Note card

Paper/Printing
Poster board/Color Xerox

A fun greeting for any occa-
sion, this watercolor creation
has a blank inside. It can also
be mounted on different color
background if specified.

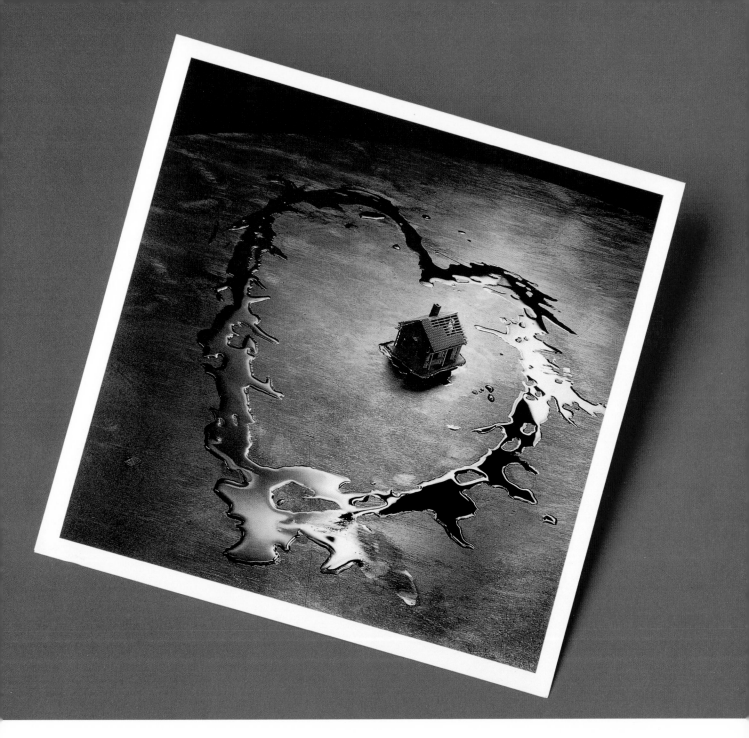

Design Firm
Nesnadny and Schwartz

Art Directors/
Designers
Mark Schwartz, Tina Katz

Photographer
Zeke Berman

Client
Mark Schwartz and Tina Katz

Purpose or Occasion
Valentine's Day card

Paper/Printing
100 lb. gloss coated
cover/Fortran printing

Number of Colors
Four

This image was created in celebration of
the second birthday of Sophie Schwartz
on February 14, 1997. Nesnadny and
Schwartz and photographer Zeke Berman
designed the valentine, which was dis-
tributed to family, friends, and business
associates.

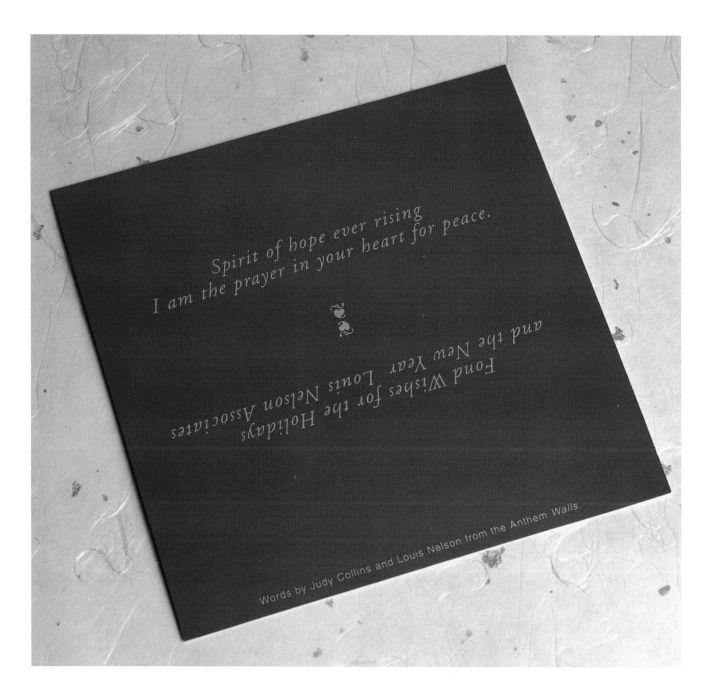

Spirit of hope ever rising
I am the prayer in your heart for peace.

Fond Wishes for the Holidays
and the New Year Louis Nelson Associates

Words by Judy Collins and Louis Nelson from the Anthem Walls.

Design Firm
Louis Nelson Associates, Inc.

All Design
Louis Nelson Associates, Inc.

Client
Louis Nelson Associates Inc.

Purpose or Occasion
Holiday greeting

Paper/Printing
12 pt. Wynestone
mirror-red cover

Number of Colors
One (PMS 362)

Louis Nelson Associates, Inc. wanted to celebrate, share, and highlight the public unveiling of the Korean War Veterans Memorial with clients, friends, and relations while simultaneously conveying holiday greetings. This was accomplished with simplicity of message and ornamental festivity.

All Design
Paul Stoddard

Client
Paul Stoddard

Purpose or Occasion
Holiday greeting

Paper/Printing
Green moss Bandelier environ-
mental papers/Laser printed

Number of Colors
One

..

Using an inexpensive means
to showcase and remind clients
of the illustrator's unique and
playful style, this limited-edition
holiday greeting card was sent
to past and present clients.
The piece was laser-printed on
green moss Bandelier environ-
mental paper, hand-colored
with Prismacolor pencils, and
then hand assembled.

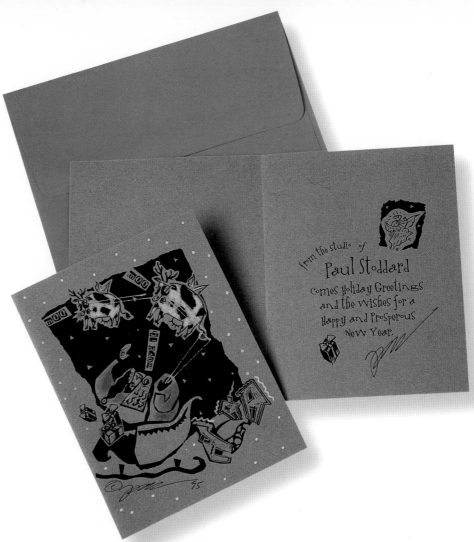

Design Firm
American Art Studio

Art Director/Designer
Barbara Biondo

Illustrator
Dena Shataosky

Client
American Art Studio

Purpose or Occasion
Holiday greeting

Paper/Printing
Laser-cut stock—Fleurishes

Number of Colors
One

..

The text originated from an
anonymous piece we discovered
and was then modified using
original calligraphy.

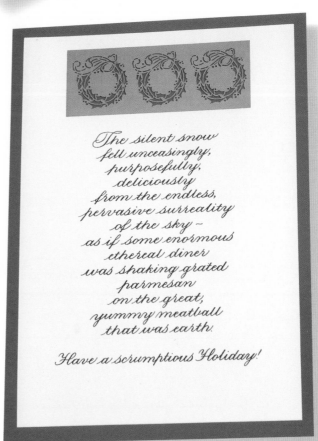

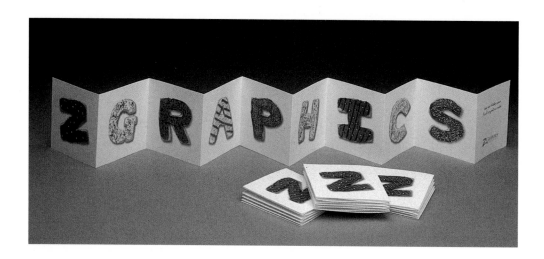

Design Firm
ZGraphics, Ltd.

Art Director
Lou Ann Zeller

Designer
Renee Niedbala

Photographer
Michael Camacho and
Associates

Client
ZGraphics, Ltd.

Purpose or Occasion
Holiday greeting

Paper/Printing
Starwhite Vicksburg/Lithography

Number of Colors
Four

Wanting a fun, clever, and visually intriguing card, we spelled out the name (ZGraphics) in colorfully decorated Christmas cookies and printed the card as a ten-page Z-fold to catch the eye. Canisters of Z-shaped cookies were also given as gifts.

SEASON'S GREETINGS

FROM

JUNG/BRANNEN 1996

❁

VOYAGE PITTORESQUE DE LA SYRIE, DE LA PHENICIE,

DE LA PALESTINE, ET DE LA BASSE EGYPTE

DESSINE PAR L.F. CASSAS, GRAVE PAR VARIN

Design Firm
Clifford Selbert Design
Collaborative

Art Director
Bill Crosby

Designer
Devin Muldoon

Client
Jung/Brannen Associates

Purpose or Occasion
Holiday poster

Paper/Printing
Finch

Number of Colors
Two

In the past, the client had produced a series of one-color holiday posters using an extensive library of archival architectural images. This design was a real leap for them and the meeting in which they approved it was both tense and exciting. Needless to say, both the client and the recipients of the poster responded enthusiastically.

Design Firm
Dever Designs

All Design
Jeffrey L. Dever

Client
Dever Designs

Purpose or Occasion
Holiday greeting

Paper/Printing
Strathmore Pastelle/
Bateman Printing

Number of Colors
Two

This card was mailed to Dever Designs' clients, who expect a unique and sophisticated design solution. The traditionally rendered art was combined with type in QuarkXPress. The ribbon was hand-threaded and hand-tied.

Design Firm
Julia Tam Design

All Design
Julia Chong Tam

Client
Julia Tam Design

Purpose or Occasion
Christmas greeting

Paper/Printing
Confetti duplex/
Crown Graphics

Number of Colors
One and foils

Designed in Adobe Illustrator, the printer's limited capacity required the use of duplex to add color and foils. Die-cuts are also used and the piece was hand-folded.

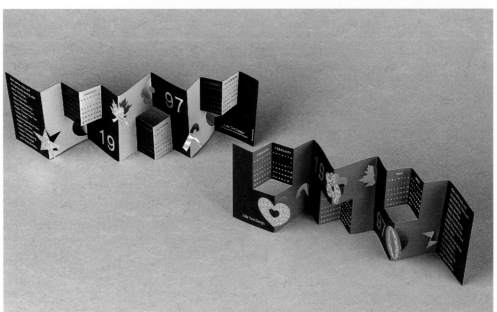

Promoti
Cards

nal Promotional Cards

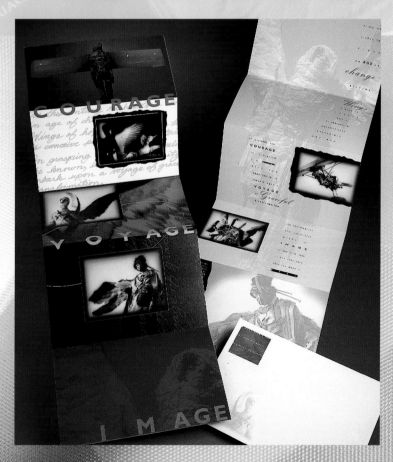

Women

Men

Design Firm
Manley Design

All Design
Don Manley

Client
Don Manley

Purpose or Occasion
Promotion

Paper/Printing
Neenah classic laid
cover/Inkjet printer

Number of Colors
Printed in-house,
300 dpi HP inkjet printer

Every few months throughout
the year, the designer sends out
promotional postcards as a fun
reminder of his design services.
The cards are produced in-
house on an HP 300 dpi color
inkjet printer. Recipients enjoy
the humorous, lighthearted
approach and often mount the
cards in their offices.

Design Firm
Mires Design

Art Director
John Ball

Designers
John Ball, Miguel Perez

Client
Copeland Reis Talent Agency

Purpose or Occasion
Promotion

Paper/Printing
Vintage Velvet

Number of Colors
One

A simple design proved an
effective way to show
prospective clients what this
talent agency had to offer.

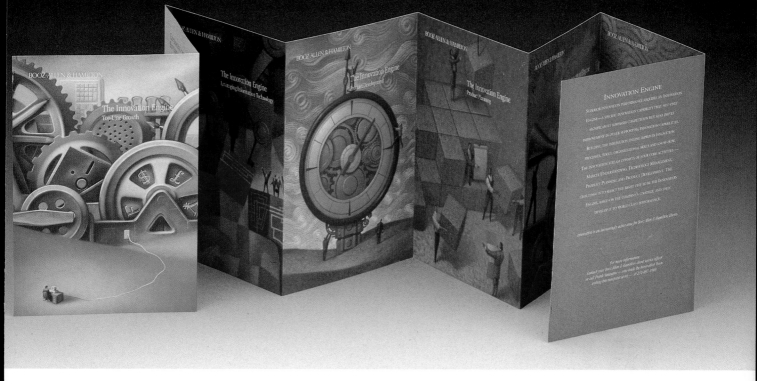

Design Firm
Metropolis Corporation

Creative Director
Denise Davis

Designers
Lisa DiMaio,
Craig Des Roberts

Client
Booz, Allen and Hamilton, Inc.

Purpose or Occasion
Explaining innovation engine

Paper/Printing
Hammermill Regalia

Number of Colors
Five

...........

A series of brochures created
to explain Booz, Allen and
Hamilton's strategy of creating
world class performance
through an innovation engine.
Building the innovation engine
improves innovation processes,
tools, organizational skills,
and know-how.

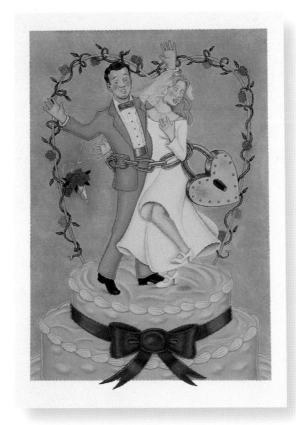

Design Firm
Lorraine Williams Illustration

All Design
Lorraine Williams

Client
Lorraine Williams Illustration

Purpose or Occasion
Self-promotion

Paper/Printing
Offset

Number of Colors
Four

...........

This postcard is one in a
series of self-promotional
cards sent quarterly to various
art directors to increase
awareness. The mixed-media
piece, entitled "Nevermind,"
was created using dyes, pastels,
and watercolor pencil and was
sent as a June mailing.

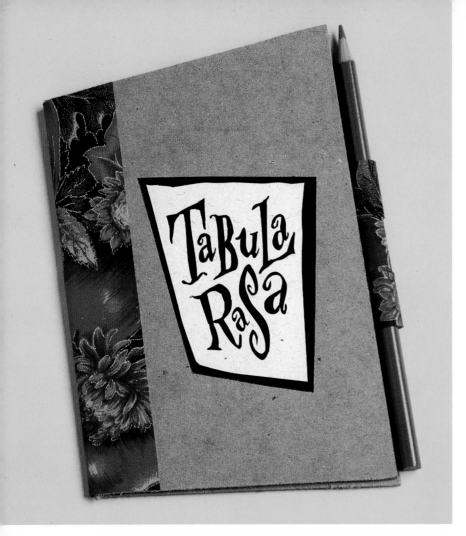

Design Firm
W design, Inc.

Art Director
Alan Wallner

Designer
Christopher Marble

Client
W design

Purpose or Occasion
New Year's self-promotion

Paper/Printing
Davey board/Laser printer

Number of Colors
One

As a company, W design decided to put together a unique self-promotion that would involve all members of the staff. Six hundred Tabula Rasa books were assembled over a two-week span. It proved to be truly a labor of love, but the final effect was well worth it.

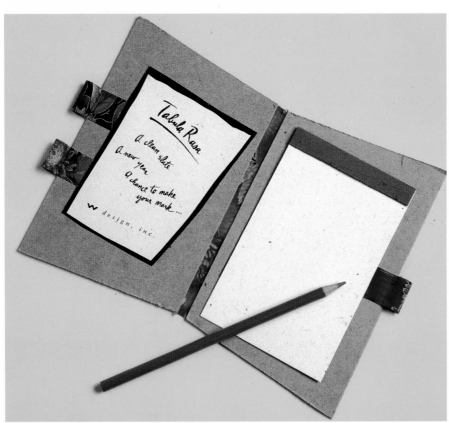

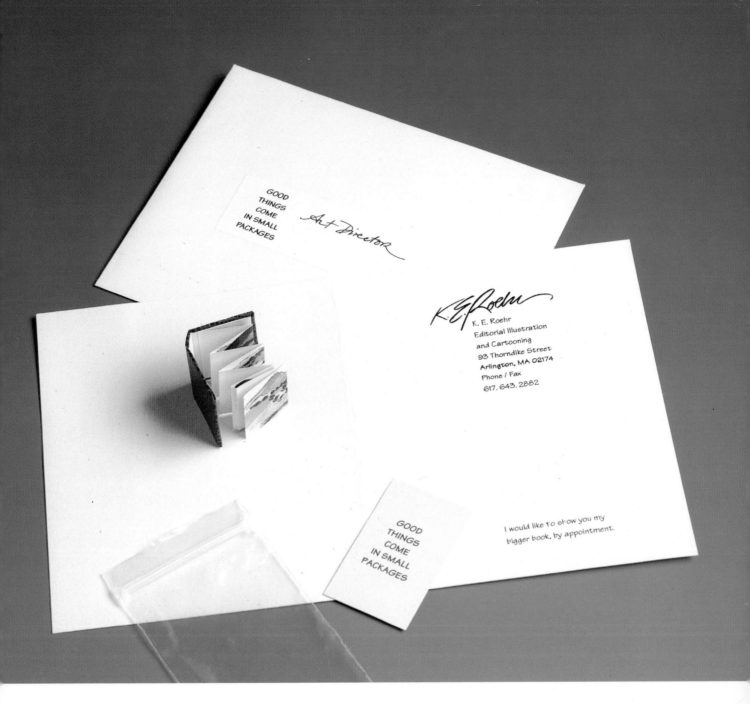

GOOD
THINGS
COME
IN SMALL
PACKAGES

Art Director

K. E. Roehr
Editorial Illustration
and Cartooning
93 Thorndike Street
Arlington, MA 02174
Phone / Fax
617. 643. 2882

GOOD
THINGS
COME
IN SMALL
PACKAGES

I would like to show you my
bigger book, by appointment.

Design Firm
K. E. Roehr Design and
Illustration

All Design
K. E. Roehr

Client
K. E. Roehr

Purpose or Occasion
Self-promotion
illustration piece

Paper/Printing
Various/hand-made books

Number of Colors
Four-color insert

This illustration includes a
handmade miniature book
produced with the intent of
giving prospective clients
something precious and
unique that would remain in
sight rather than being filed.

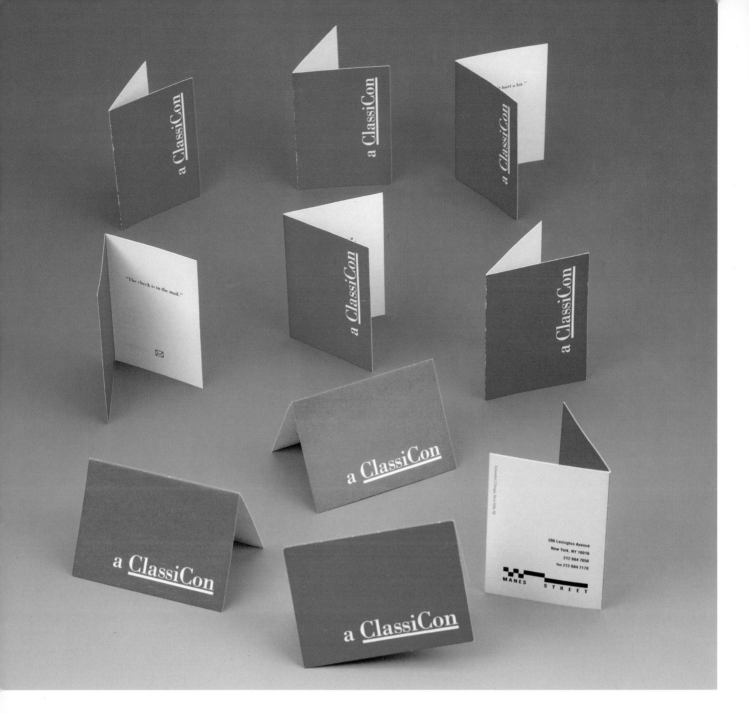

Design Firm
Toni Schowalter Design

Art Director/Designer
Toni Schowalter

Client
Manes Space

Purpose or Occasion
Promotion

Paper/Printing
65 lb. cover

Number of Colors
Two

The project involved producing ten individual cards that would promote the furniture company's name, Classic Con, by tying into well-known quotes. Each card has a different quote and they were distributed as a series to provide momentum.

Design Firm
Manley Design

All Design
Don Manley

Client
Don Manley

Purpose or Occasion
Regular promotion

Paper/Printing
Neenah classic laid
cover/Inkjet printer

Number of Colors
Printed in-house, 300 dpi
HP inkjet printer

Every few months throughout
the year, the designer sends
out promotional postcards
as a fun way of letting clients
know that he is still active. The
cards are produced in house on
an HP 300 dpi color inkjet
printer. Recipients appreciate
the humorous, lighthearted
approach and often mount the
cards in their offices.

Design Firm
The Weller Institute

All Design
Don Weller

Client
The Weller Institute

Purpose or Occasion
Note card

Paper/Printing
Offset lithography

Number of Colors
Four

Using a Texas longhorn with a
map of Texas as a spot on his
side and clouds that form a
lone star in the sky, this note
card works well by tapping
into Texans' love of Texas.

Design Firm
Toni Schowalter Design

Art Director/
Designer
Toni Schowalter

Client
Manes Space

Purpose or Occasion
Promotion

Paper/Printing
Strathmore Grandee/die-cut

Number of Colors
Two on paper, four on card

The die-cut announcement card, printed on yellow stock, has a separate inserted plastic card that turns color when pressed to promote a furniture dealer's capabilities.

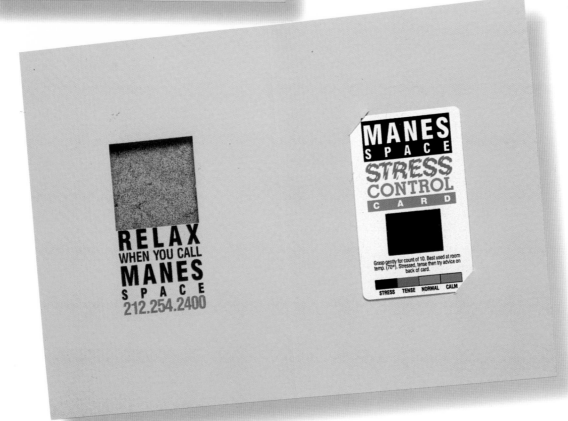

Design Firm
Toni Schowalter Design

**Art Director/
Designer**
Toni Schowalter

Client
Bright Chair

Purpose or Occasion
Promote new product

Paper/Printing
Plastic card

Number of Colors
Four

..................................

This plastic card is vacuum
formed over a photograph to
announce and highlight the
client's new product.

Design Firm
Teikna

**Art Director/
Designer**
Claudia Neri

Client
Hostellerie de Crillon le Brave

Purpose or Occasion
Promotion of new cooking
program

Paper/Printing
Champion Benefit/Keller
Graphics

Number of Colors
Two

..................................

The purpose of this mailer
is to generate interest and
sales for a high-level cooking
course held in two small,
luxurious hotels in Provence,
France. With the limitations of
a very small budget, ingenuity
became an essential element
of the completed piece.

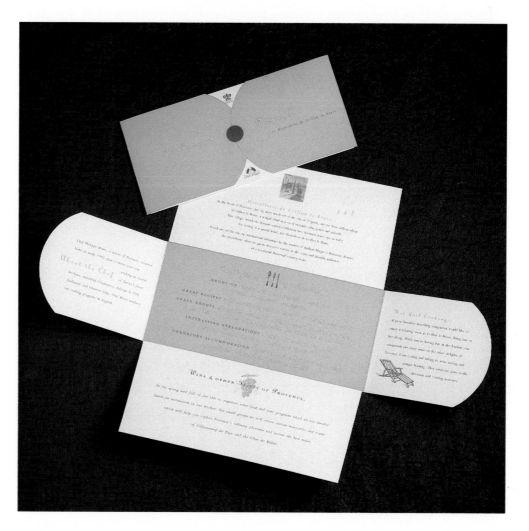

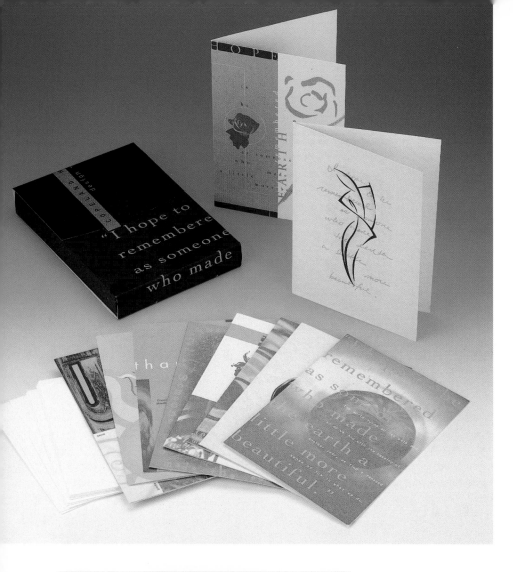

Design Firm
Copeland Hirthler design and communications

Creative Directors
Brad Copeland, George Hirthler

Art Directors
David Butler, Raquel C. Miqueli

Designers
David Butler, Lea Nichols, David Woodward, David Crawford, Shawn Brasfield, Todd Brooks, Sean Goss, Jeff Hack, Sam Hero, Sarah Huie, Mark Ligameri, Raquel Miqueli, David Park, Melanie Bass Pollard, Michelle Stirna, Mike Weikert

Illustrators
Studio

Client
Copeland Hirthler design and communications

Purpose or Occasion
Seasonal promotion

Paper/Printing
Neenah

Number of Colors
Four

This seasonal gift/promotion incorporates twelve different interpretations of a card with a message that centers on peace.

Design Firm
Bartels and Company

Art Director
David Bartels

Designer
John Postelwait

Illustrators
Michael Deas, Gregory Manchess, Gary Kelley, Robert Rodriguez, Ted Coconis, Guy Porfirio

Client
St. Patrick Center

Purpose or Occasion
Fund-raising

Paper/Printing
Quest Printing

Number of Colors
Four plus varnish

The cards were the inspiration of a staff member at the St. Patrick Center. Design services for the project were donated and illustrators were solicited to render the necessary graphics. The illustrators were paid a token fee and the printing and paper were billed at cost.

Design Firm
Shook Design Group, Inc.

Designers
Ginger Riley, Graham Schulken

Client
UNC—Charlotte College
of Architecture

Purpose or Occasion
Solicitation for donations

Paper/Printing
Classic Crest

Number of Colors
One

Shook Design Group, Inc.
designed an invitation to donate
funds to benefit the UNC—
Charlotte's purchase of 7,000
new books for its College of
Architecture library.

Design Firm
Kan and Lau Design
Consultants

Art Directors
Kan Tai-Keung, Freeman Lau
Siu Hong

Designer
Veronica Cheung Lai Sheung

Computer Illustrator
Benson Kwun Tin Yau

Client
Bank of China—Macau Branch

Number of Colors
Four

The designers used Adobe
Photoshop, Adobe PageMaker,
and Macromedia FreeHand on
a Power Macintosh to render
this official document for the
Macau Branch of the Bank
of China.

Design Firm
Quilt Designs

Designer
Sharon DeLaCruz

Quilter/Artist
Sharon DeLaCruz

Purpose or Occasion
Promotional cards

Paper/Printing
Color Xerox

Number of Colors
Four

These promotional cards show-
case the artist's Fiber-Graphic
Quilts and other original artwork
created in mixed media (ink,
watercolor, and marbling.)
Original renderings are printed
with Canon's T-shirt transfers
and sewn into quilts ranging
in size from 18" x 24" to mural
dimensions.

Design Firm
Austin Design

Art Director/
Designer
Wendy Austin

Client
Austin Design

Purpose or Occasion
Autumn promotion

Paper/Printing
ConteHi/Canson Satin/
Four Star Printing

Number of Colors
Two

This promotion was the
second in a series to
which an actual autumn
leaf was added as a surprise.
The card generated a very
favorable response.

Art Director
Rioji Oba

Illustrator
James Marsh

Client
AO Records

Purpose or Occasion
Promotional card

Number of Colors
Four

...

These cards, designed for an independent record company, include a blank inside and were produced to match the size of a CD for inclusion in direct mailings.

Design Firm
James Marsh

All Design
James Marsh

Client
James Marsh

Purpose or Occasion
Promotional card

Number of Colors
Four

...

Titled "Pigeon-Holed," the card's design draws attention to the act of pigeon-holing— from which we all wish to escape.

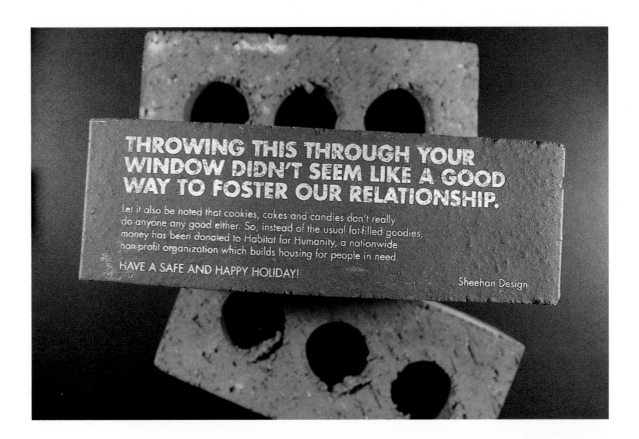

Design Firm
Sheehan Design

Art Director/
Designer
Jamie Sheehan

Client
Sheehan Design

Purpose or Occasion
Holiday promotion

Paper/Printing
Bricks

Number of Colors
One

.......................................

Using bricks, my intention was to poke fun at the standard holiday gorging while making it known that money was donated to charity in place of an expensive gift to the recipient. The bricks were wrapped in fancy paper and delivered by courier to local clients. The design for the text was done using a computer and printed using silkscreen.

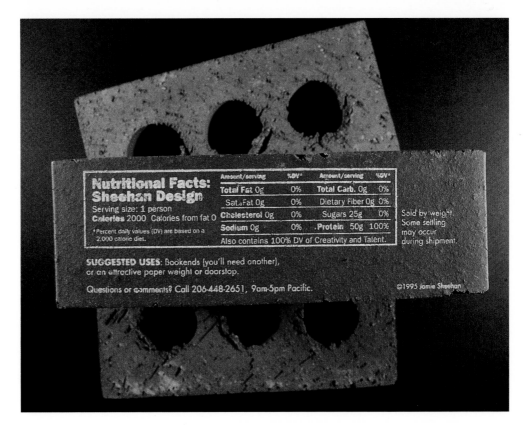

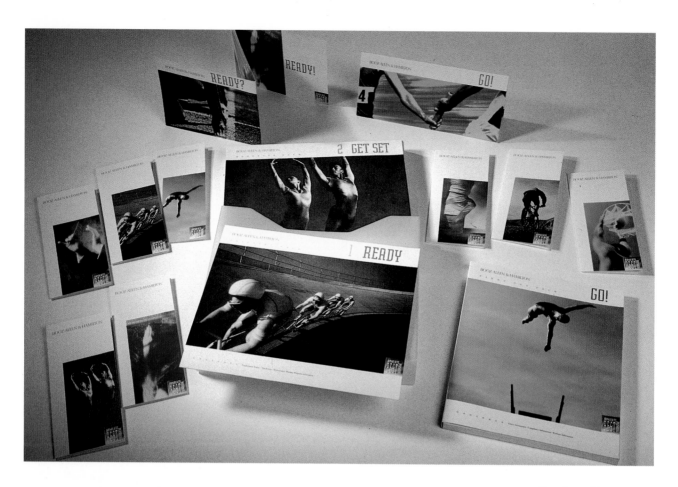

Design Firm
Held Diedrich

Art Director
Doug Diedrich

Designer
Megan Snow

Client
Held Diedrich

Purpose or Occasion
Self-promotion

Number of Colors
Four

...

This in-house promotion
allowed some creative
breathing space. Rather than
a Christmas card, the firm
opted for a calendar so
prospective and current
clients would be reminded of
the designers throughout the
year. Some minor image
manipulation took place in
Adobe Photoshop and the file
was created in QuarkXPress.

Design Firm
Metropolis Corporation

Creative Director
Denise Davis

Client
Booz, Allen and
Hamilton, Inc.

Purpose or Occasion
Employee welcome kit

Paper/Printing
Mohawk

Number of Colors
Six

...

The kit's purpose was to
clarify new-hires to the
procedures at Booz, Allen and
Hamilton. The aggressive yet
sophisticated design helped
bring this piece together as a
family package, relative to
the theme of joining the Booz,
Allen and Hamilton family.

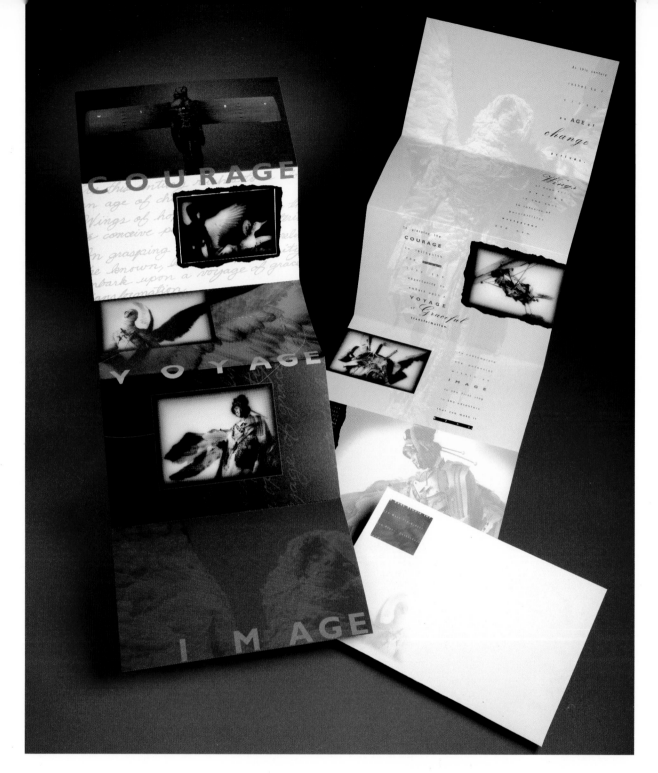

Design Firm
DZone Studio, Inc.

Art Director
Joseph L. Yule

Photographer
Ray Carofano

Artist
Ron Pippin

Purpose or Occasion
Self-promotion

Paper/Printing
Karma matte 80 lb. natural
cover

The process of bringing together the work of a gifted photographer and a highly creative sculptor using the discipline of design was very challenging. The piece had to do justice to all of the contributors as well as integrate the dimension of the written word. The finished product captures the power and magic of collaboration at its finest.

Directory

Adams Art Lettering and Design 67
2124 NW 139th Street
Des Moines, IA 50325

After Hours Creative 94
1201 E. Jefferson B100
Phoenix, AZ 85034

Allan Burrows Limited 21
Essex House, High Street in Gatestone
Essex, CM4 9HW
United Kingdom

American Art Studio 10, 24, 53, 137
124 West 24th Street, #2A
New York, NY 10011

Angela Jackson 109
7329 Washburn Way
North Highlands, CA 95660

Atlantic Design Works 86, 96
24 Glenbrook Road
West Hartford, CT 06107

Austin Design 38, 153
163 Commonwealth Avenue, #8
Boston, MA 02116

AWG Graphics B.C.I.LTDA 95, 123
R. Maestro
Cardim 377-CJ86
Brazil

Bakagai Design 32
221 W. Eugenie, 1F
Chicago, IL 60614

Bartels and Company 150
3284 Ivanhoe Avenue
St. Louis, MO 63139

Becker Design 20, 74, 90-91
225 E St. Paul Avenue
Suite 300
Milwaukee, WI 53202

C. Benjamin Dacus 42
3105 Moss Side Avenue
Richmond, VA 23222

CBS Television City Graphics 86
2501 Foothill Boulevard, # 3
La Crescenta, CA 91214

Clearpoint Communications 46
50 Oliver Street
N. Easton, MA 02356

Clifford Selbert Design Collaborative 138
2067 Massachusetts Avenue
Cambridge, MA 02140

Copeland Hirthler design and communications 29, 87, 97, 150
40 Inwood Circle
Atlanta, GA 30309

D4 Creative Group 106
4100 Main Street, Suite 210
Philadelphia, PA 19127-1623

David Carter Design 114, 115
4112 Swiss Avenue
Dallas, TX 75204

Design Art, Inc. 118
6311 Romaine Street, # 7311
Los Angeles, CA 90038

Design Guys 14, 27, 36
119 N. 4th Street, # 400
Minneapolis, MN 55401

Dever Designs 139
9101 Cherry Lane, # 102
Laurel, MD 20708

DZone Studio, Inc. 157
273 W. 7th Street
San Pedro, CA

Ellen Kendrick Creative, Inc. 53
6646 Garlinghouse Lane
Dallas, TX 75252

Entheos Design 41
1422 24th Street, #4
Kenosha, WI 53140

Frank Kunert 23, 116
Koselstrasse 49
60318 Frankfurt
Germany

Franz and Company, Inc. 78
3309-G Hampton Point Drive
Silver Spring, MD 20904

FRCH Design World Wide 14
444 N. Front Street, # 211
Columbus, OH 43215

GAF Advertising/Design 15, 65, 124
7215 Holly Hill, Suite 102
Dallas, TX 75231

Get Smart Design Company 65, 89, 98, 119
899 Jackson Street
Dubuque, IA 52001

Graphic One, Inc. 76
347 W. 57th Street, Suite 17E
New York, NY 10014

Greencards 104
2112 40th Place
Des Moines, IA

Greteman Group 58, 118
142 N. Mosley
Wichita, KS 67202

Han Design 39
500 N. Michigan Avenue, Suite 1600
Chicago, IL 60611

HC Design 20
3309-G Hampton Point Drive
Silver Spring, MD 20904

Held Diedrich 67, 85, 156
703 E. 30th, # 16
Indianapolis, IN 40205

Inland Group Inc. 47
222A North Main
Edwardsville, IL 62025

Insight Design Communications 17
322 S. Mosley
Wichita, KS 67202

J. Graham Hanson Design 10, 87, 94
307 E. 89th Street, # 6G
New York, NY 10128

James Marsh 25, 125, 154
21 Elms Road
London SW4 9ER
United Kingdom

Joanna Roy 100
549 W. 123rd Street
New York, NY 10027

Julia Tam Design 16, 139
2216 Via La Brea
Palos Verdes, CA 90274

K. E. Roehr Design and Illustration 145
93 Thorndike Street
Arlington, MA 02174

Kan and Lau Design Consultants 152
28/F Great Smart Tower
230 Wanchai Road
Hong Kong

Larry Burke-Weiner 120
832 S. Woodlawn Avenue
Bloomington, IN 47401

Larsen Design and Interactive 133
7101 York Avenue South
Minneapolis, MN 55435

Lehner and Whyte 105
8-10 S. Fullerton Avenue
Montclair, NJ 07042

Lianne Cortese 132
452 Hanover Street, # 6
Boston, MA 02113

Lightner Design 44, 48–49
9730 SW Cynthia Street
Beaverton, OR 97008

Lorraine Williams Illustration 105, 143
36 Plaza Street East, # 4B
Brooklyn, NY 11238

Louis Nelson Associates Inc. 136
80 University Place
New York, NY 10003

MAH Design 101
14814 Heritage Wood
Houston, TX

Manley Design 142, 147
255 Budlong Road
Cranston, RI 02920

Marketing Services—Indiana University 122

Marsh, Inc. 99
34 W. 6th Street, Suite 1100
Cincinnati, OH 45202

McCullough Creative Group 11
890 Iowa Street
Dubuque, IA 52001

McGaughy Design 113
3706-A Steppescourt
Falls Church, VA 22041

Melinda Persing Design 128
11930 Belmont Avenue
Cleveland, OH 44111

Melissa Passehl Design 52, 53
1275 Lincoln Avenue, Suite 7
San Jose, CA 95125

Metropolis Corporation 13, 43, 75, 120, 143, 156
P. O. Box 32
Milford, CT 06460

Mike Salisbury Communications, Inc. 88
2200 Amapola Court, Suite 202
Torrance, CA 90501

Mires Design 11, 36, 56, 127, 128, 142
2345 Kettner Boulevard
San Diego, CA 92101

Misha Design Studio 68, 126
1638 Commonwealth Avenue, # 24
Boston, MA 02135

Mohr Design 30
Huettenweg 28A
14195 Berlin
Germany

Muller and Company 25, 51
4739 Belleview Avenue
Kansas City, MO 64112

Nancy Stutman Calligraphics 34, 35
3008 Rana Court
Carlsbad, CA 92009

Nesnadny and Schwartz 64, 135
10803 Magnolia Drive
Cleveland, OH 44106

Our Mind's Eye Creation 134
1341 E. Dartmouth Avenue
Englewood, CO 80110

Paper Shrine 63
604 France Street
Baton Rouge, LA 70802

Paresky Design 122, 129, 130
3109 Grand Avenue, # 430
Coconut Grove, FL 33133

Paul Stoddard 121, 137
524 Main Street
Stoneham, MA 02180

Perucho Mejia Graphic Design 100
Torres Del Rio Bloque, Apt. D 401
235086 Popayan
Colombia

Planet Design Company 103
605 Williamson Street
Madison, WI 53716

Pollard Creative 37
1431 Lanier Place
Atlanta, GA 30306

Quilt Designs 152
5052 N. Marine, Apt`. 7-d
Chicago, IL 60640

Rapp Collins Communications 134
901 Marquette Avenue
17th Floor
Minneapolis, MN

R. E. Roehr 79
93 Thorndike Street
Arlington, MA 02174

Rainwater Design 12
63 Congress Street
Hartford, CT 06114

Rick Eiber Design (RED) 58, 71
31014 SE 58th Street
Preston, WA 98050

The Riordon Design Group, Inc. 51
131 George Street
Oakville, ON 40J 3B9
Canada

Russell Design Associates 69, 72
584 Broadway
New York, NY 10012

Sagmeister, Inc. 54-55, 113
222 West 14th Street
New York, NY 10011

Samaritan Design Center 18, 22

Sandy Gin Design 131
329 High Street
Palo Alto, CA 94301

Sayles Graphic Design 28, 38, 68, 74
308 Eighth Street
Des Moines, Iowa 50309

Schumaker 127
466 Green
San Francisco, CA 94133

Sharp Designs 98

Sheehan Design 94, 155
500 Aurora Avenue N, # 404
Seattle, WA 98109

Shields Design 70
415 E. Olive Avenue
Fresno, CA 93728

Shook Design Group, Inc. 17, 57, 112, 151
2000 S. Boulevard, Suite 510
Charlotte, NC 28203

Sibley/Peteet Design 28, 50, 57, 59
3232 McKinney, # 1200
Dallas, TX 75204

Smith Design Associates 19
205 Thomas Street, Box 190
Glen Ridge, NY 07028

Sommese Design 44
481 Glenn Road
State College, PA 16803

Standard Delux Design and Silkscreen Print Shop 77
171 Doolittle Lane
Birmingham, AL 35255

Steve Trapero Design 42
3309-G Hampton Point Drive
Silver Spring, MD 20904

Stoltze Design 45, 50
49 Melcher Street
Boston, MA 02210

Storm Design and Advertising 66
174 Albert Street
Prahran VIC 3181
Australia

Stowe Design 33, 101, 107
125 University Avenue, Suite 220
Palo Alto, CA 94301

Tandem Graphics 13, 117
Langwiederstrasse 26A
85221 Dachau
Germany

Teikna 62, 84, 149
366 Adelaide Street East, # 541
Toronto, ON N5A 3X9
Canada

"That's Nice" L.L.C. 84
235 East 13th Street, # 6L
New York, NY 10003-5650

This Gunn for Hire 30
1428 Caminito Septimo
Cardiff, CA 92007

Toni Schowalter 32, 73, 80, 81, 83, 102, 107, 110, 111, 125, 132, 146, 148, 149
1133 Broadway, Suite 1610
New York, NY 10010

Tower of Babel 130
24 Arden Road
Asheville, NC 28803

Towers Perrin 40, 77
200 W. Madison, Suite 3100
Chicago, IL 60606

Val Gene Associates—Restaurant Group 12, 69
5208 Classen Boulevard
Oklahoma City, OK 73118

W Design, Inc. 144
411 Washington Avenue N., # 208
Minneapolis, MN 55401

The Weller Institute 147
P. O. Box 518
Oakley, UT 84055

Wood/Brod Design 108
2410 Ingleside Avenue
Cincinnati, OH 45206

The Wyatt Group 18
5220 Spring Valley Road, # 6
Dallas, TX 75240

X Design Company 16, 21, 26, 31
2525 W. Main Street, Suite 201
Littleton, CO 80120

Zappata Disenadores S.C. 26, 82
180 Angulo Campillo
Lafayette 143, Anzures C.P. 11590
Mexico City
Mexico

ZGraphics 138
322 North River Street
E. Dundee, IL 60118